WILD & SCENIC
FLORIDA
A PHOTOGRAPHIC PORTFOLIO

PHOTOGRAPHY
BY
JAMES RANDKLEV

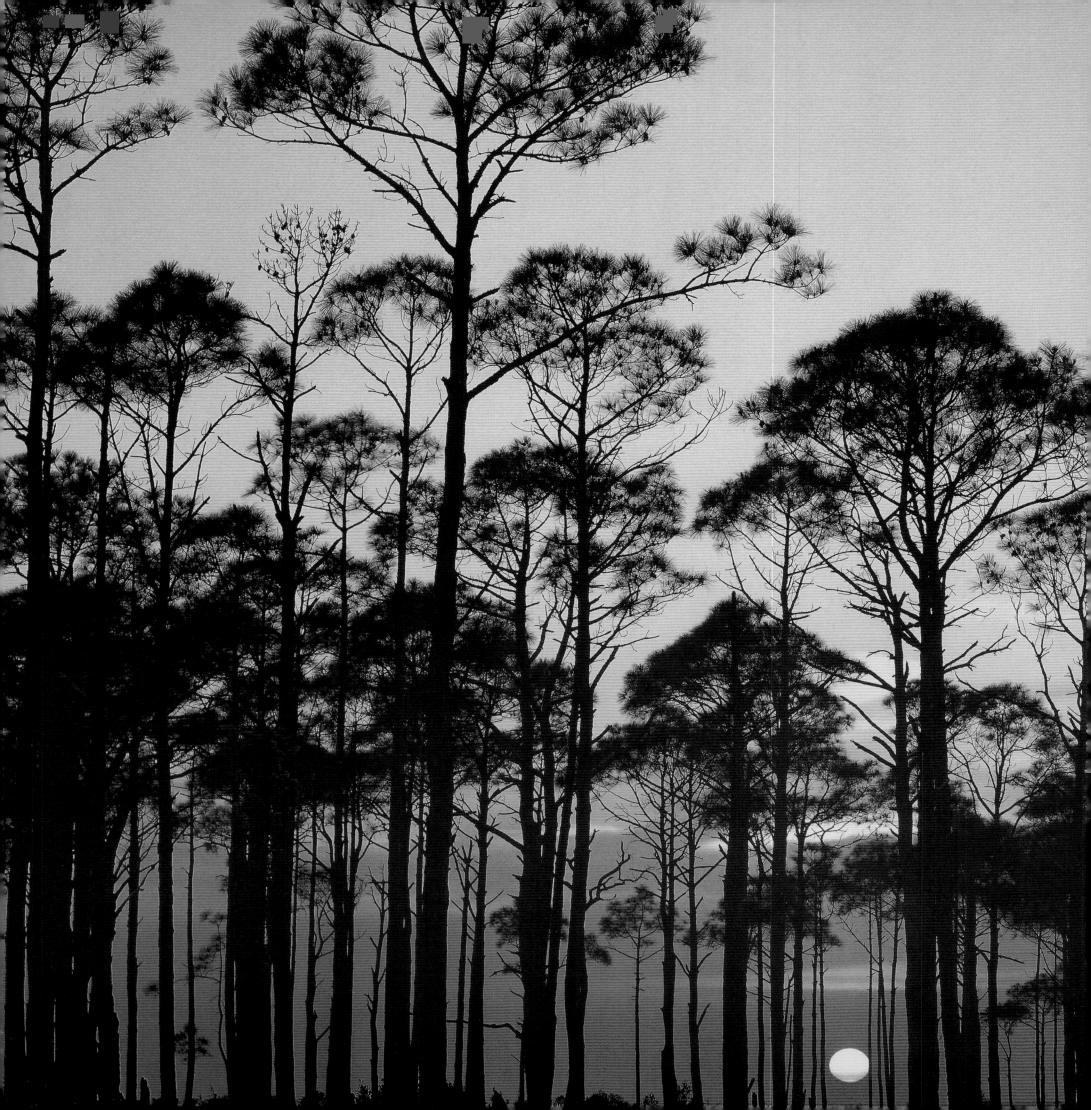

WILD & SCENIC
FLORIDA
A PHOTOGRAPHIC PORTFOLIO

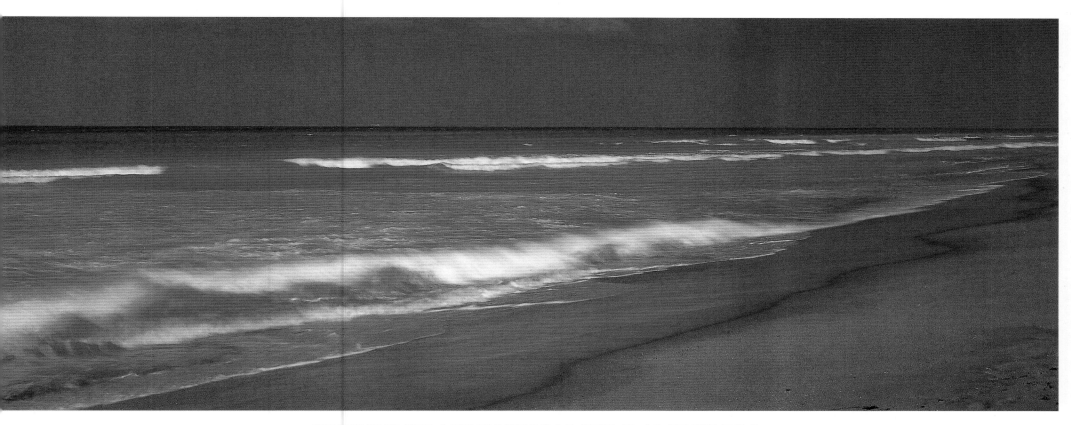

PHOTOGRAPHY BY JAMES RANDKLEV

BROWNTROUT PUBLISHERS, INC.
SAN FRANCISCO

(PRECEDING PAGES)

SUNSET SILHOUETTES PINE FOREST,
ST. GEORGE ISLAND STATE PARK,
GULF OF MEXICO

SURF ALONG BOCA RATON BEACH,
ATLANTIC COAST

WILD & SCENIC FLORIDA
A PHOTOGRAPHIC PORTFOLIO
PHOTOGRAPHY BY JAMES RANDKLEV

Entire contents ©1995 BrownTrout Publishers, Inc.
Introduction, Photographs and Captions ©1995 James Randklev
Photographs reprinted with permission
©1995 Art Wolfe, ©1995 Doug Perrine

All rights reserved under International and Pan-American Copyright Conventions. No part of this book may be reproduced in any form or by any electronic or mechanical means, including information storage and retrieval systems, without permission in writing from the publisher.

LIBRARY OF CONGRESS CATALOGING-IN-PUBLICATION DATA

Randklev, James.
 Wild & scenic Florida a photographic portfolio / photography by James Randklev
 p. cm.
 ISBN 1-56313-702-X (alk. paper)
 1. Florida—Pictorial works. 2. Natural areas—Florida—Pictorial works. 1. Title.
F312.R36 1995 95-35810
975.9'0022'2—dc20 CIP

10 9 8 7 6 5 4 3

PUBLISHED IN THE UNITED STATES OF AMERICA BY
BROWNTROUT PUBLISHERS, INC.
P.O. BOX 280070
SAN FRANCISCO, CA 94128 USA
PRINTED IN KOREA

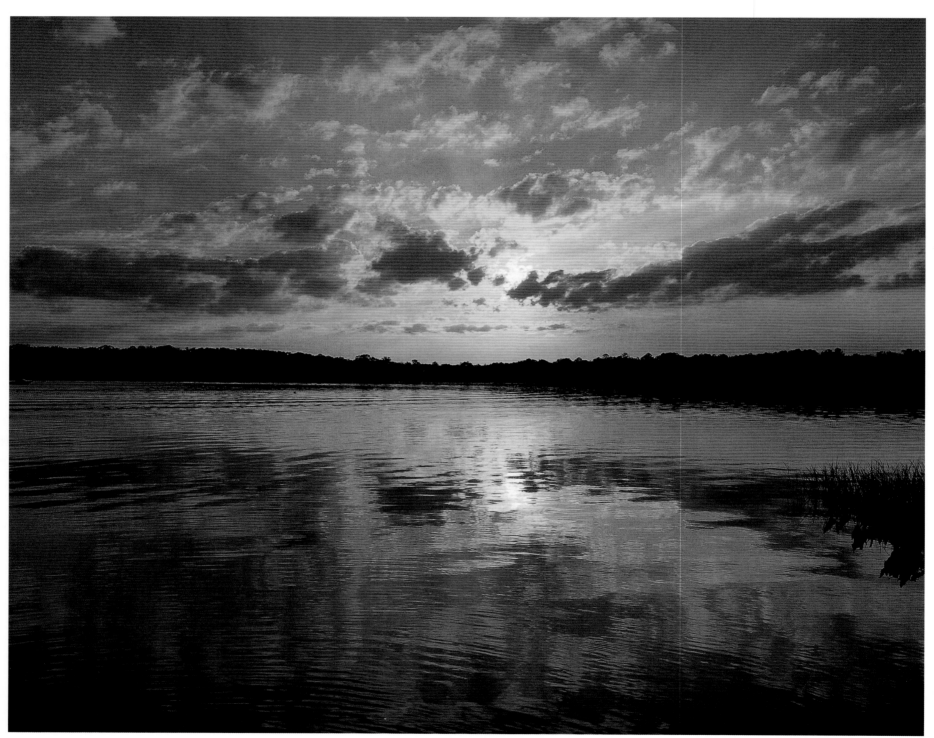

SUNSET OVER LAKE WAUBERG,
PAYNES PRAIRIE STATE PRESERVE, GAINESVILLE

PHOTOGRAPHER'S INTRODUCTION
FLORIDA— Feast of Flowers

RISING from the depths of an emerald sea some 20 million years ago, this unique peninsula of limestone, sand, and water that we know today as Florida has become a paradise of windswept beaches, hardwood hammocks, and crystalline springs. In the world's largest freshwater marsh and on mangrove keys too numerous to count, wildlife continues to flourish in this subtropical land. Plants truly exotic in nature remind us of a distant time and place.

When Spanish explorer Juan Ponce de Leon first set foot on the broad beaches of northeast Florida in 1513, and claimed the land for Spain, he was searching for the legendary "Isle of Bimini," where ancient lore said could be found a miraculous "fountain of youth." He failed to find that elusive treasure but he did give the lush landscape its beautiful name of *Florida,* in honor of Spain's Easter holiday Pascua Florida, which means "feast of flowers."

On March 3, 1845 Florida became the 27th state to enter the Union. It remains a veritable feast for the eyes. If you take the time to explore Florida's hidden treasures you will be rewarded with unforgettable views of the pristine Florida in which Native Americans lived.

The Florida landscape provides little relief for the eye to embrace. As a native of the Pacific Northwest, I grew up among the towering peaks of the Olympic Range and their glacial-cut valleys which give way to coastlines of driftwood-strewn beaches. As a child the natural world seemed grand and aloof. I grew accustomed to such grandeur. Subtleties did not impress me until I journeyed East and found myself drawn into a more intimate landscape, with its textures and shades of muted colors. The horizon seemed infinite, as if it were the edge of the world, forcing my eyes to look closer at what lay before me. I felt energized, absorbed by the radiant warmth of this land of sunshine.

My first trip to Florida was 10 years ago. It was May, the beginning of Florida's rainy season, and mosquitos, affectionately called the state bird, were sampling my western blood. Storm clouds gathered and the thunder rolled. Lighting seemed to dance down around me. The blackened sky became one with the earth, and for me there was something primal and exciting about this common afternoon event. I stood in awe, looking up at those angry skies, as they lashed out their charged energy of brilliant flashes. Soon there was a downpour unlike anything I'd ever experienced; sheets of water drenched the broad landscape of bending sawgrass and palms. I was soaked within seconds, but I reveled in the spectacular performance.

Florida is a peninsula that lies in the hurricane belt. Its existence is totally dependent upon the eternal cycle of water. Ever in motion, rainwater becomes absorbed by the porous limestone sediment from which it came. Great aquifer cave systems give rise to more than 300 major springs that spawn many of

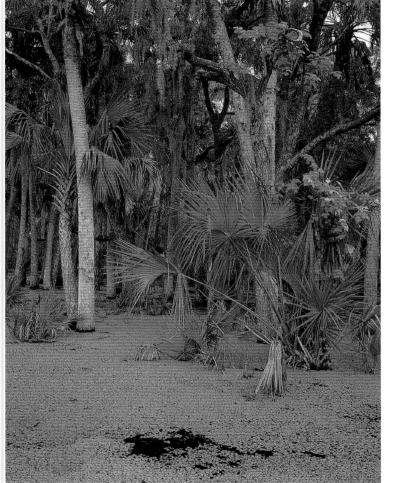

SABAL PALMS IN A FLOODED HAMMOCK COVERED IN DUCK WEED, THE NATIONAL AUDUBON SOCIETY'S KISSIMMEE PRAIRIE PRESERVE

Florida's lakes and river systems. I remember swimming in the clear waters of Ginnie Springs and following its spring run past submerged banks of eel grass, before the waters emptied into the Santa Fe River. I thought I could imagine how sacred these crystalline pools were to the ancient peoples.

With more than 8,000 miles of tidal coastline, Florida far exceeds any other state in water habitat. In the last few years I drove the entire coastline twice, experiencing visually all I could absorb of this incredible landscape. The Gulf shores are famous for their impeccable white sand beaches and barrier islands that vacationers flock to, but equally rewarding are the quiet estuaries, lagoons, and bays of these coastal communities. At St. Marks National Wildlife Refuge I climbed atop my van to photograph the setting sun over a small lagoon. I paused and listened to the grunting sounds of distant alligators while snowy egrets fed along the shallow shores.

I continued my journey along the Gulf, exploring the brilliant shores of St. George Island and Cedar Key, seeking out the gentle manatees at Homosassa Springs, and catching the flavor of the Greek community at Tarpon Springs and its sponge fishing fleet. Photographing the abundant wildlife at J.N. Darling National Wildlife Refuge on Sanibel Island and strolling along its shell strewn beaches left no wonder why people grow to love southwestern Florida.

Taking wing in a small plane, I flew over Cayo Costa Island and past the golden shores of Naples and Marco Island, then southward to the Ten Thousand Island region of the Everglades. These fragile atolls of mangroves cover a vast area of the Everglades watersystem. Mangroves are the only trees that can extract freshwater from saltwater. As I stood among their tangled roots, I felt protected from the elements by their parasols of green. Later I learned that these close-ranked guardians of the shore have helped to save the coastline from devastating hurricanes and the encroaching sea.

Near the southern tip of the state is found 5,000 square miles of a wild and fragile ecosystem that for decades was thought a nuisance. The Everglades, long considered to be only a mosquito-infested swampland is now widely recognized as the critically important "river of grass" essential for maintenance of the ecosystem that stretches from Lake Okeechobee to the waters of Florida Bay. Countless plants and animals are necessary to maintain this unobstructed flow of water. Florida Bay is presently at risk of dying from agricultural phosphate pollution. This is a critical time for the survival of this fragile environment.

The Florida Keys are a chain of lush subtropical islands floating like a string of pearls in the sparkling sapphire seas where the Gulf of Mexico meets the Atlantic Ocean. With the building of a railroad in 1912 and the subsequent Overseas Highway, the Keys were forever changed. Near the kaleidoscope of shops, resorts, and restaurants I found John Pennekamp Coral Reef State Park on Key Largo. I dove at

nearby Molasses Reef with its staghorn coral and schools of smallmouth grunt fish. Flying out by seaplane beyond the eclectic charm of Key West, I explored the Dry Tortugas, a family of islands rich in history. On Garden Key I stood atop the 50 foot walls of Ft. Jefferson which seemed unchanged since its 19th century occupation. From its ramparts I gazed toward the azure sea and listened to the excited calls of nesting terns on nearby Bush Key.

The Gold Coast of Florida's Atlantic shores may have succumbed to developers' dreams but that hasn't diminished their natural beauty. Between the pastel colors of South Miami's Art Deco district and the picturesque lighthouse and marina at Jupiter Island, I discovered many pockets of natural beauty. At The Nature Conservancy's Blowing Rocks Preserve, I was fascinated by the pounding surf washing over sculpted rocks of Anastasia limestone—the largest outcropping of its kind on the Atlantic Coast.

Driving northward, I journeyed past coastal communities boardered by long stretches of beach fringed with dunes that sprouted sea grape and palmettos as well as occasional splashes of vivid wildflowers. The barrier island system that includes Canaveral National Seashore hosts a 24-mile stretch of wilderness beach and lagoons perfect for wildlife viewing, even though it lies within earshot of NASA's Kennedy Space Center.

With more than 400 years of history, St. Augustine is America's oldest city. I walked narrow cobblestone streets lined with colorful shops and marveled at the imposing Spanish-built fortress of Castillo de San Marcos, now a National Monument, which stands sentinel over the banks of the Matanzas River. Florida's historical sites are

as rich and varied as its natural wonders; a precious legacy for future generations to enjoy.

Florida's interior, though never more than 60 miles from the sea, plays out upon the landscape with a different character than its coastal counterparts. Driving through vast sun-drenched orange groves, I was overwhelmed by the heavy scent of orange blossoms. Traveling on I photographed massive Lake Okeechobee, the life blood of the Everglades. I canoed the Loxahatchee River—Florida's only National Scenic River. I swam the warm waters of Blue Springs with its wintering manatees and descended the wooden staircase at Devils Millhopper State Geologic Site—a massive sinkhole lined with subtropical ferns. The Nature Conservancy's Apalachicola Bluffs and Ravines Preserve provided a view from the state's highest exposed bluff, overlooking a refuge of ancient flora and fauna relatively unchanged for millions of years. This is the Florida that restores my sense of wonder for all that is wild and free.

The pressures of growth and development have been Florida's challenge for the past century and will continue into the next. Dreams of gold and the "fountain of youth" have been replaced by the reality of resorts and retirement communities basking in the sun of prosperity. But without balancing the priceless value of natural habitats and historic sites, this prosperity will have no meaning. Florida's economy is dependent upon her natural treasures, as well as the cities and towering condos that encircle them. Concerned citizens and government agencies must meet the challenge to protect the abundant treasures that are Florida's heritage in this land of sunshine and flowers.

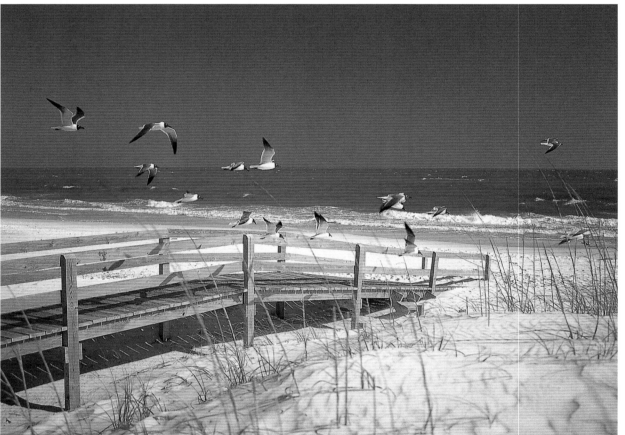

SEA OATS AND BEACH WALKWAY, GULF ISLANDS NATIONAL SEASHORE, GULF OF MEXICO

James Randklev

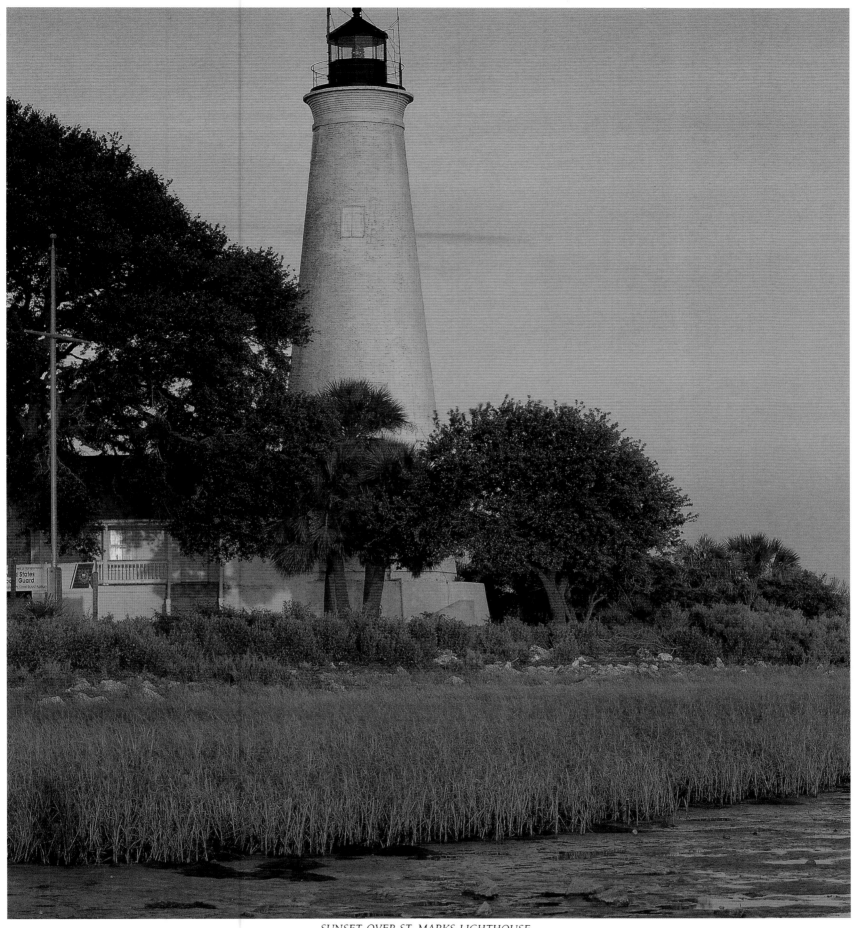

SUNSET OVER ST. MARKS LIGHTHOUSE,
APALACHEE BAY, GULF OF MEXICO

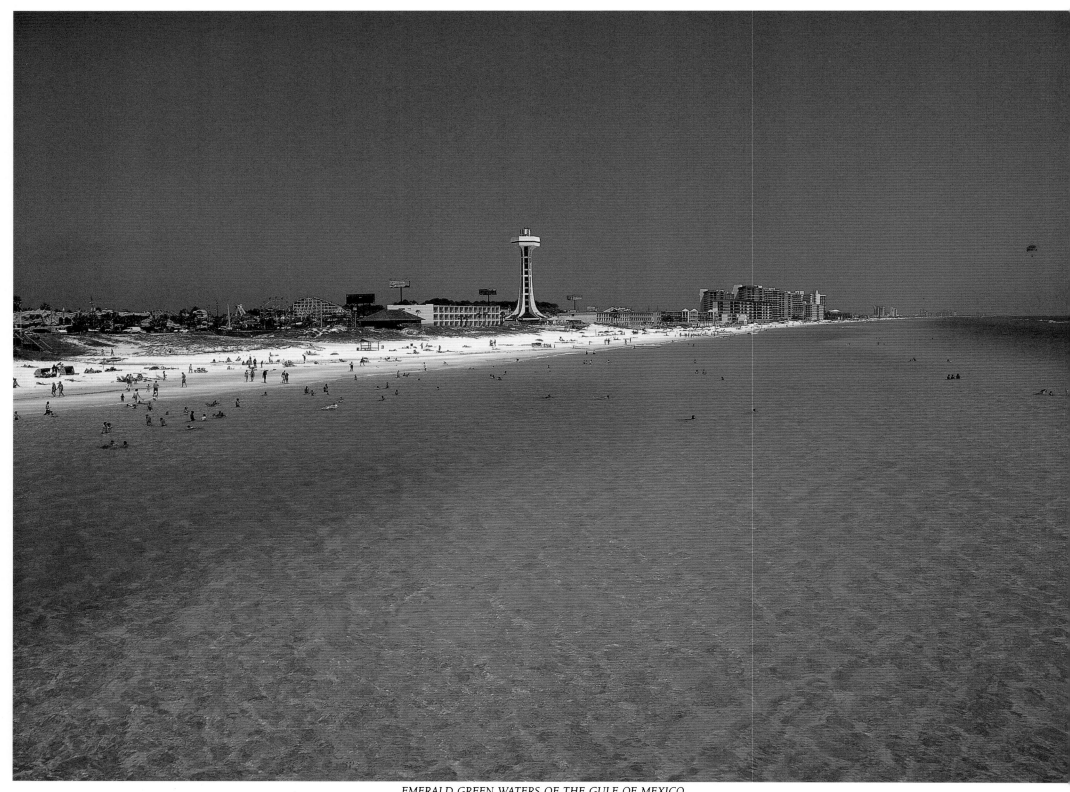

EMERALD GREEN WATERS OF THE GULF OF MEXICO,
PANAMA CITY BEACH

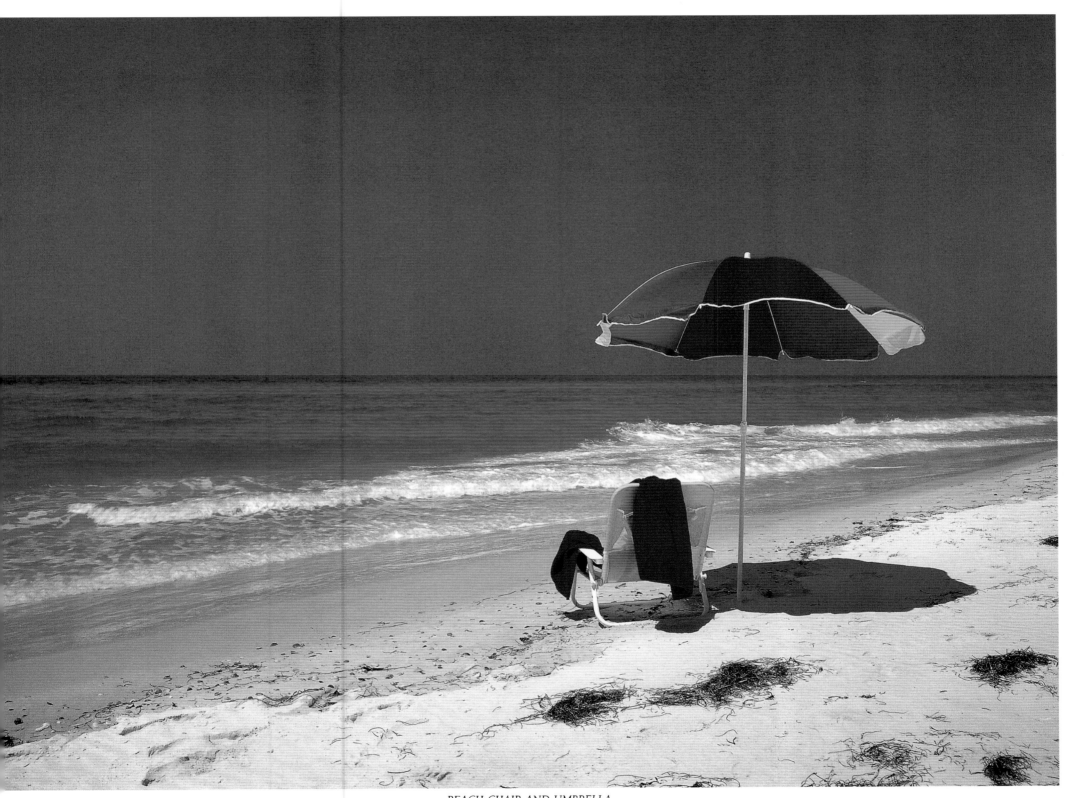

BEACH CHAIR AND UMBRELLA,
SHORES OF ST. GEORGE ISLAND STATE PARK

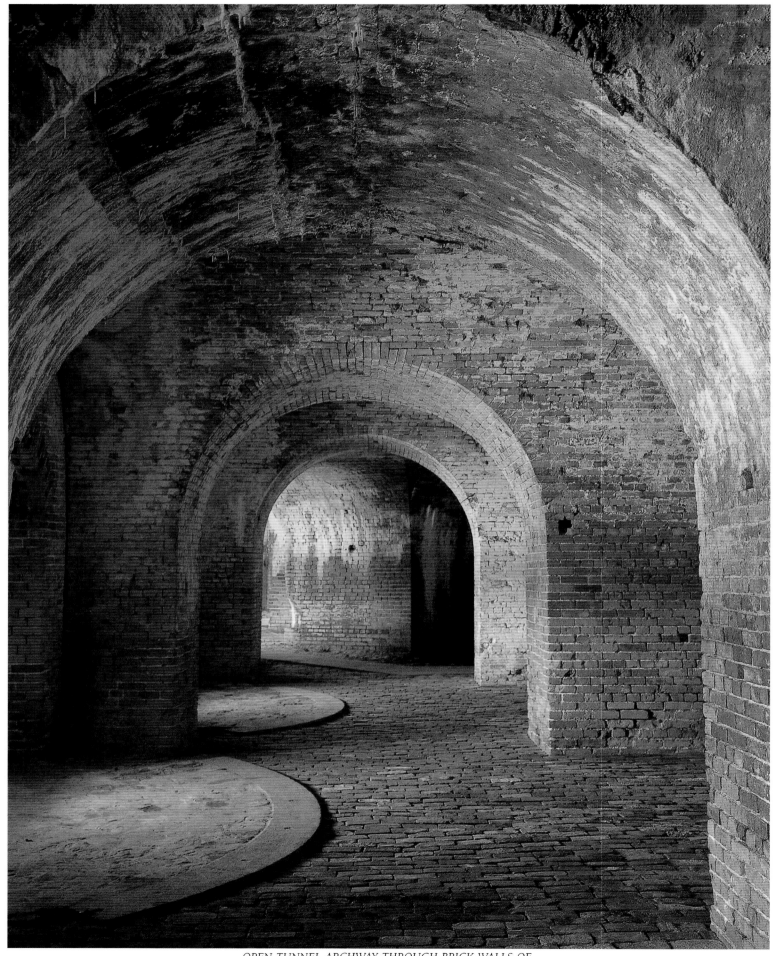

*OPEN TUNNEL ARCHWAY THROUGH BRICK WALLS OF
FT. PICKENS STATE PARK, PENSACOLA*

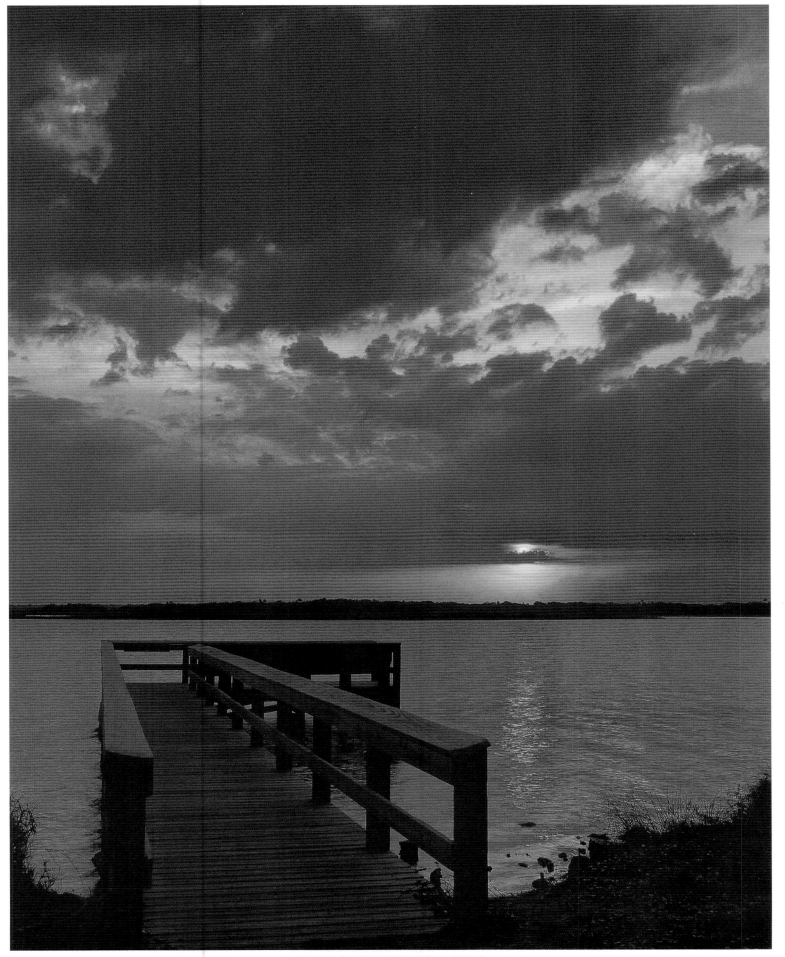

SUNSET OVER MOSQUITO LAGOON,
CANAVERAL NATIONAL SEASHORE

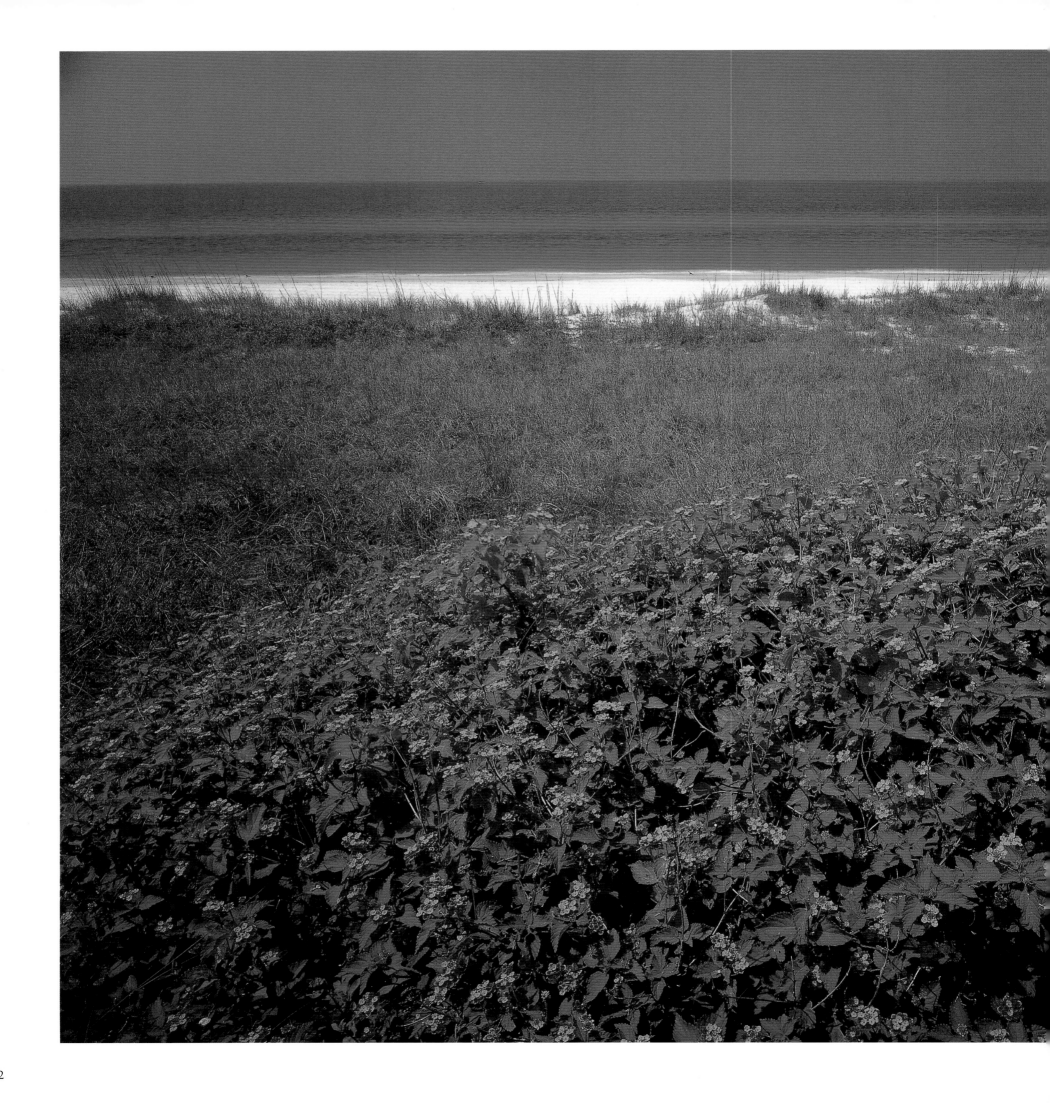

LANTANA IN BLOOM AMONG THE DUNES OF
MEXICO BEACH, GULF COAST

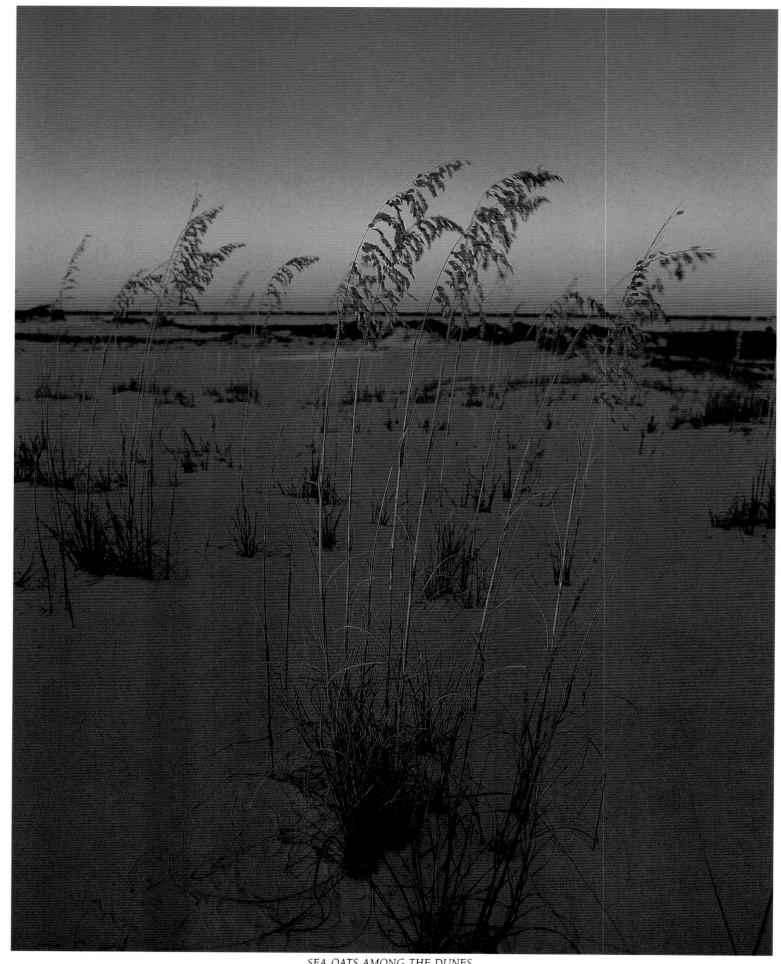

SEA OATS AMONG THE DUNES,
GULF ISLANDS NATIONAL SEASHORE

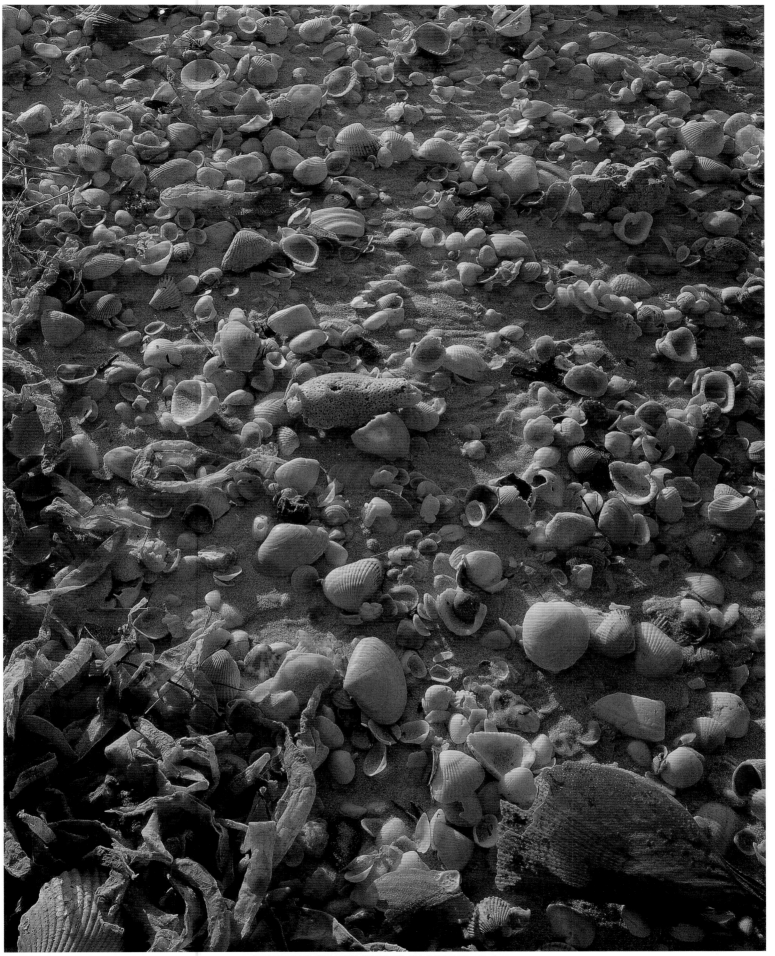

SEASHELLS ON THE SHORES OF SANIBEL ISLAND,
GULF OF MEXICO

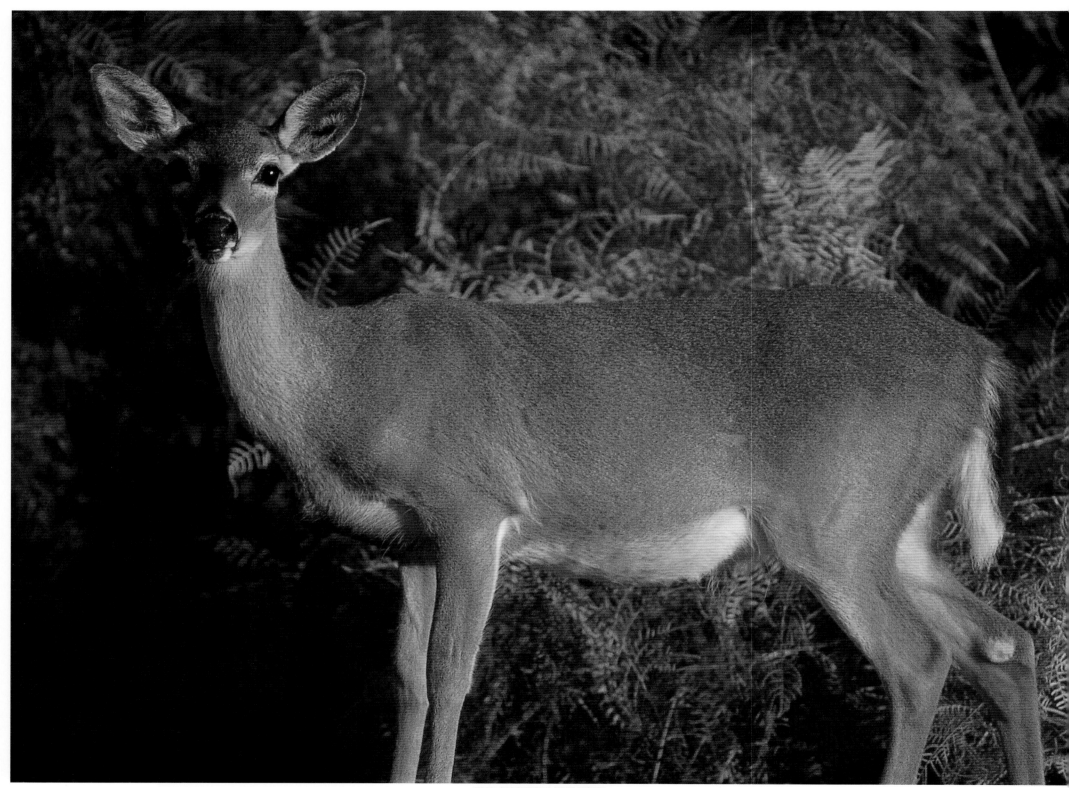

ENDANGERED KEY DEER,
BIG PINE KEY, KEY DEER NATIONAL WILDLIFE REFUGE

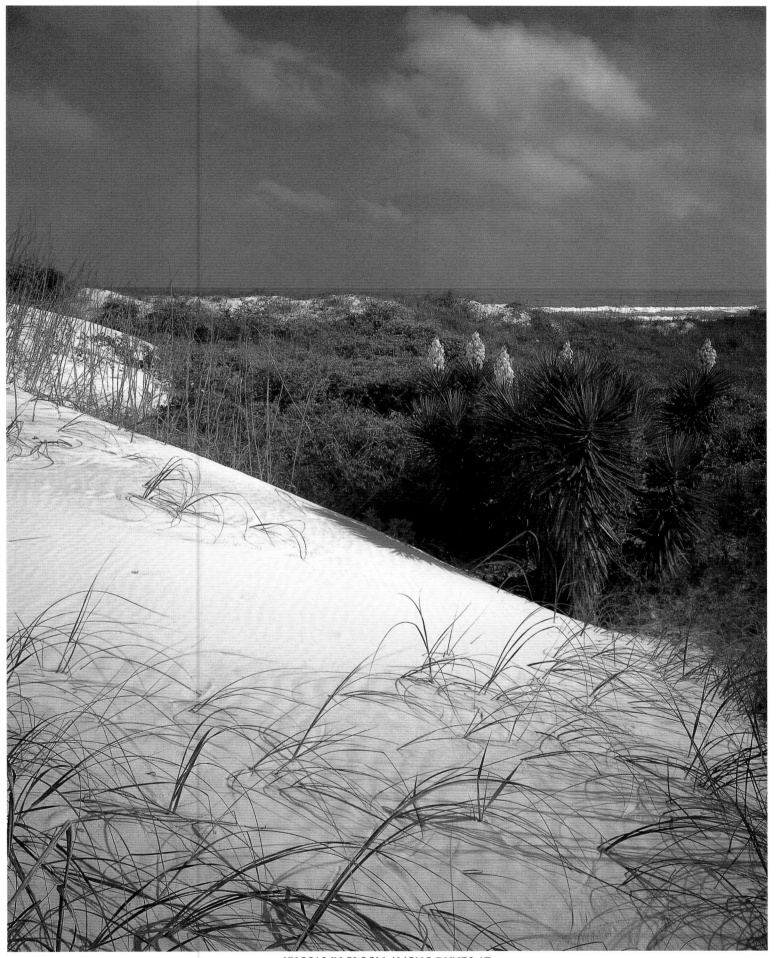

YUCCAS IN BLOOM AMONG DUNES AT
ST. GEORGE ISLAND STATE PARK

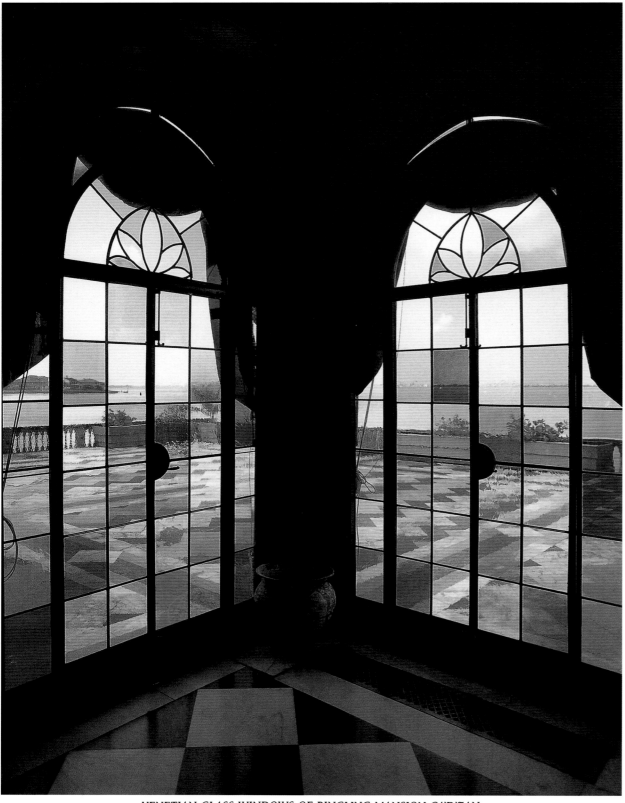

VENETIAN GLASS WINDOWS OF RINGLING MANSION CA'D'ZAN
LOOK OUT TO SARASOTA BAY

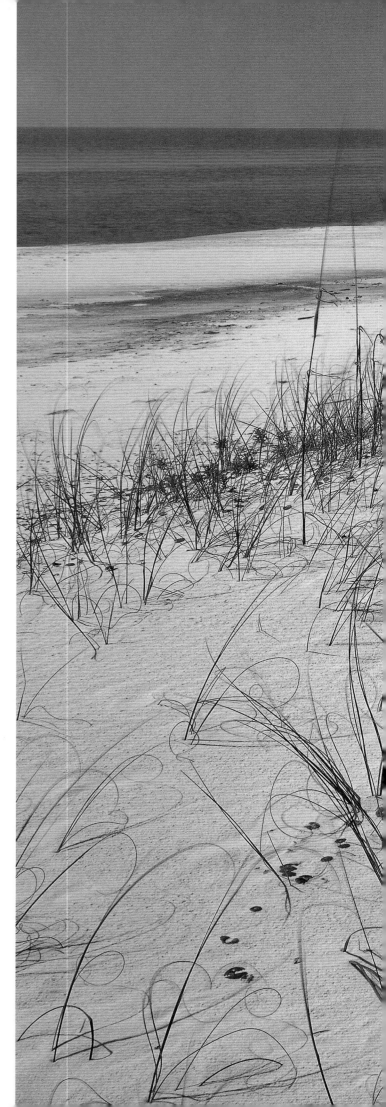

SEA OATS AMONG THE DUNES,
GULF ISLANDS NATIONAL SEASHORE

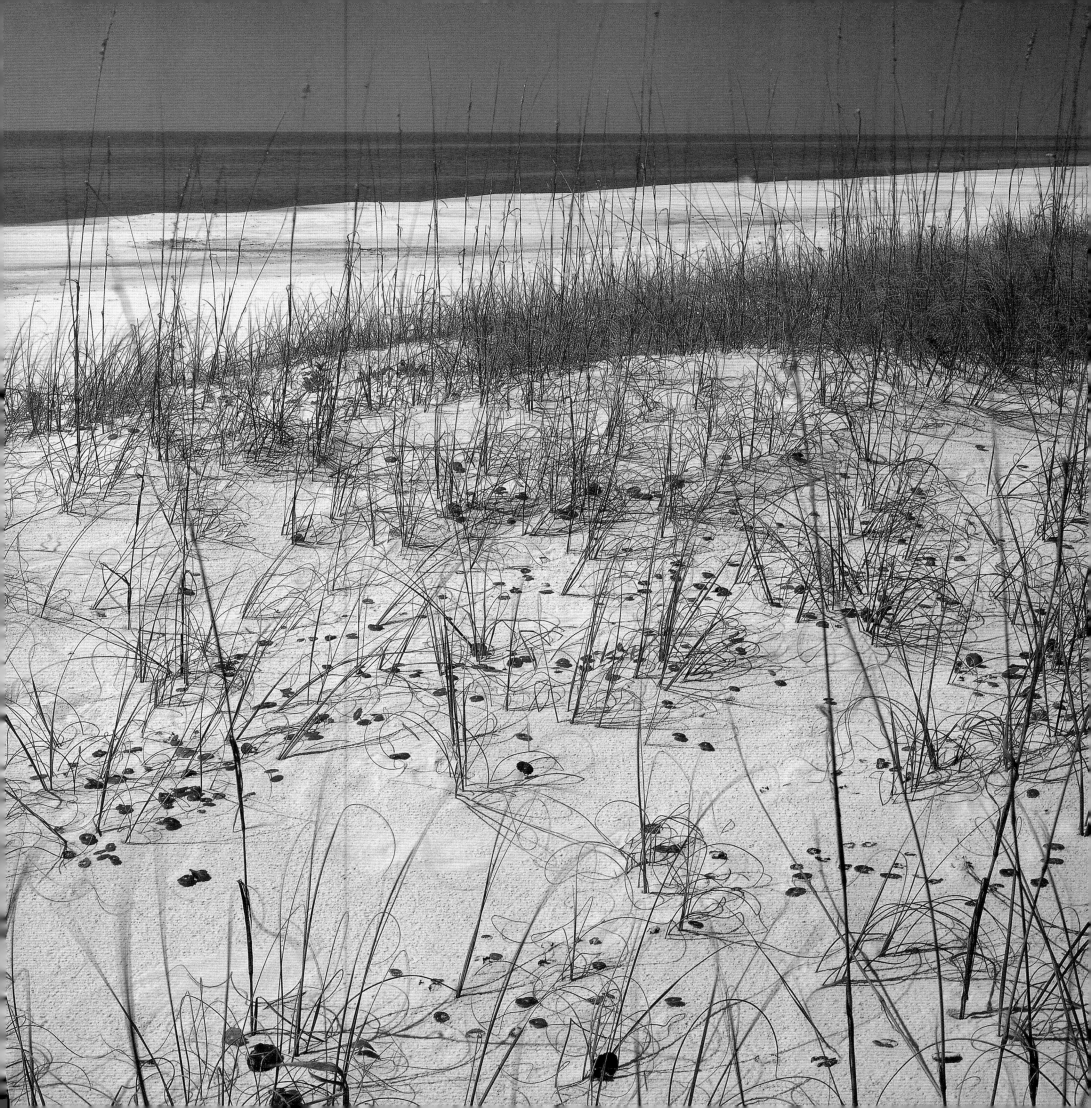

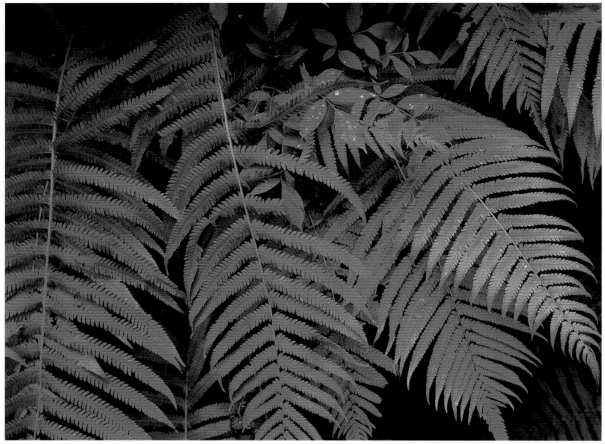

WOOD FERNS,
DEVIL'S MILLHOPPER STATE
GEOLOGIC SITE

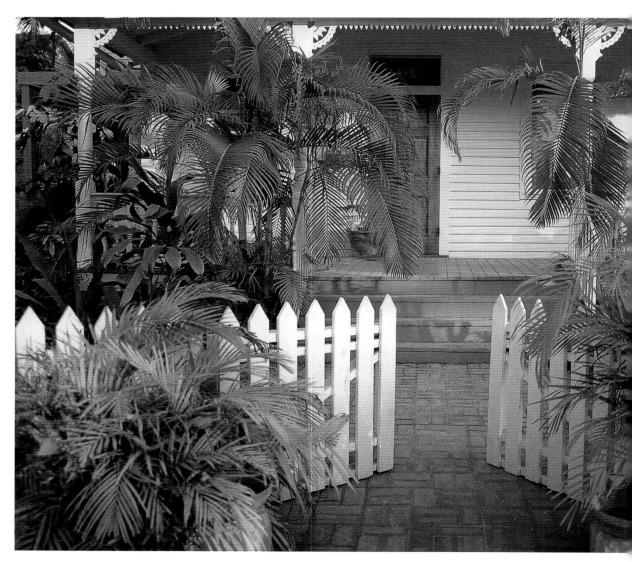

BED AND BREAKFAST INN,
KEY WEST

FIELD OF PHLOX
ALONG ROADSIDE PASTURE
NEAR OCALA

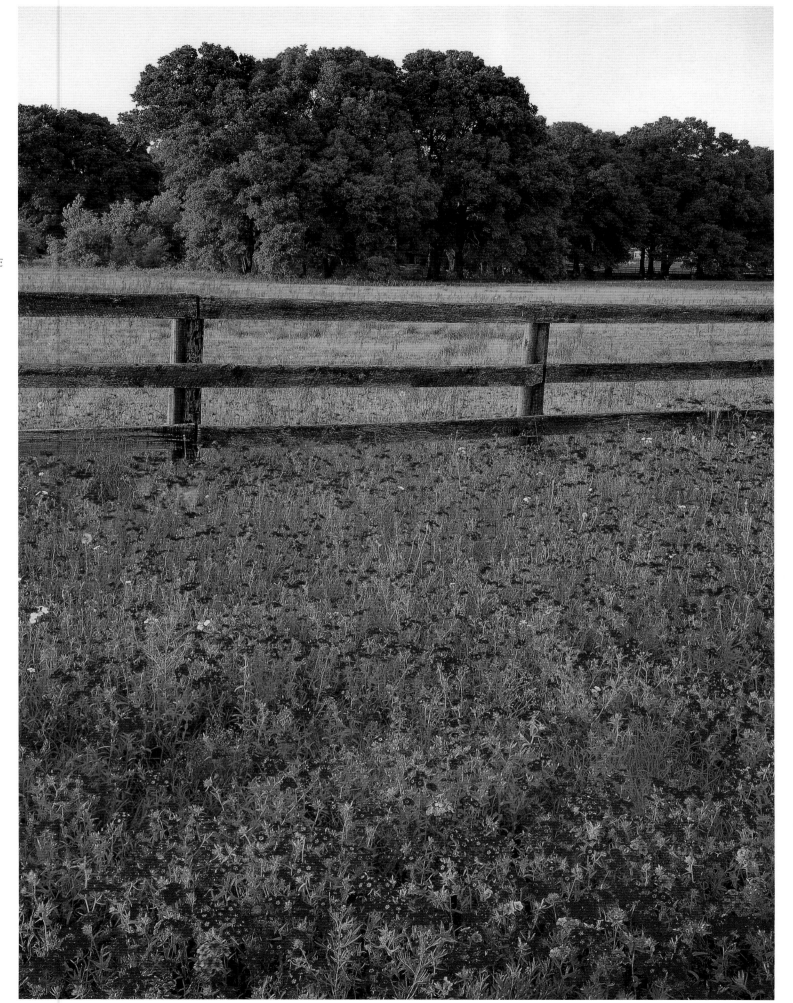

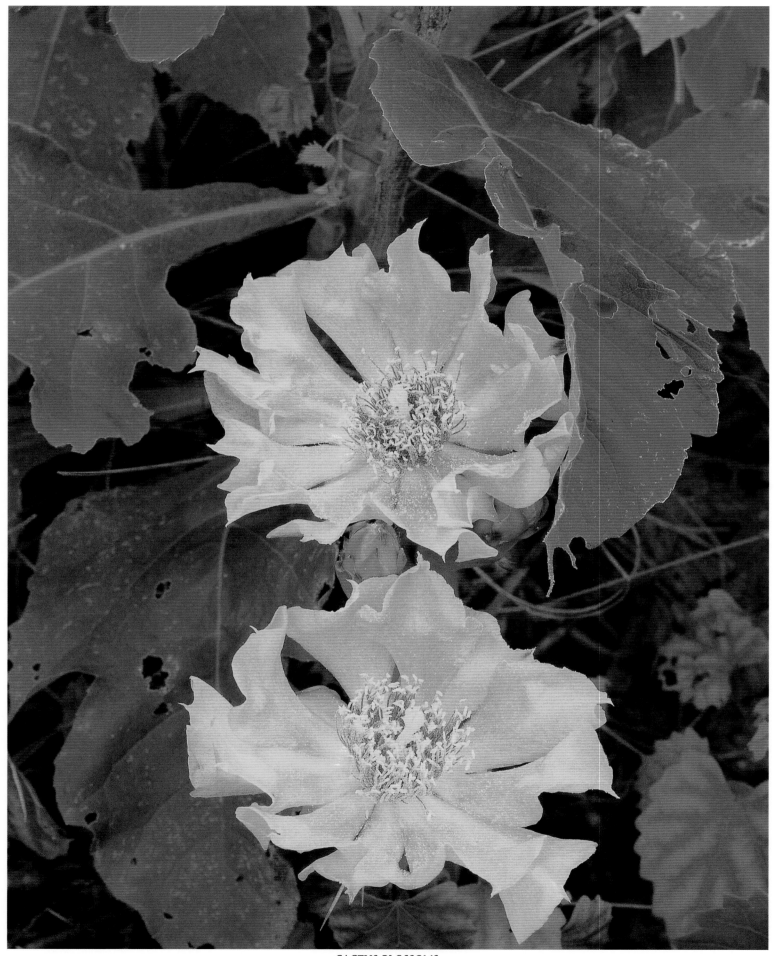

CACTUS BLOSSOMS,
CALADESI ISLAND STATE PARK, GULF COAST

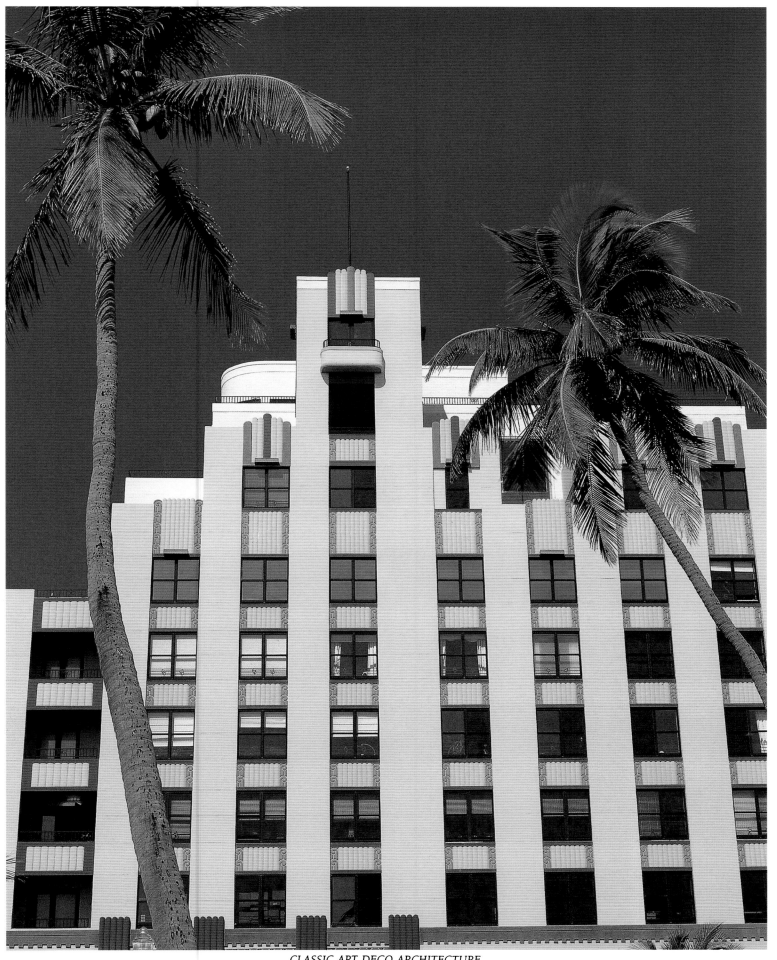

*CLASSIC ART DECO ARCHITECTURE
OF SOUTH MIAMI BEACH*

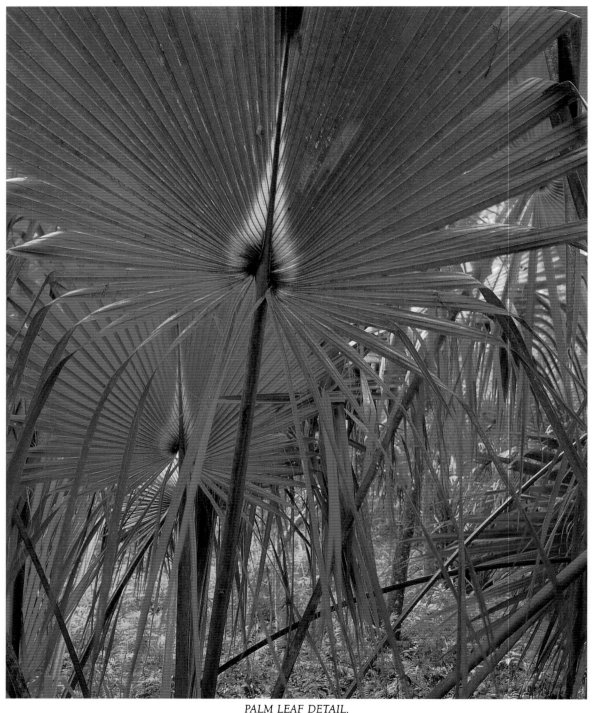

PALM LEAF DETAIL,
HIGHLANDS HAMMOCK STATE PARK

MOONRISE OVER
BIG CYPRESS NATIONAL PRESERVE

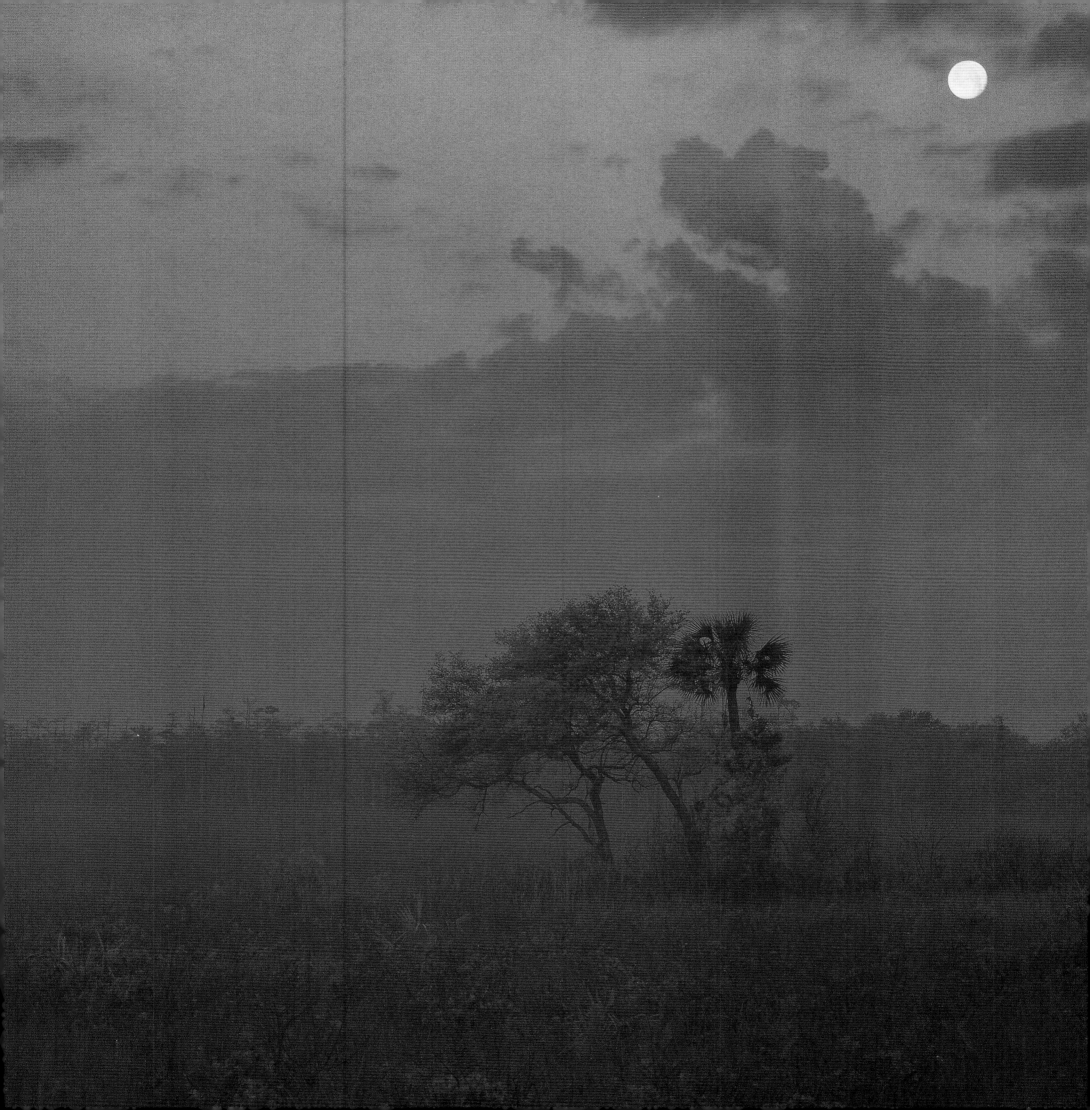

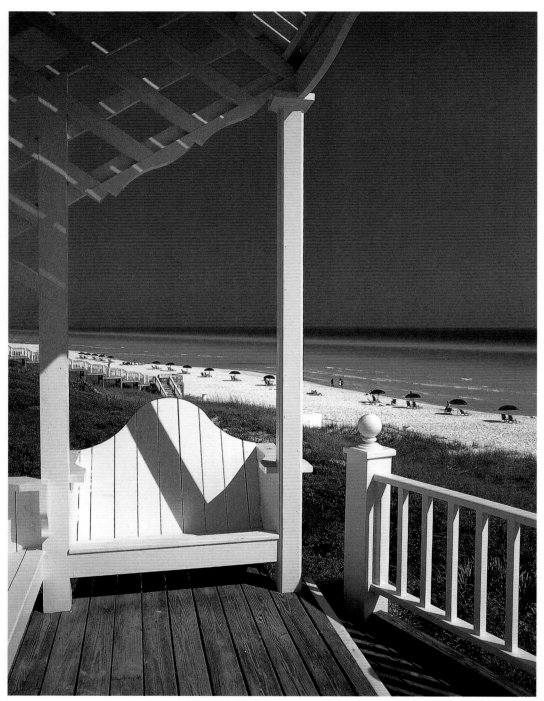

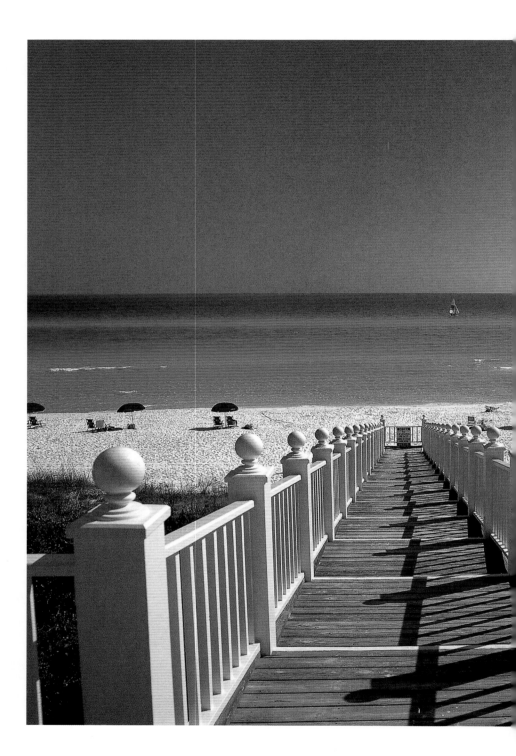

BEACH PAVILION OVERLOOKING
SEASIDE BEACH AND THE GULF OF MEXICO

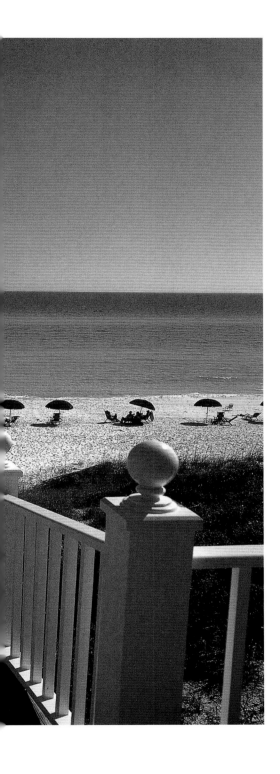
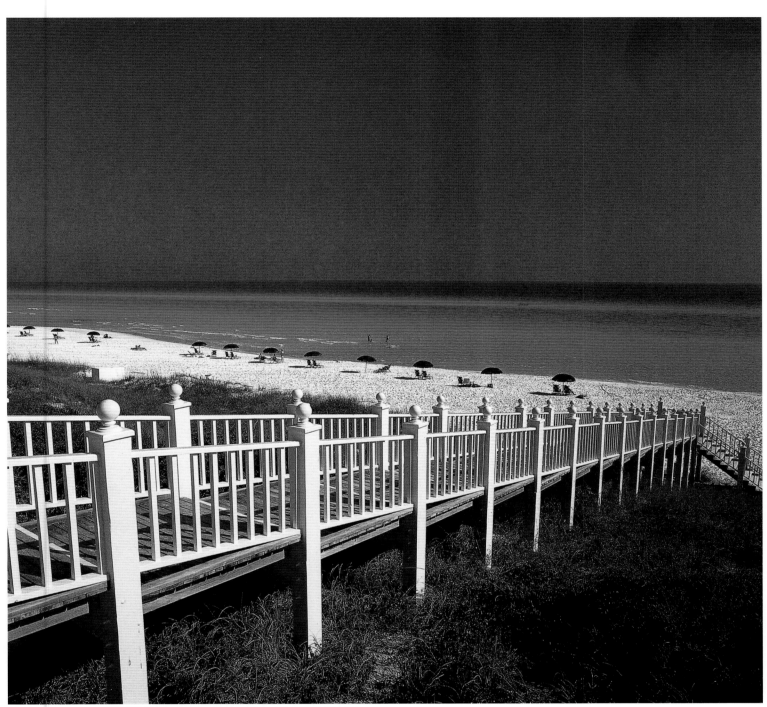

BEACH WALKWAY LEADING TO SEASIDE BEACH,
GULF COAST

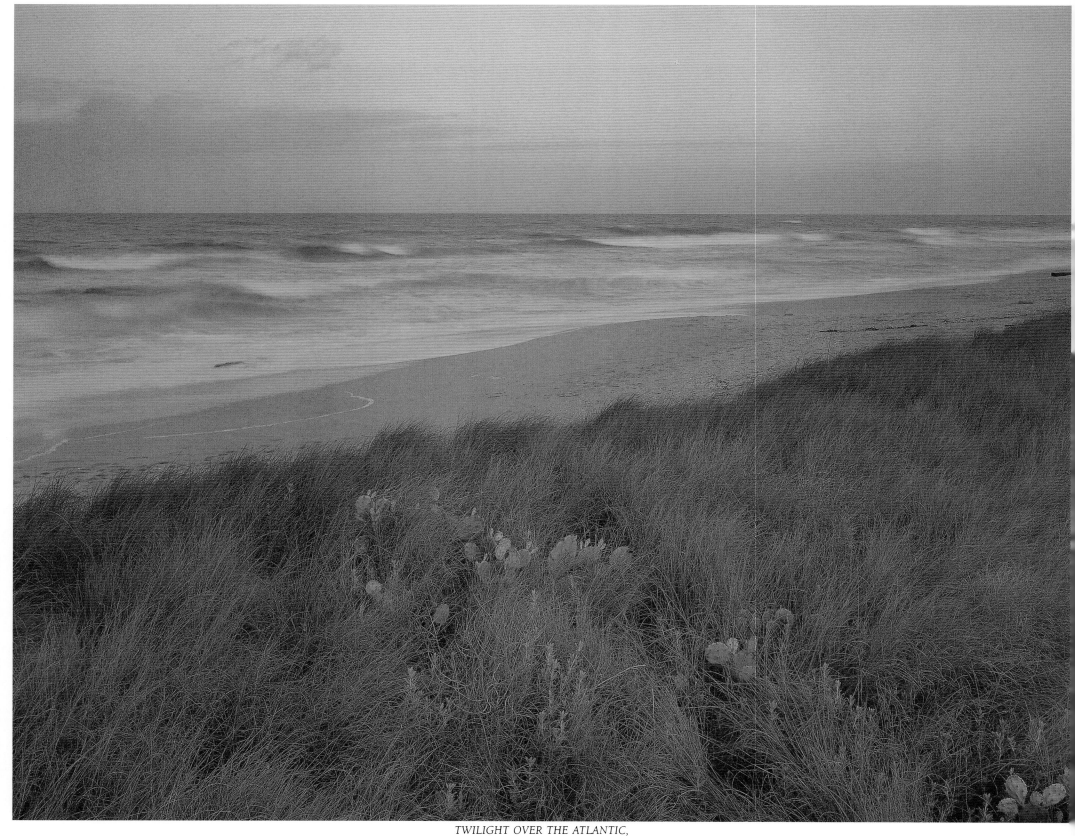

TWILIGHT OVER THE ATLANTIC,
WASHINGTON OAKS STATE GARDENS

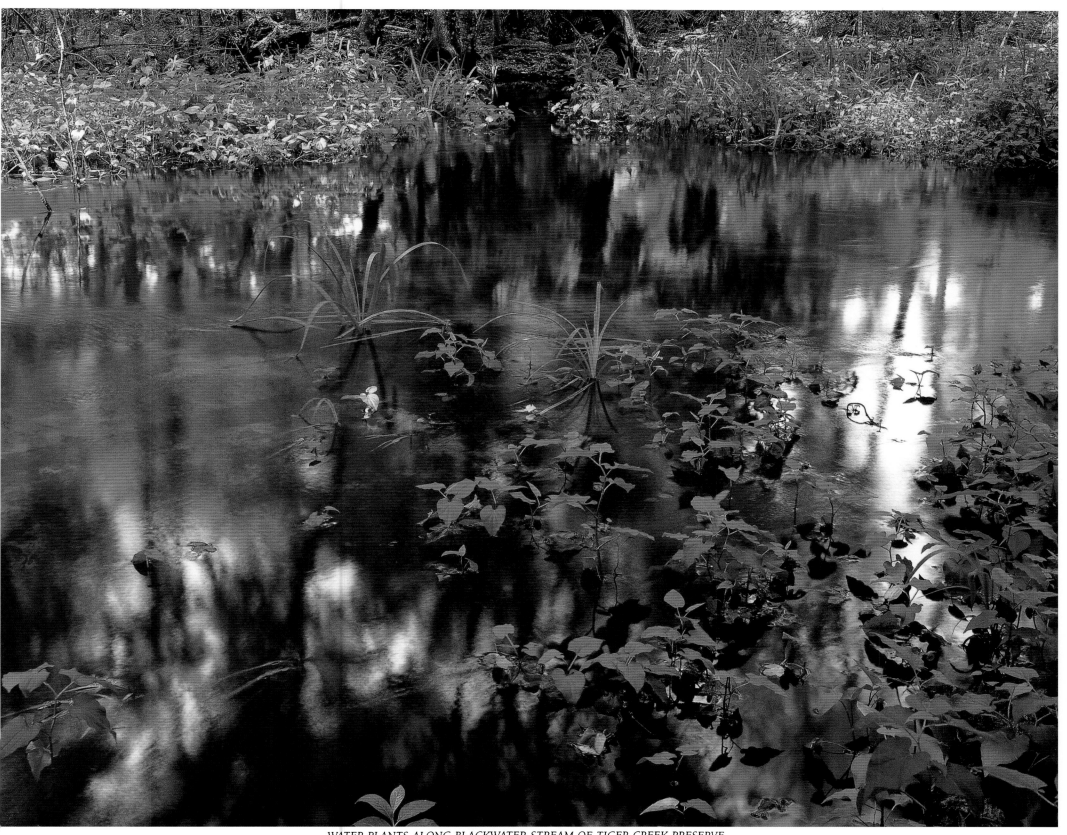

WATER PLANTS ALONG BLACKWATER STREAM OF TIGER CREEK PRESERVE,
A NATURE CONSERVANCY SITE, LAKE WALES RIDGE

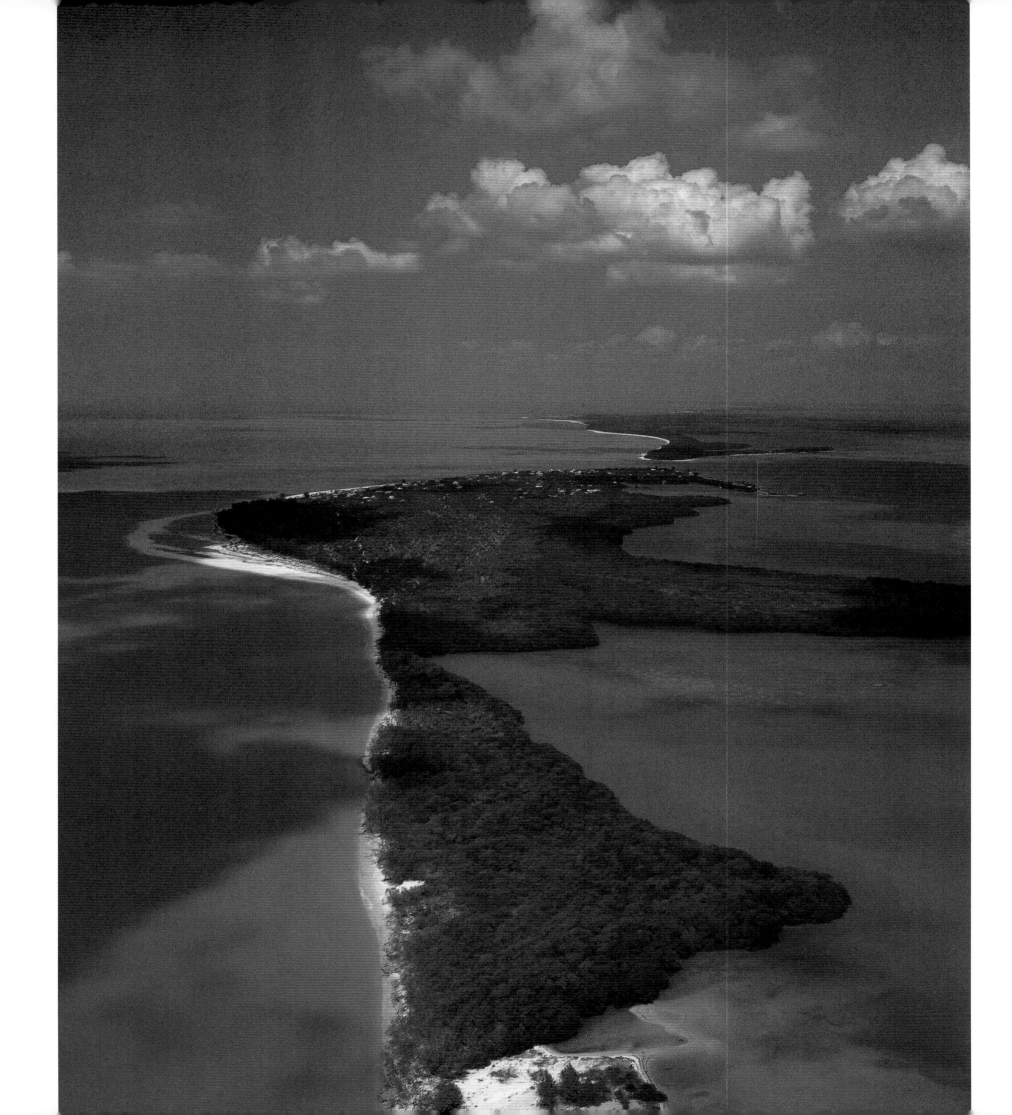

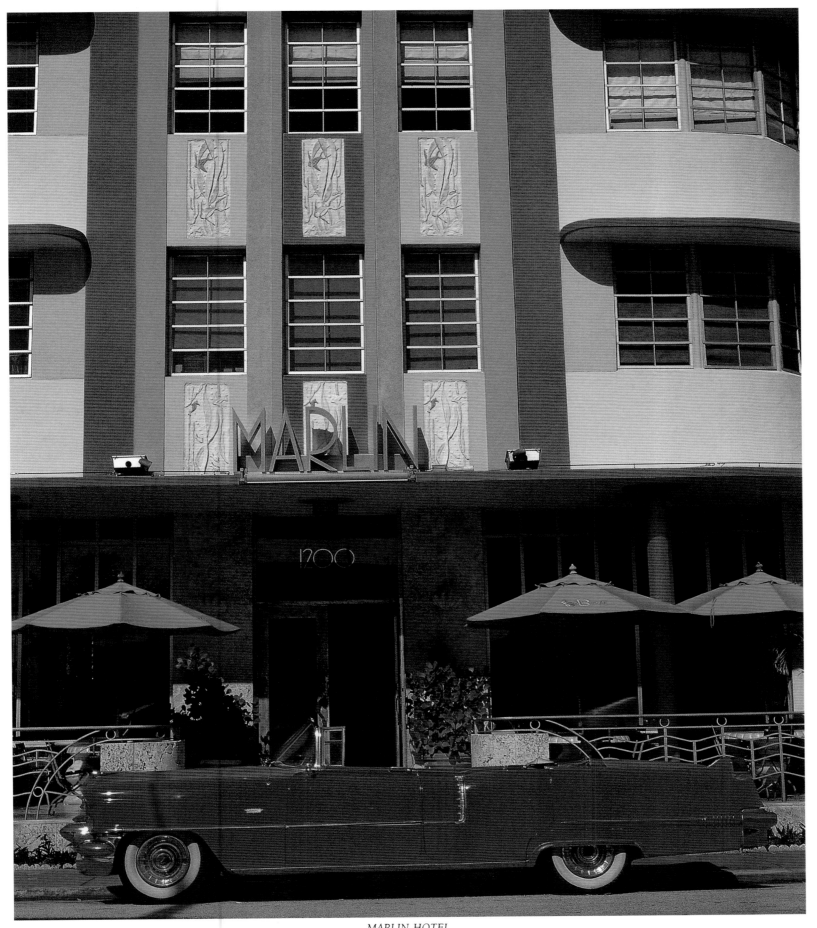

MARLIN HOTEL,
SOUTH MIAMI BEACH

AERIAL VIEW OF CAYO COSTA STATE PARK,
CAYO COSTA ISLAND, GULF COAST

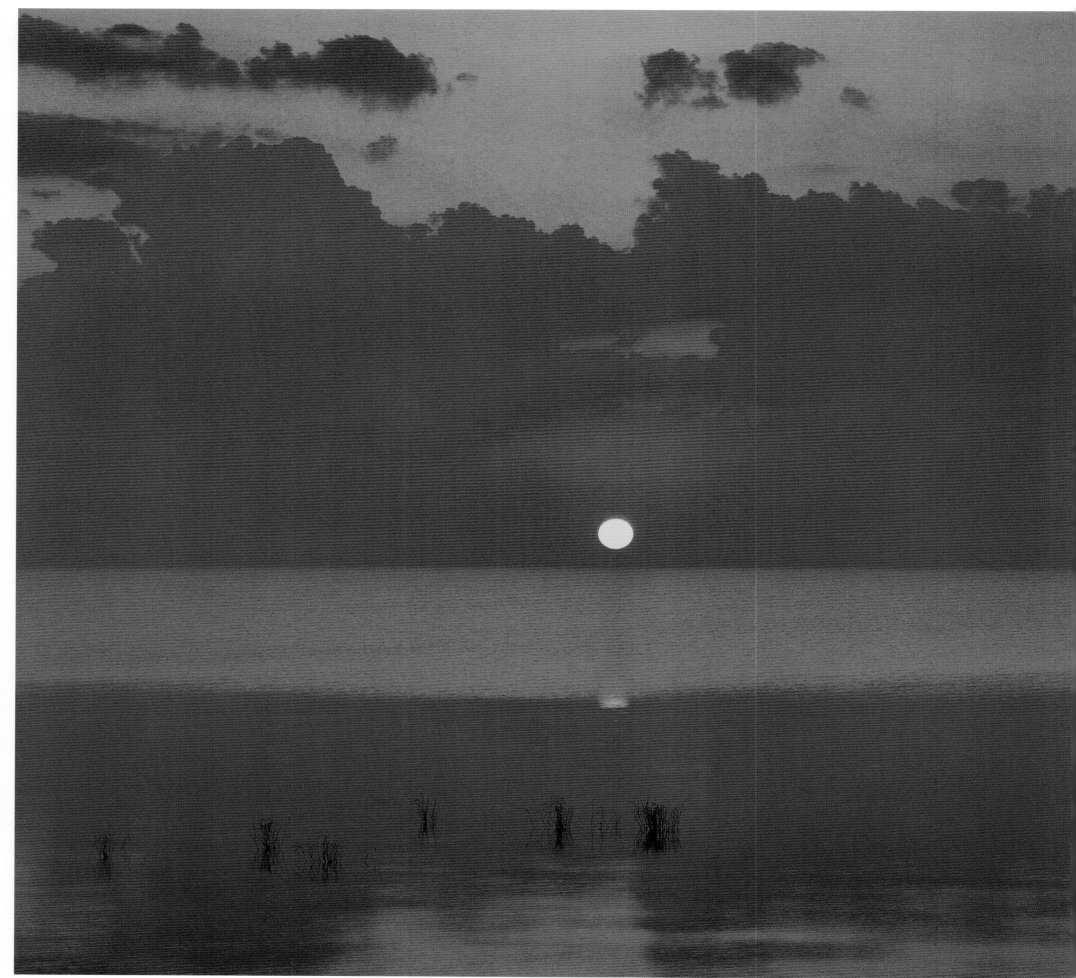

SUNSET OVER LAKE OKEECHOBEE

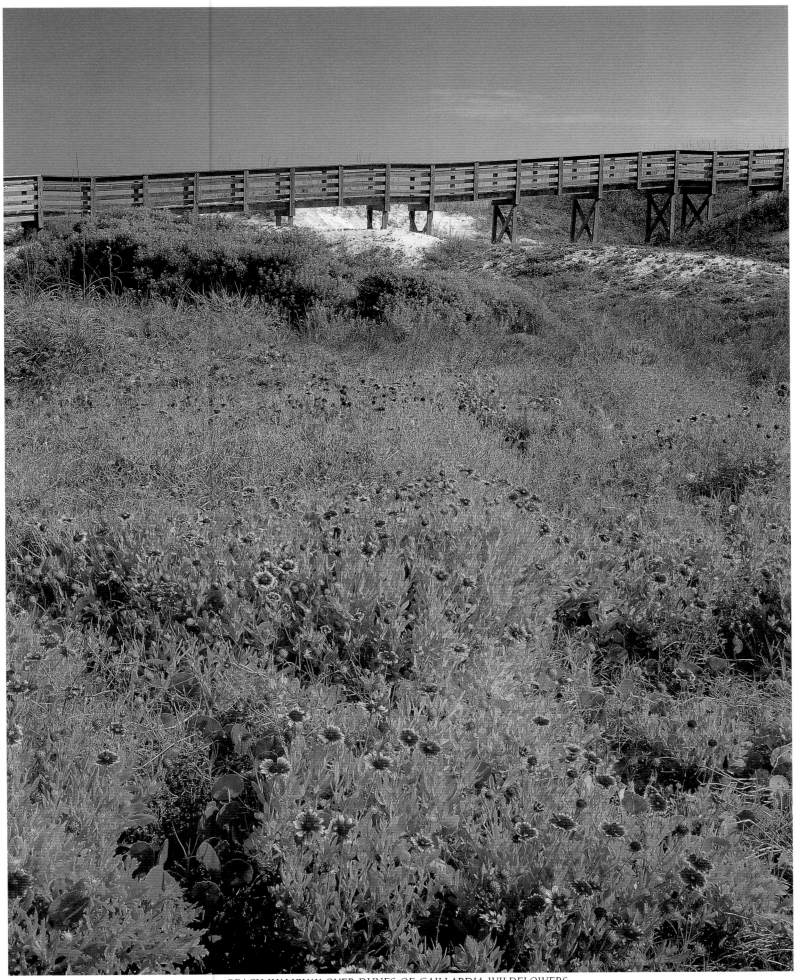

BEACH WALKWAY OVER DUNES OF GAILLARDIA WILDFLOWERS,
ANASTASIA STATE RECREATION AREA

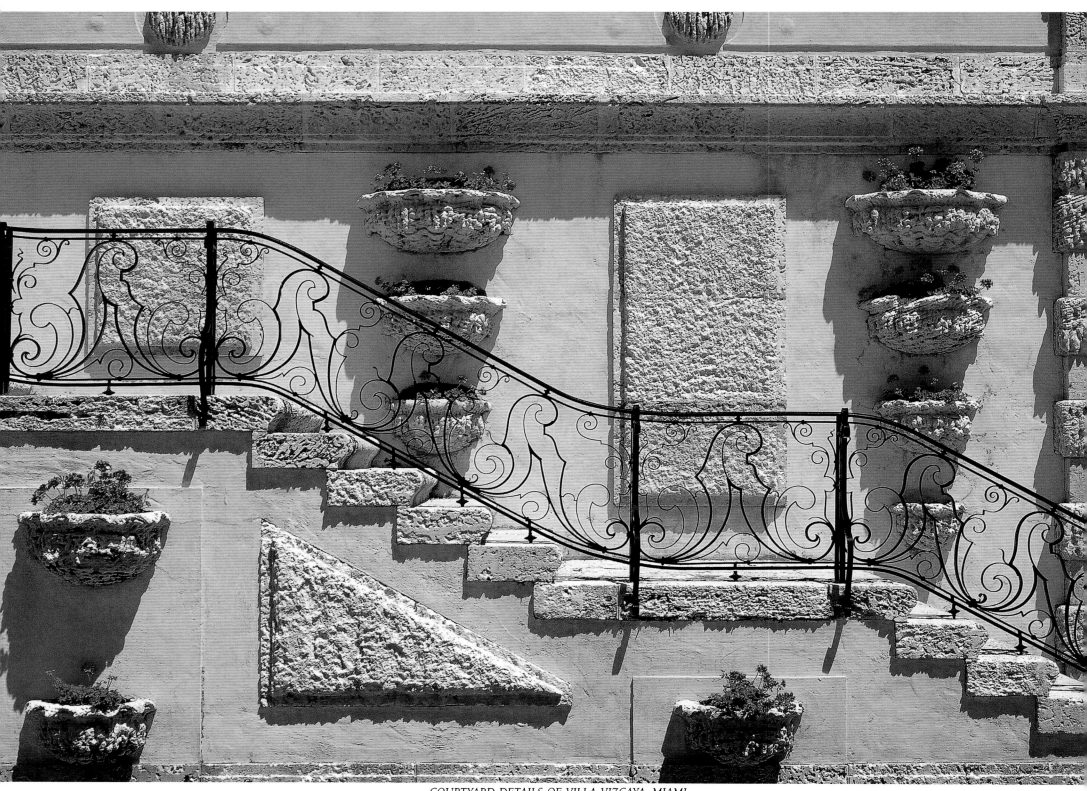

COURTYARD DETAILS OF VILLA VIZCAYA, MIAMI

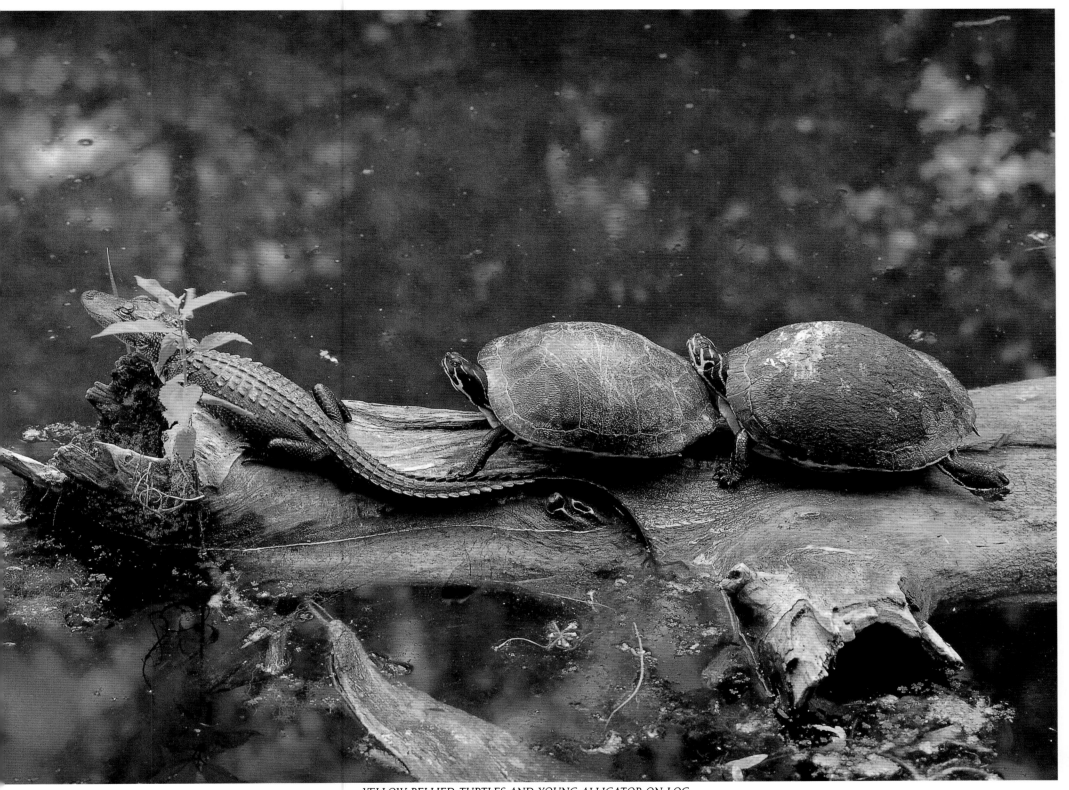

YELLOW BELLIED TURTLES AND YOUNG ALLIGATOR ON LOG,
BIG CYPRESS NATIONAL PRESERVE

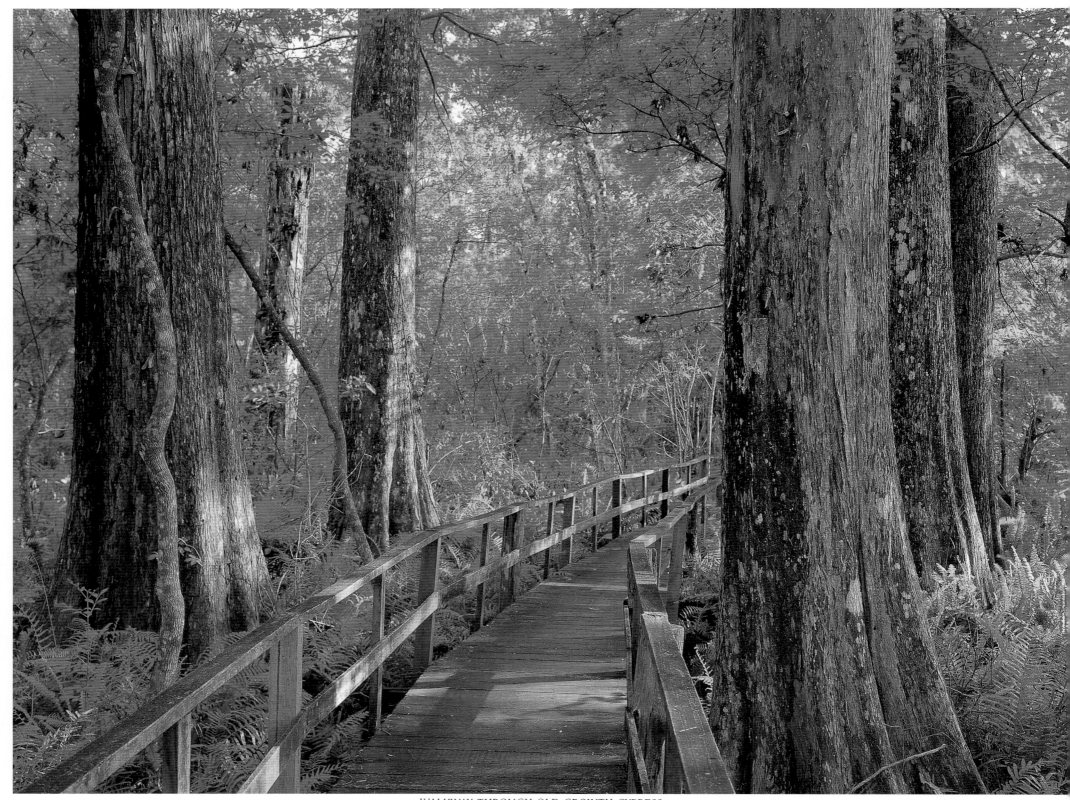

WALKWAY THROUGH OLD GROWTH CYPRESS,
AUDUBON'S CORKSCREW SWAMP SANCTUARY

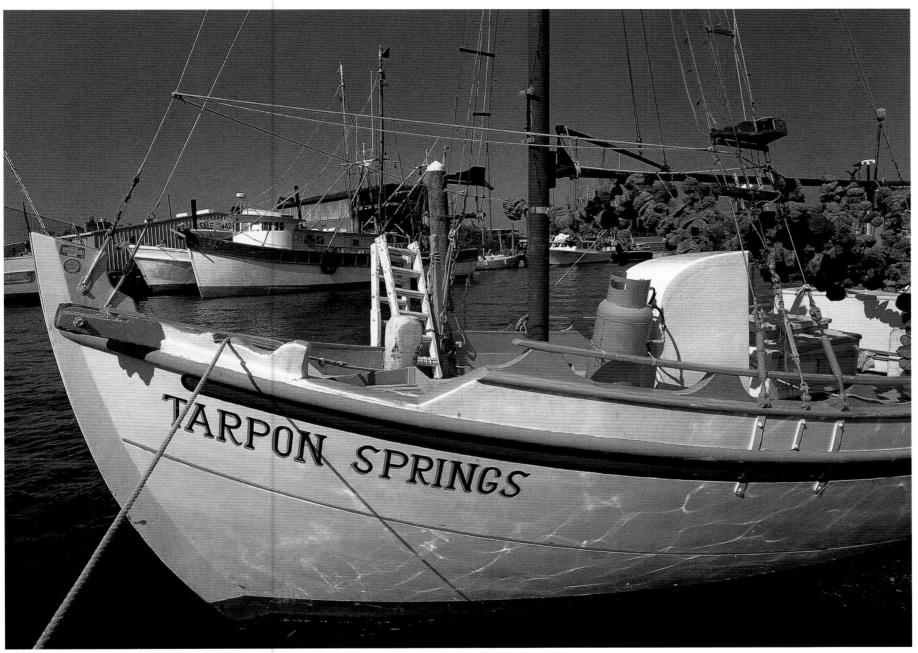

FISHING BOAT WITH SPONGE HARVEST,
TARPON SPRINGS, NORTH OF CLEARWATER

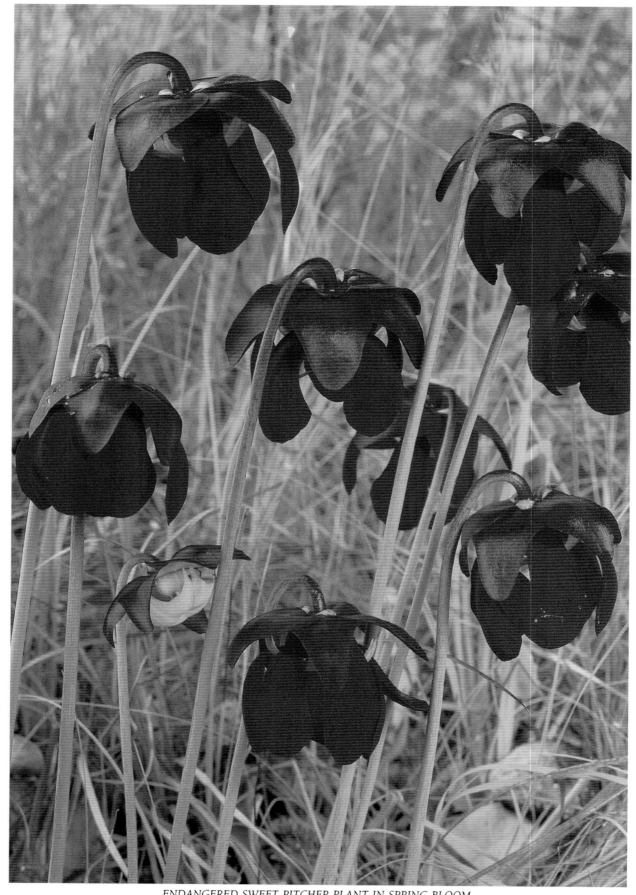

ENDANGERED SWEET PITCHER PLANT IN SPRING BLOOM,
APALACHICOLA NATIONAL FOREST

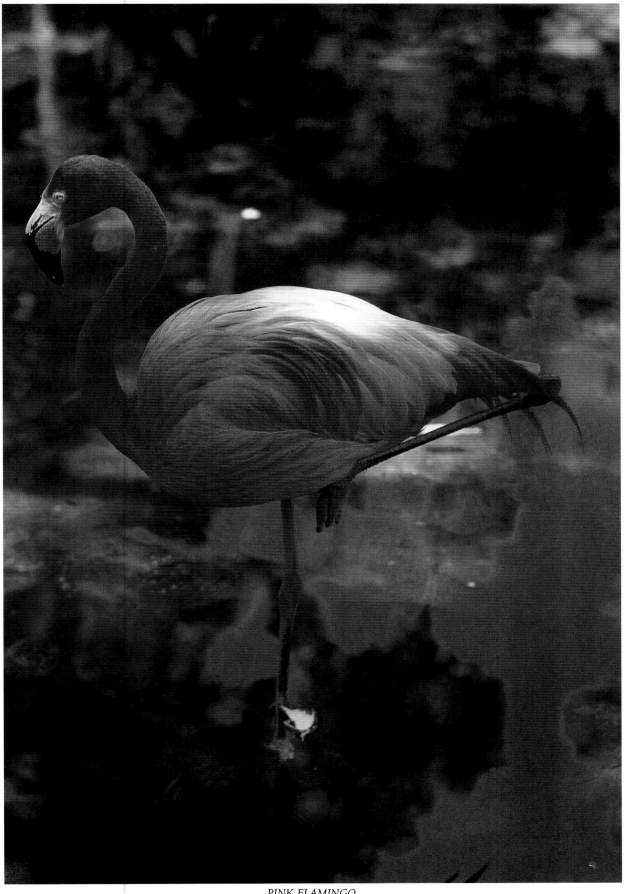

PINK FLAMINGO,
HOMOSASSA SPRINGS STATE PARK

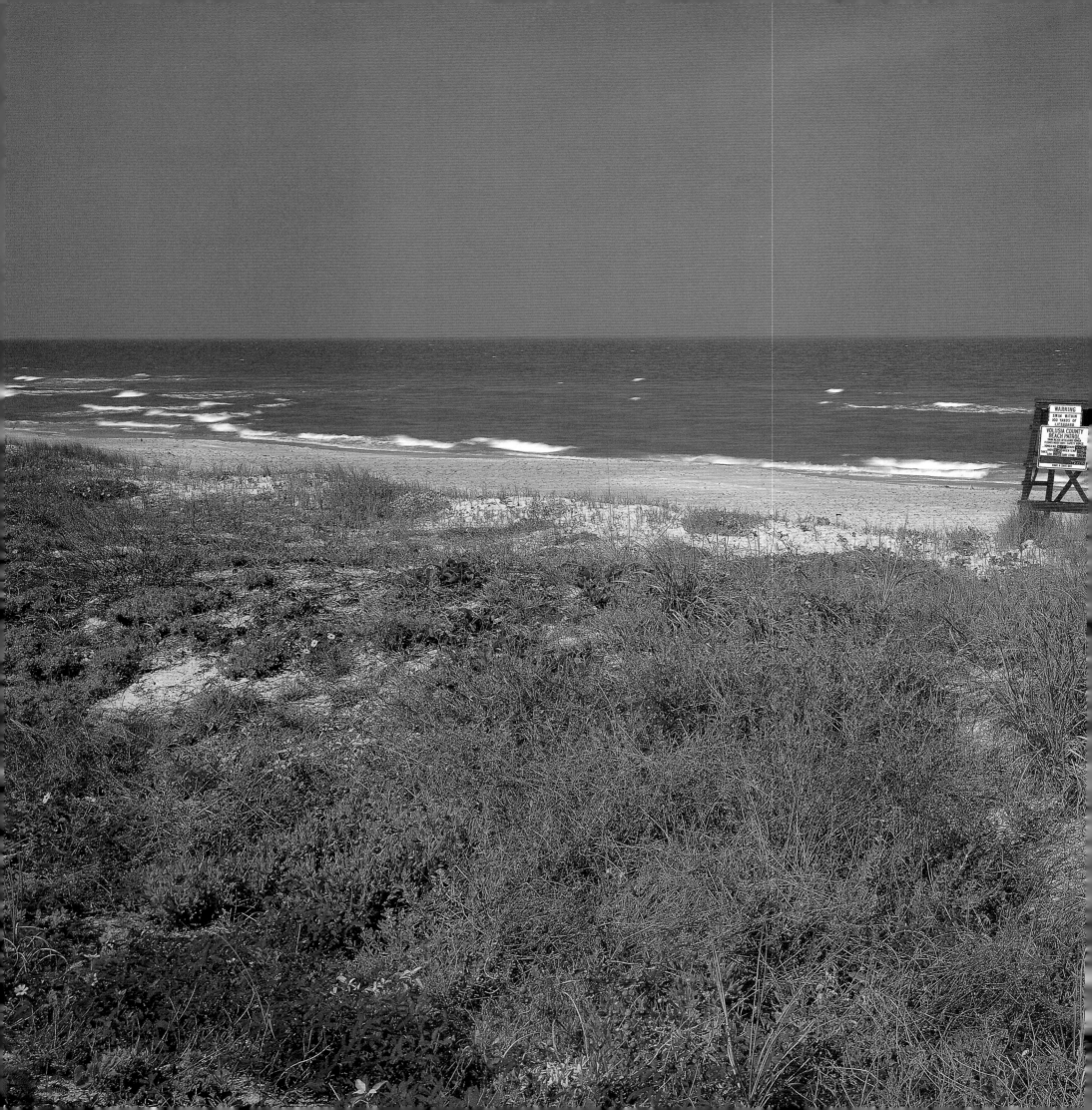

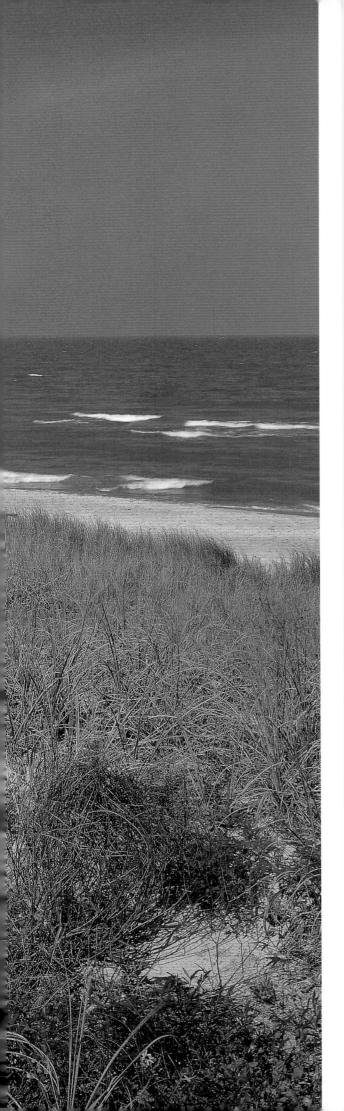

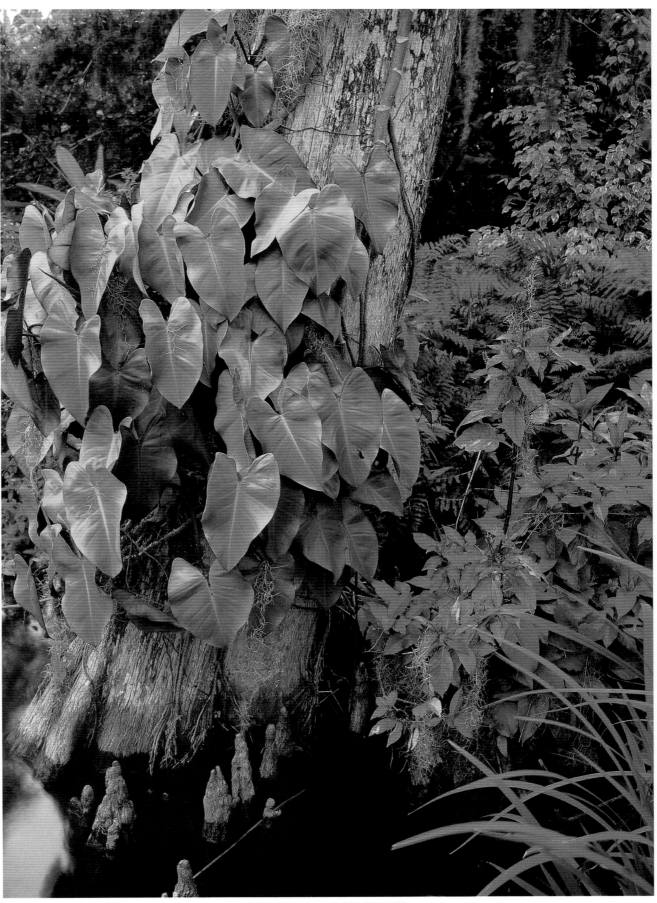

PHILODENDRON ON CYPRESS,
CYPRESS GARDENS

GAILLARDIA WILDFLOWERS AMONG SEA OATS,
ORMOND BEACH

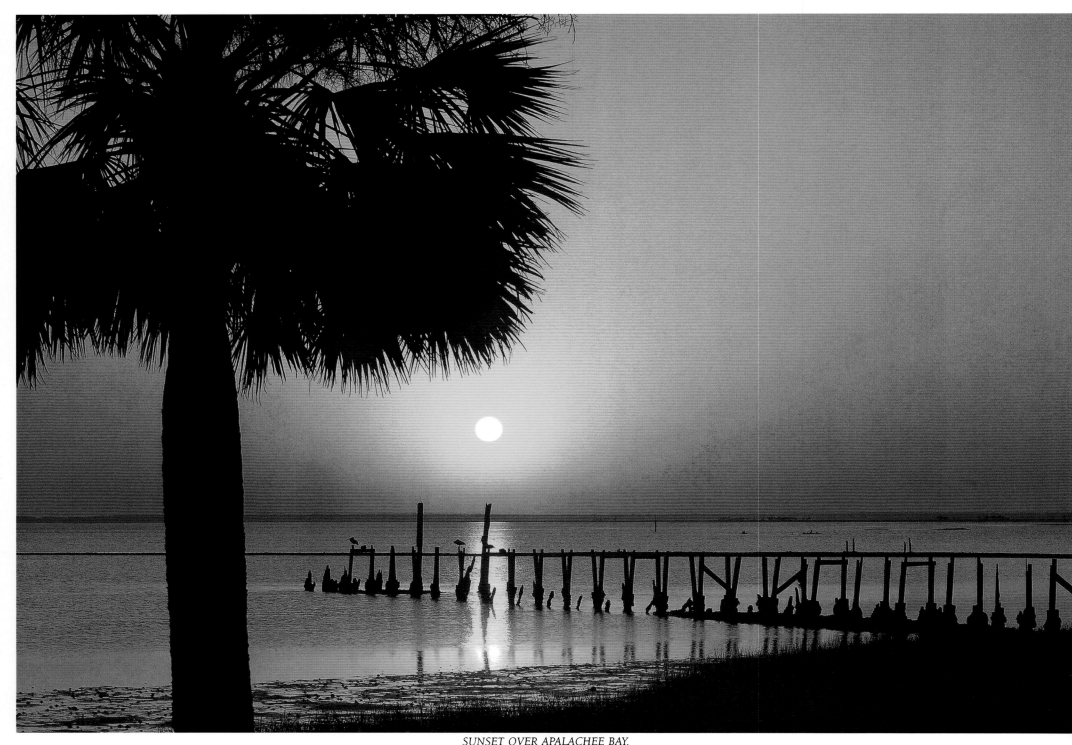

SUNSET OVER APALACHEE BAY,
ST. MARKS NATIONAL WILDLIFE REFUGE

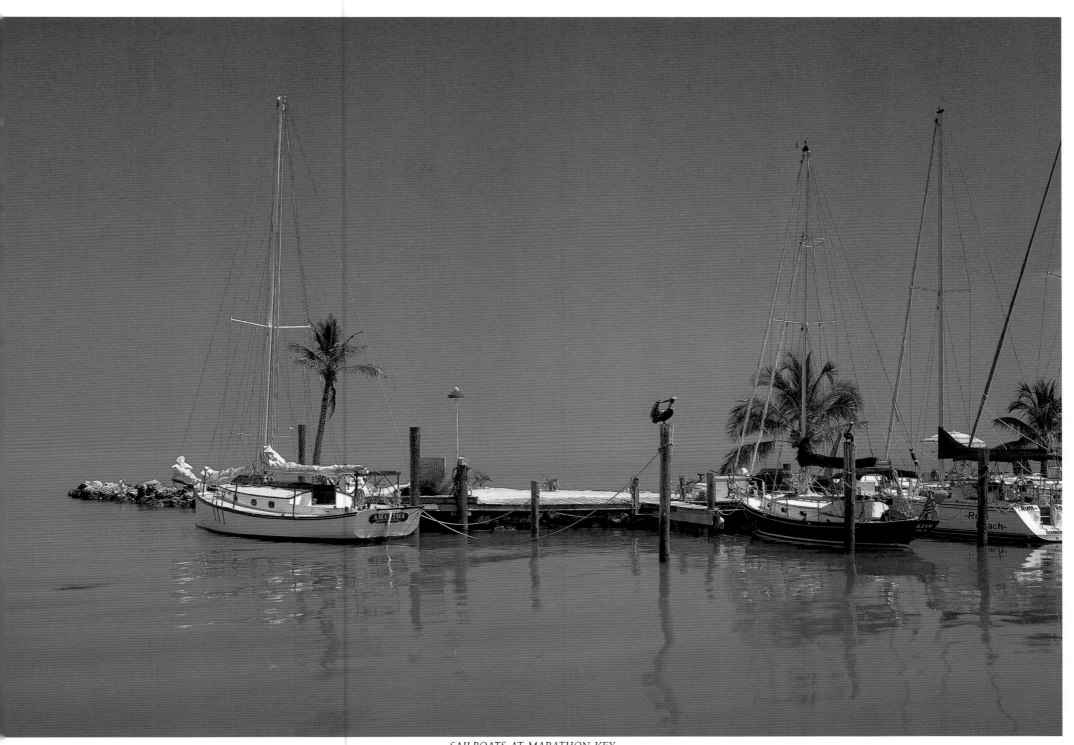

SAILBOATS AT MARATHON KEY

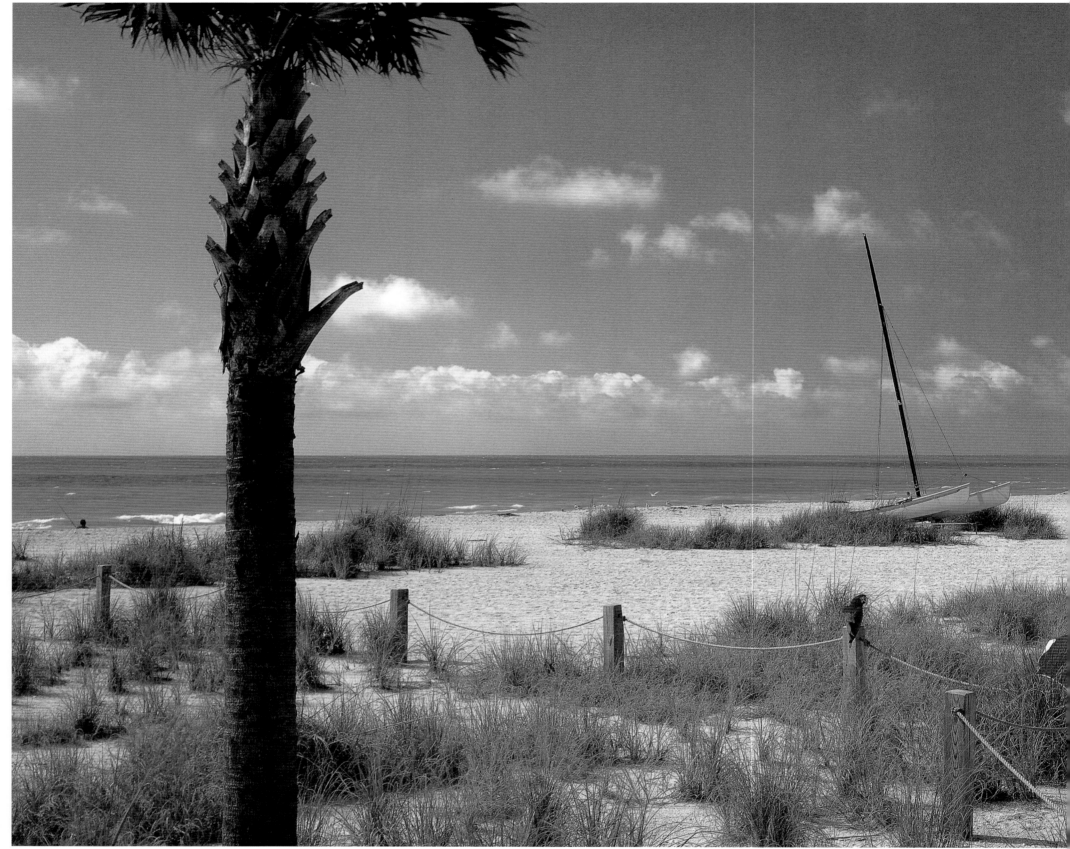

INDIAN SHORES BEACH NEAR CLEARWATER

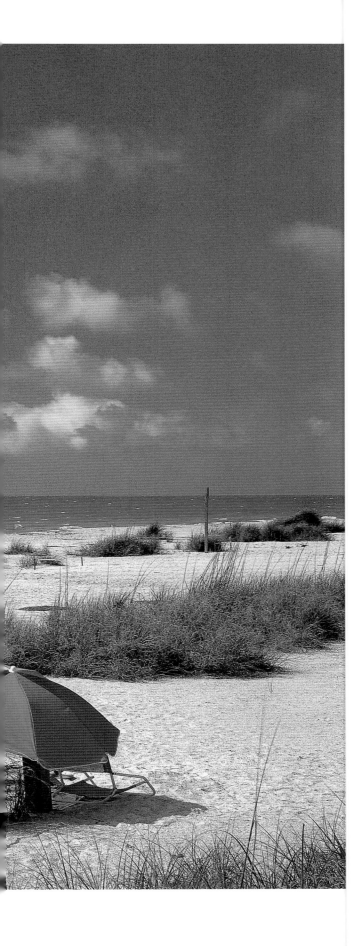

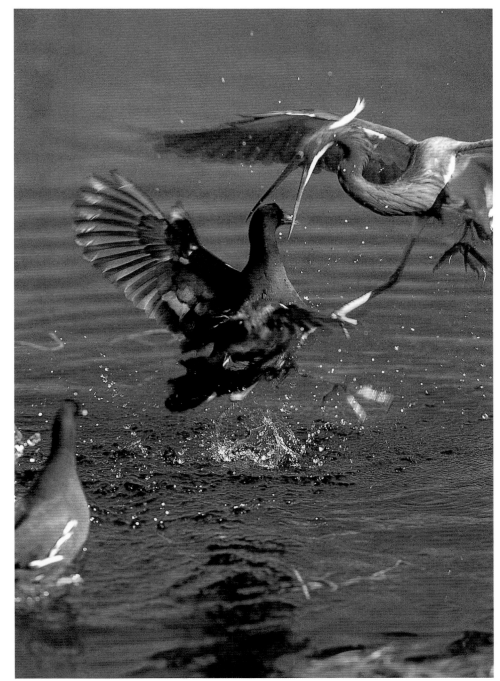

FIGHTING GALLINULE AND HERON,
EVERGLADES NATIONAL PARK

GUMBO LIMBO TREE, LONG KEY

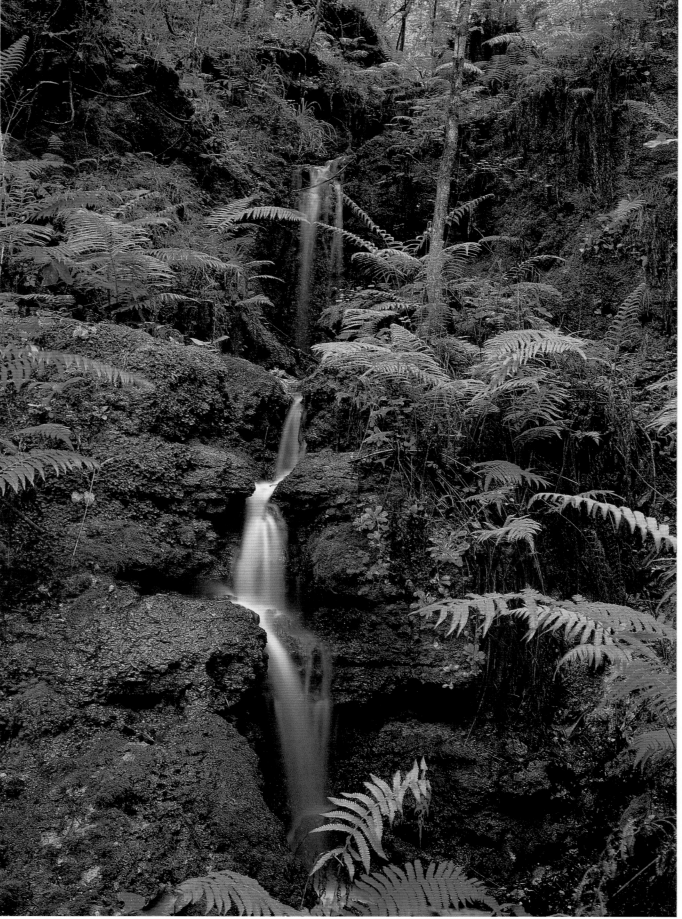

DEVIL'S MILLHOPPER STATE GEOLOGIC SITE, GAINESVILLE

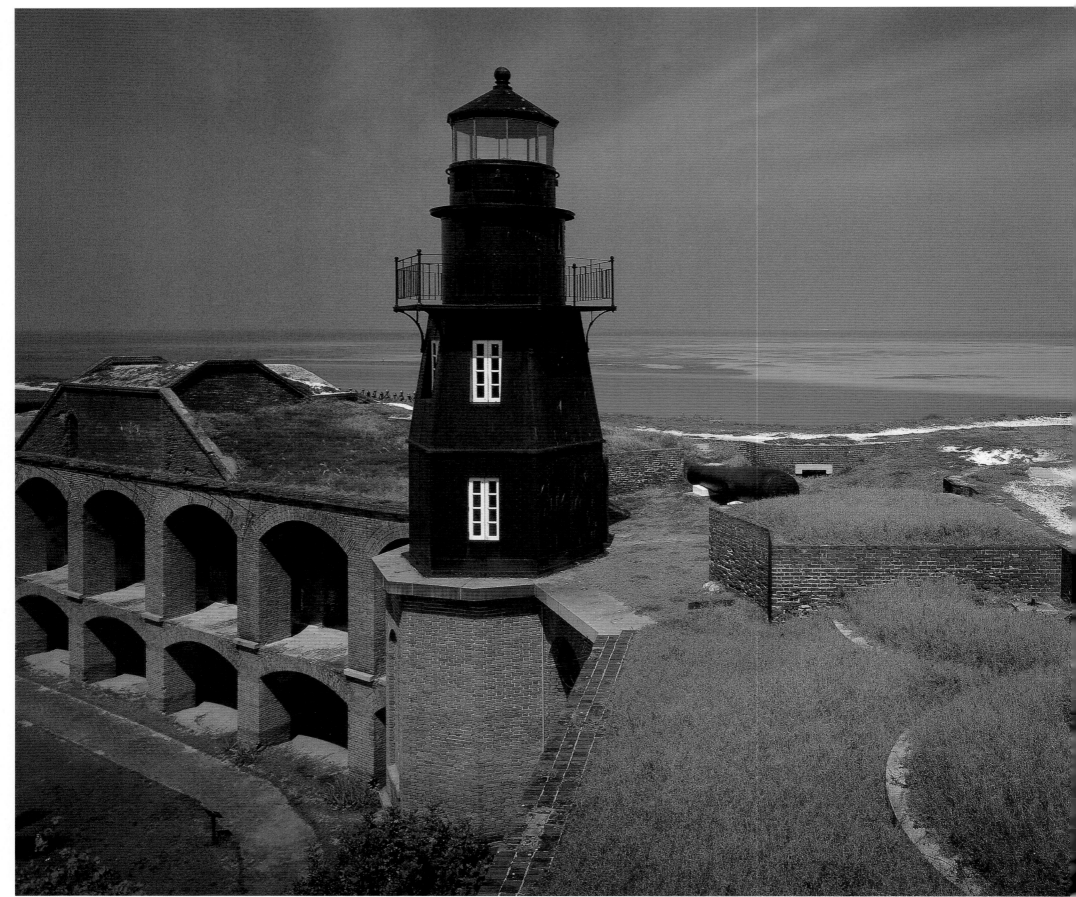

LGHTHOUSE, HISTORIC FT. JEFFERSON ON GARDEN KEY,
DRY TORTUGAS NATIONAL PARK

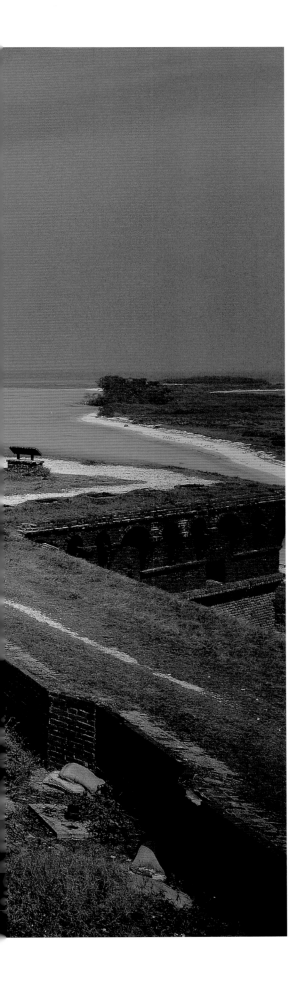

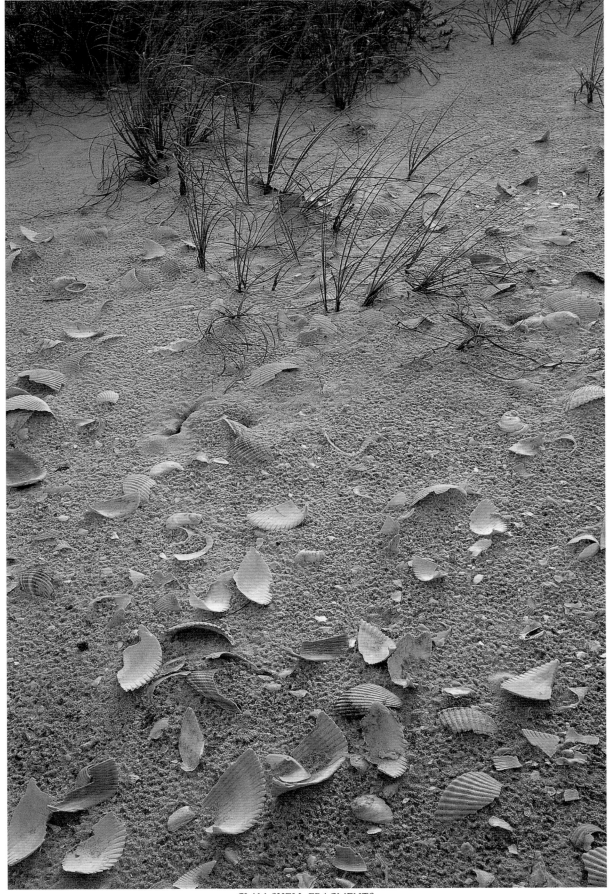

CLAM SHELL FRAGMENTS,
ST. GEORGE ISLAND STATE PARK

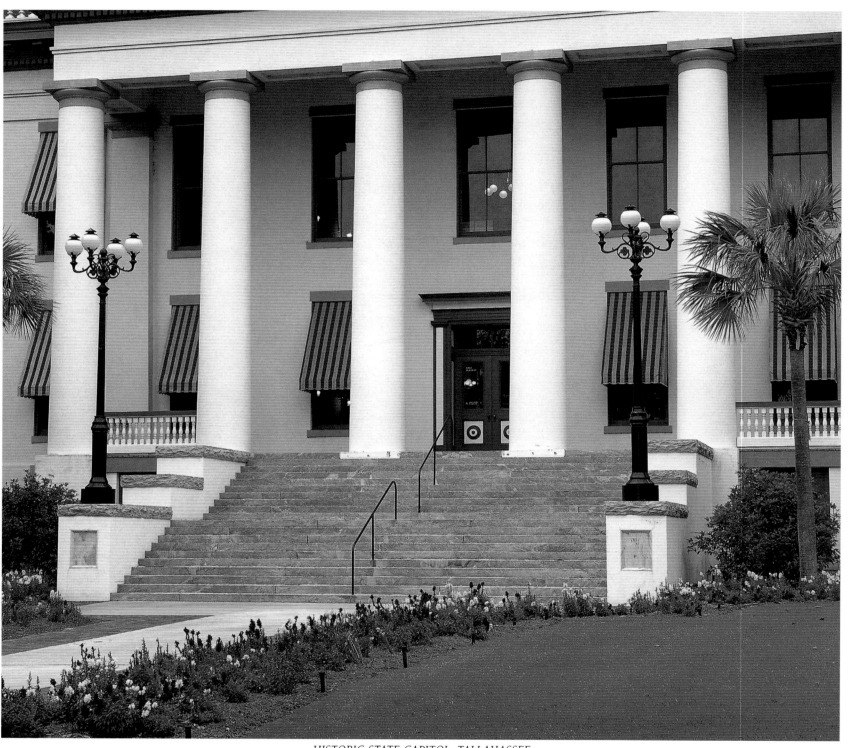

HISTORIC STATE CAPITOL, TALLAHASSEE

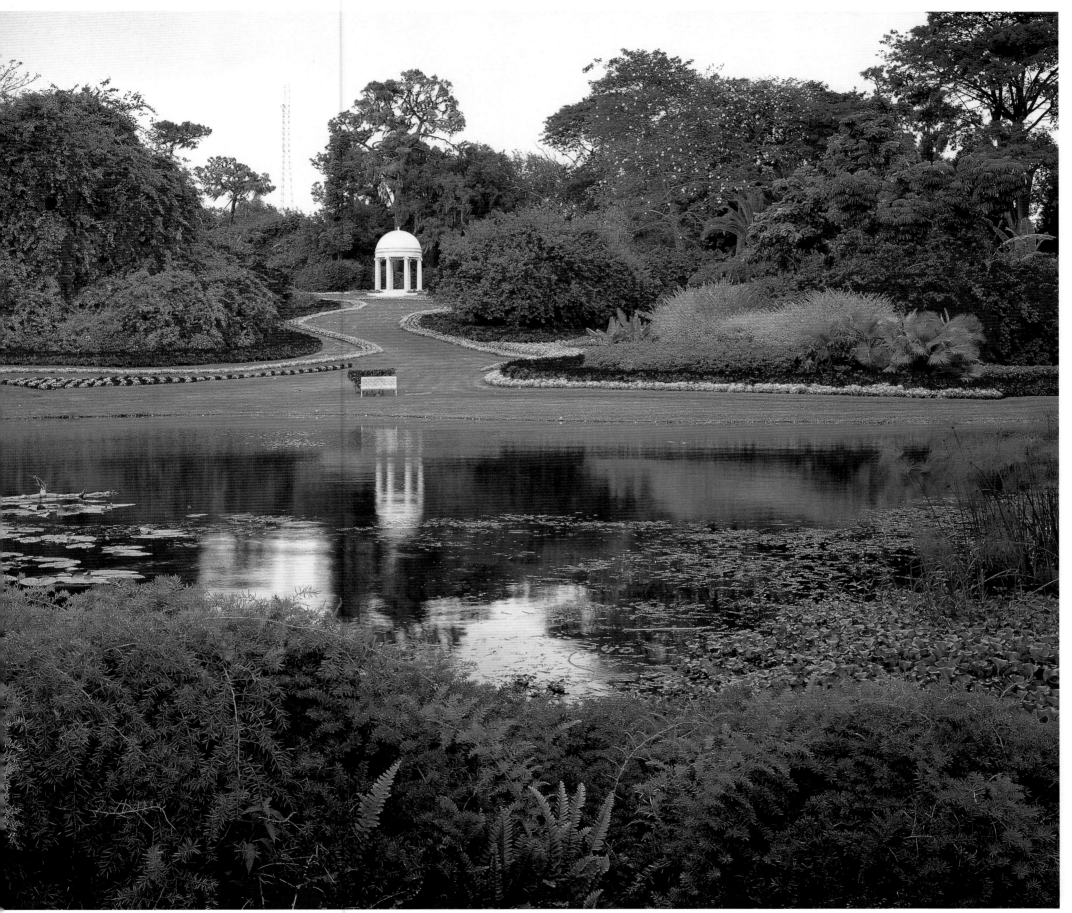

FORMAL GARDENS AT CYPRESS GARDENS, WINTER HAVEN

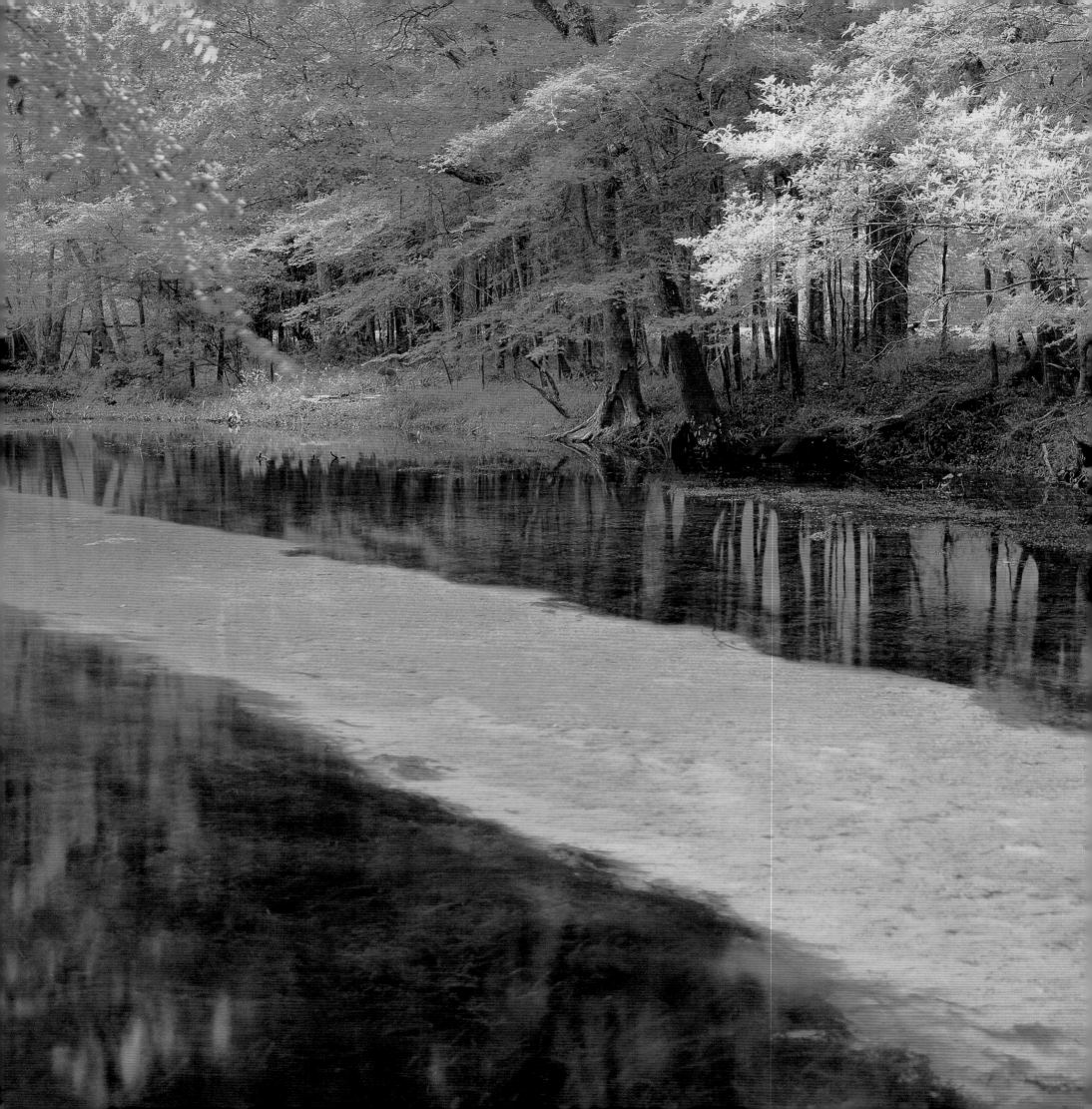

CRYSTAL CLEAR WATERS OF GINNIE SPRING RUN
FLOW INTO SANTA FE RIVER

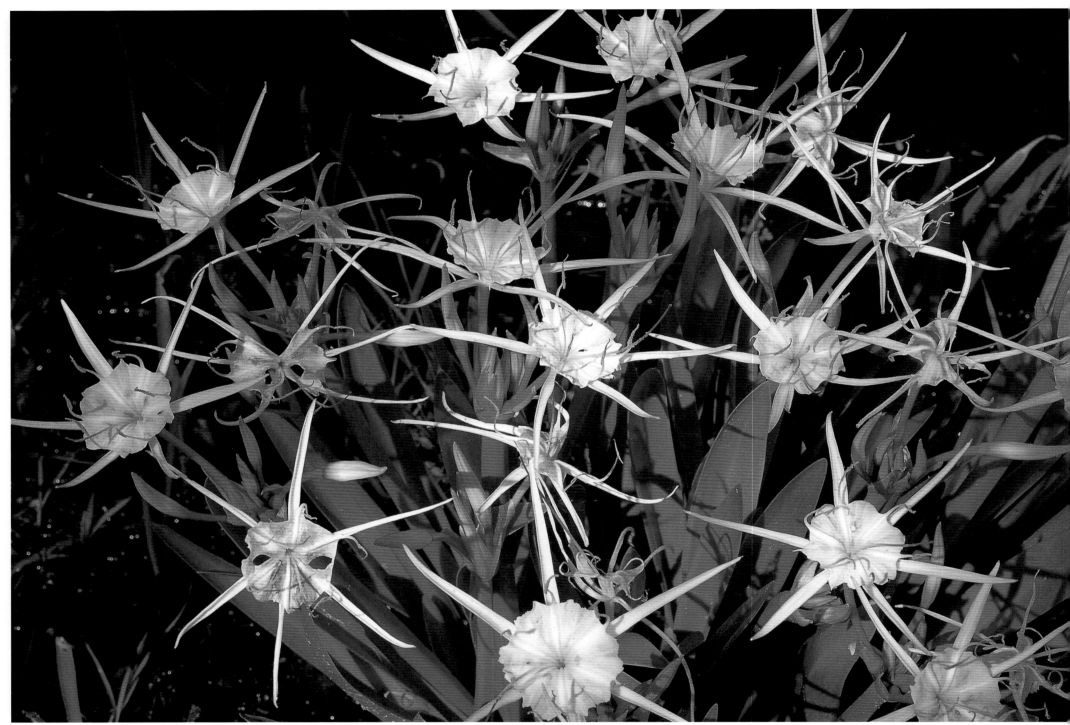

SPIDER LILIES IN BLOOM, NEAR SUWANNEE RIVER

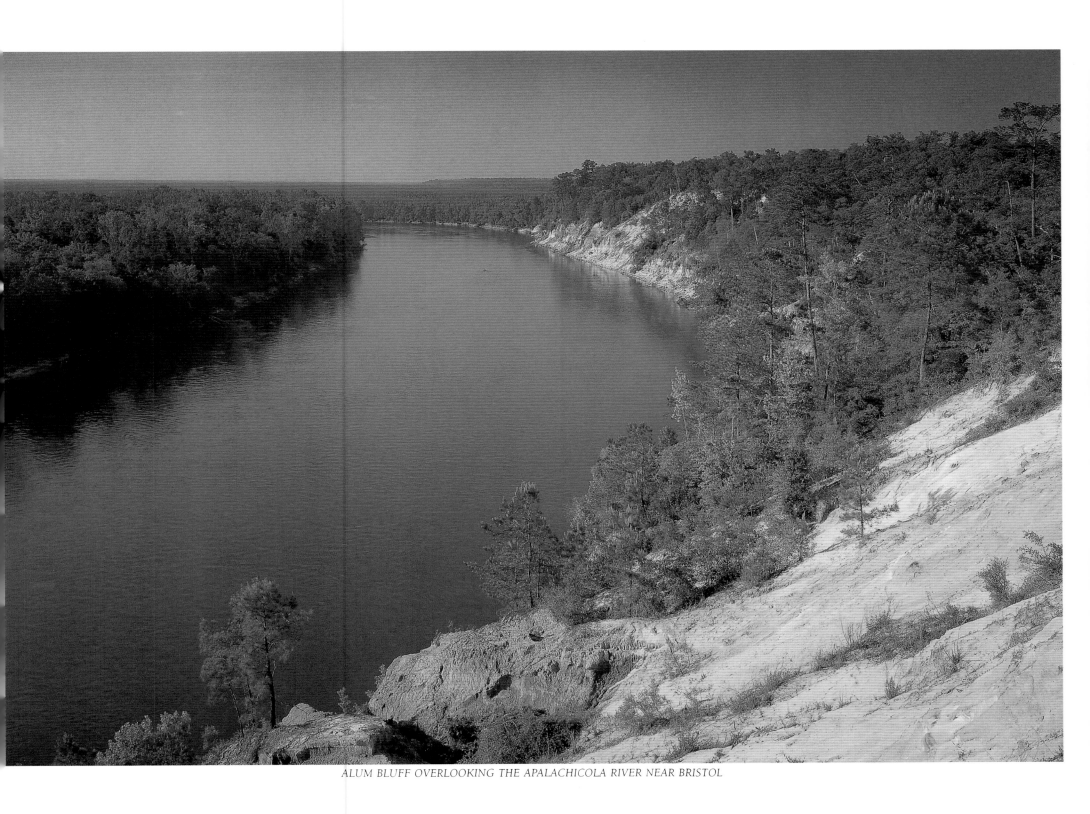

ALUM BLUFF OVERLOOKING THE APALACHICOLA RIVER NEAR BRISTOL

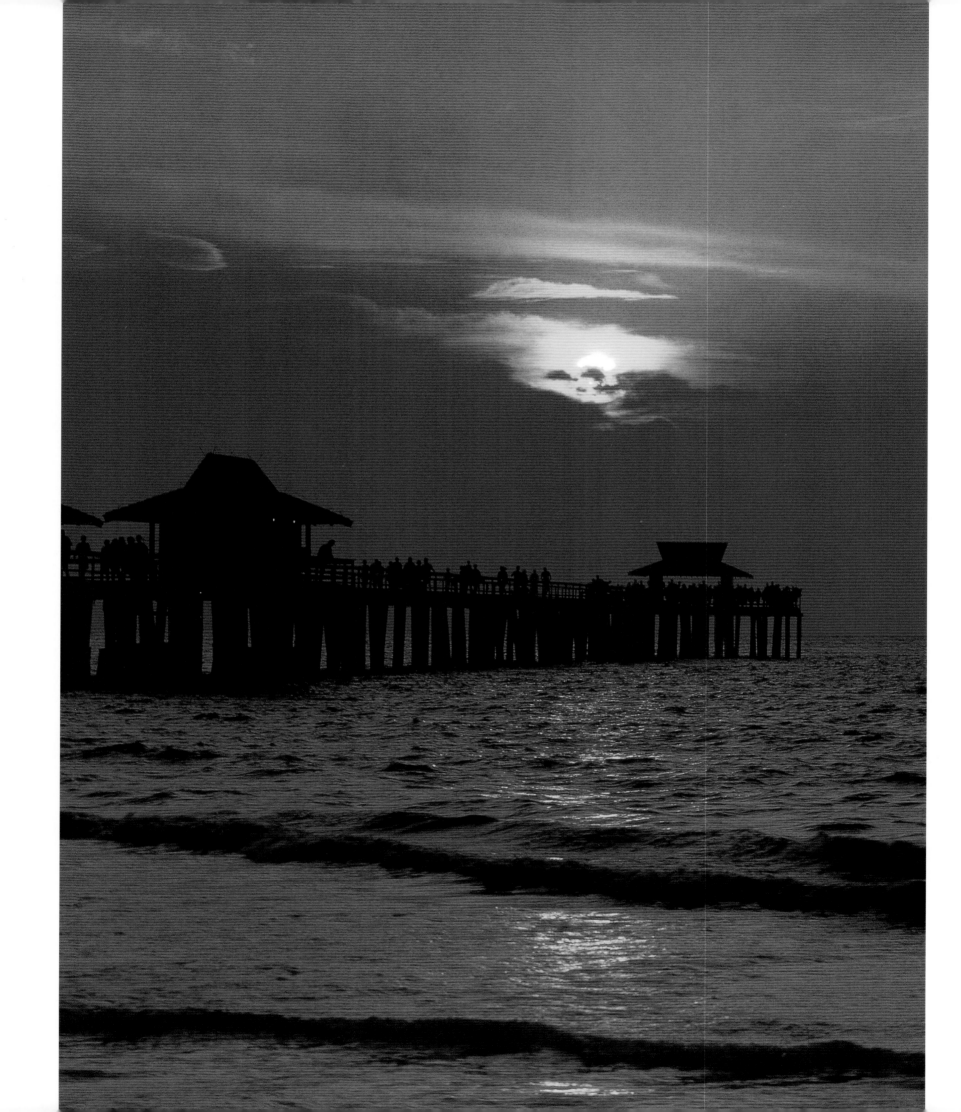

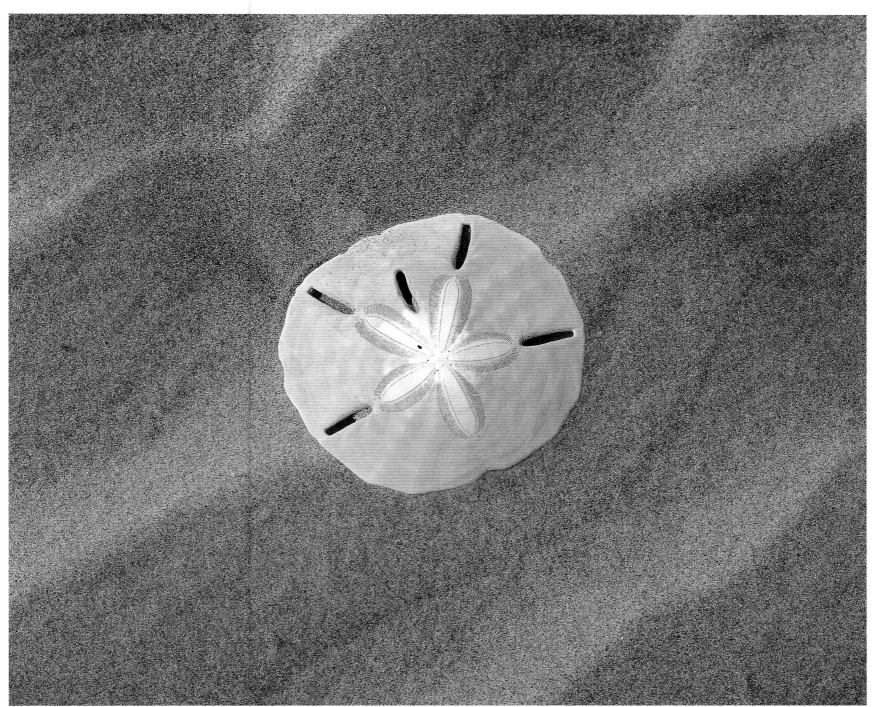

SAND DOLLAR, FERNANDINA BEACH,
ATLANTIC OCEAN

THE NAPLES PIER AT SUNSET,
A LANDMARK ALONG THE GULF COAST

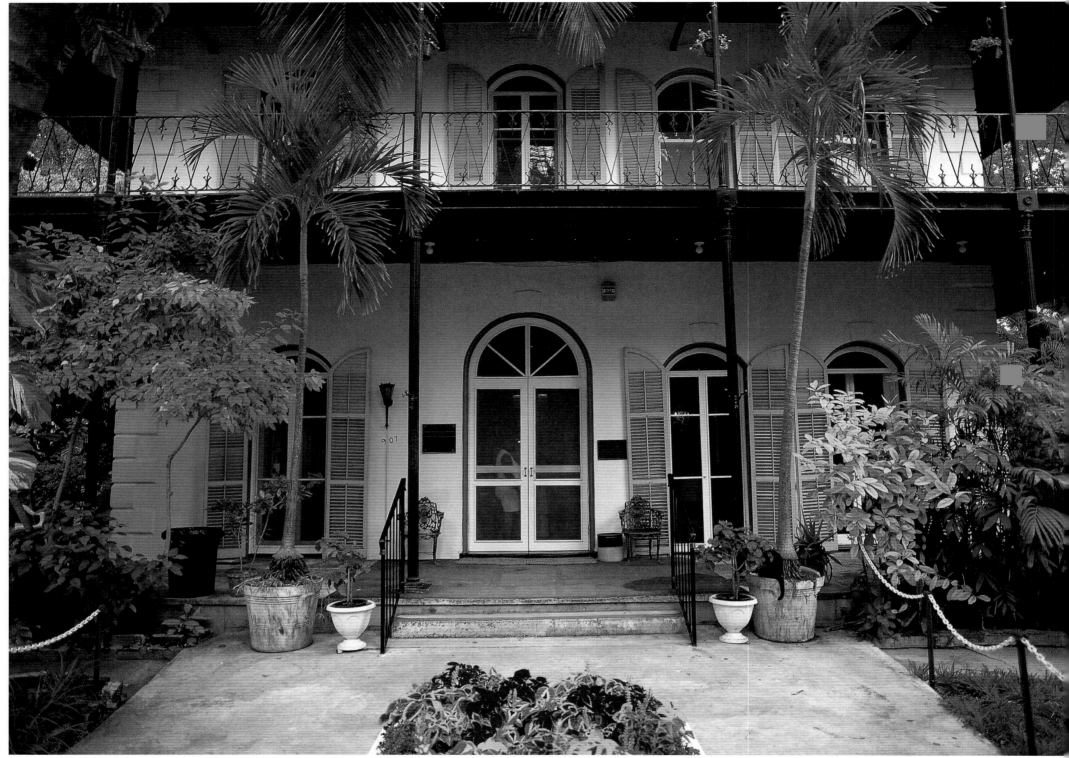

ERNEST HEMINGWAY HOUSE, KEY WEST

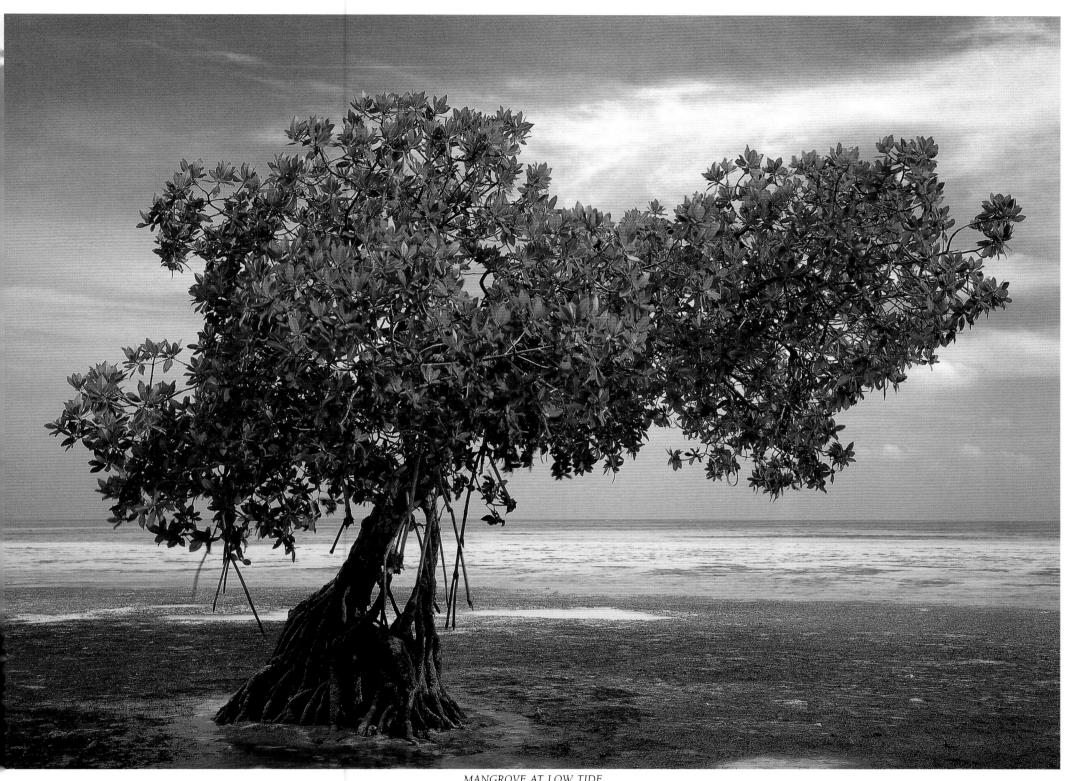

*MANGROVE AT LOW TIDE,
LONG KEY STATE RECREATION AREA*

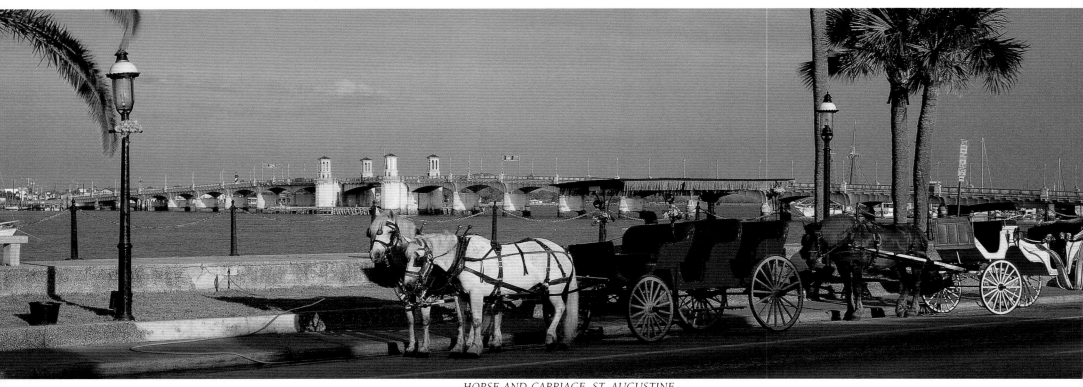

HORSE AND CARRIAGE, ST. AUGUSTINE,
WITH BRIDGE OF LIONS CROSSING THE MATANZAS RIVER IN DISTANCE.

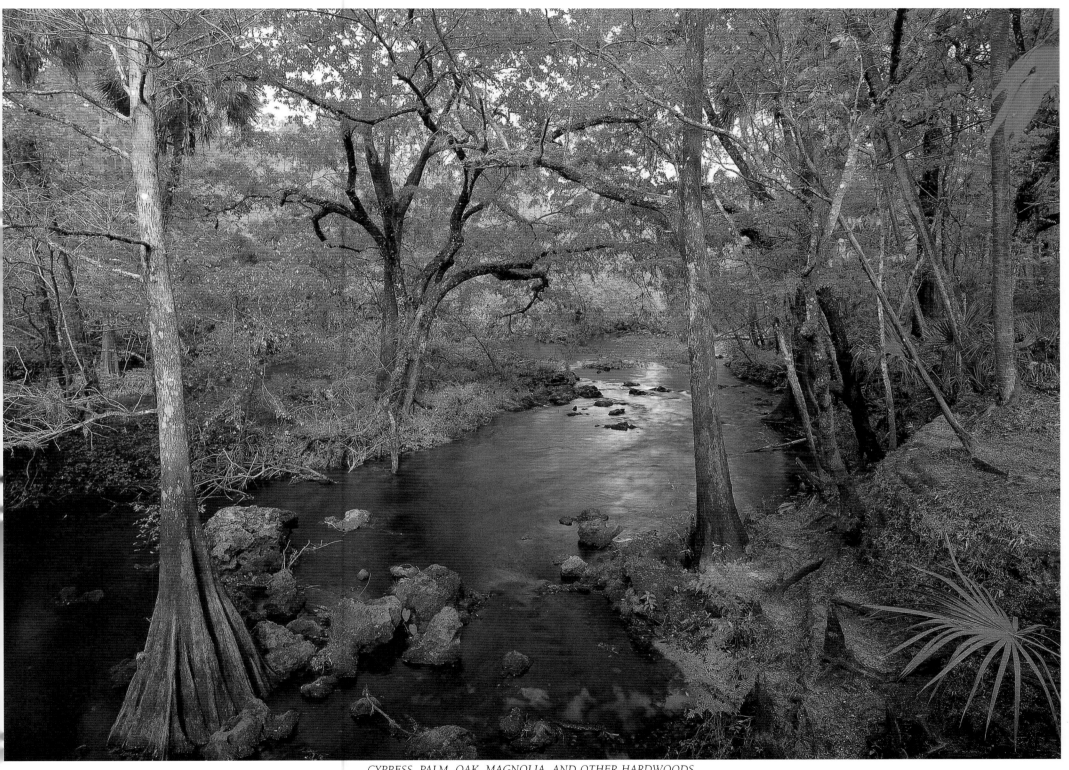

CYPRESS, PALM, OAK, MAGNOLIA, AND OTHER HARDWOODS,
HILLSBOROUGH RIVER STATE PARK

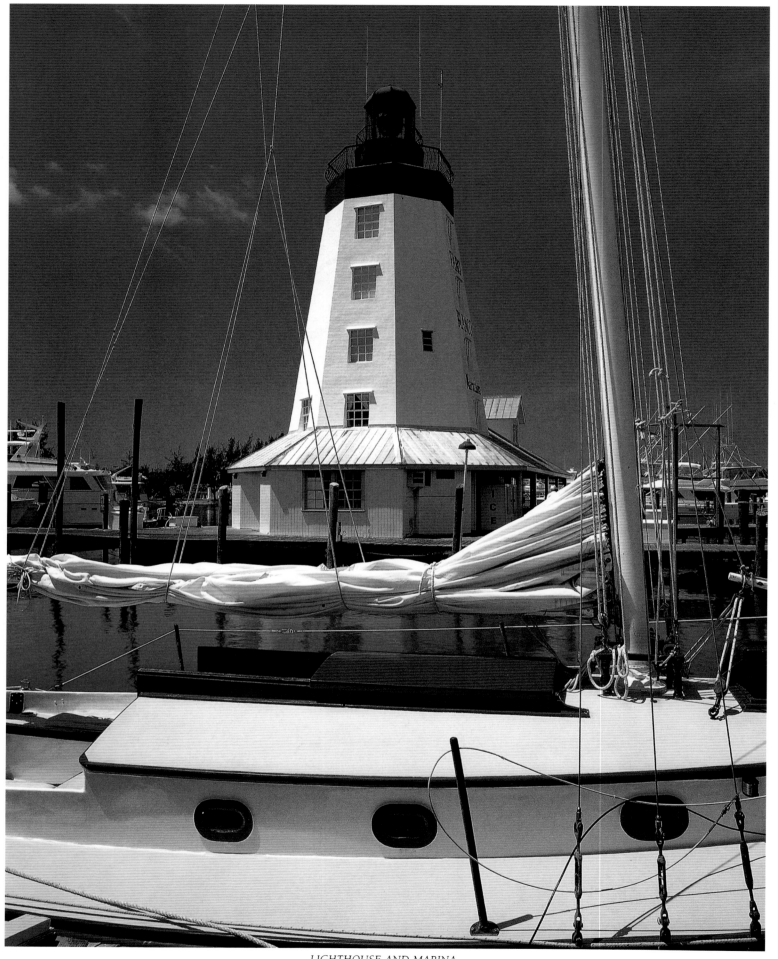

LIGHTHOUSE AND MARINA,
MARATHON KEY

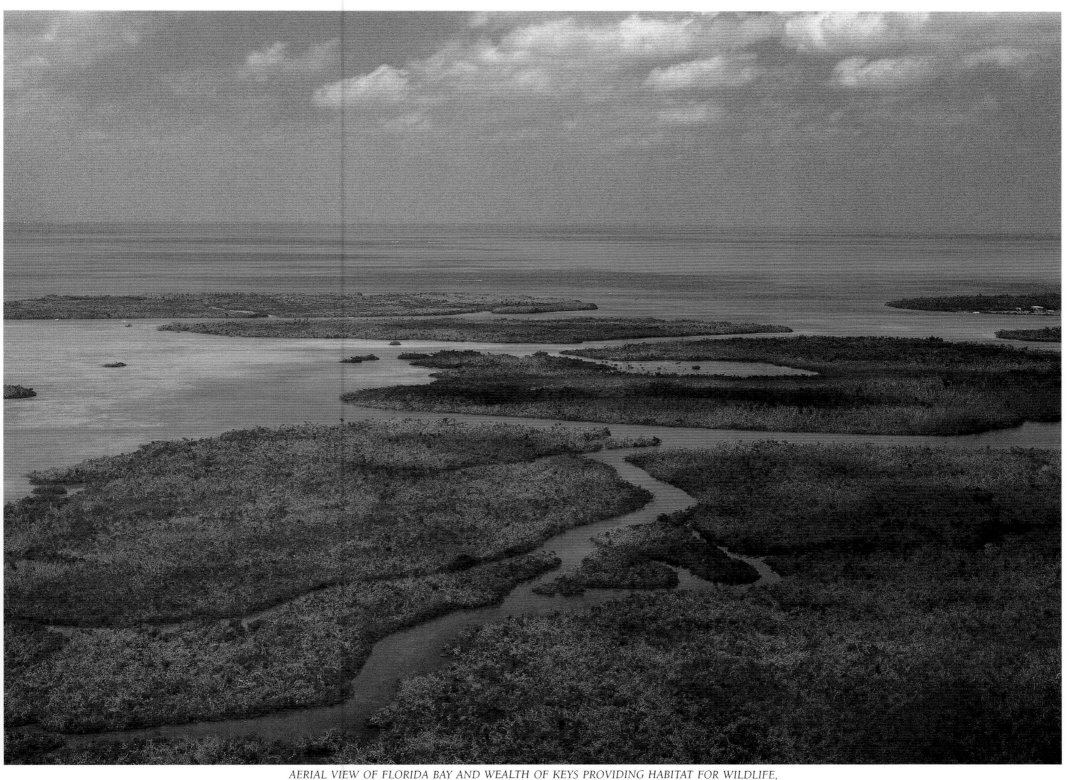

*AERIAL VIEW OF FLORIDA BAY AND WEALTH OF KEYS PROVIDING HABITAT FOR WILDLIFE,
EVERGLADES NATIONAL PARK*

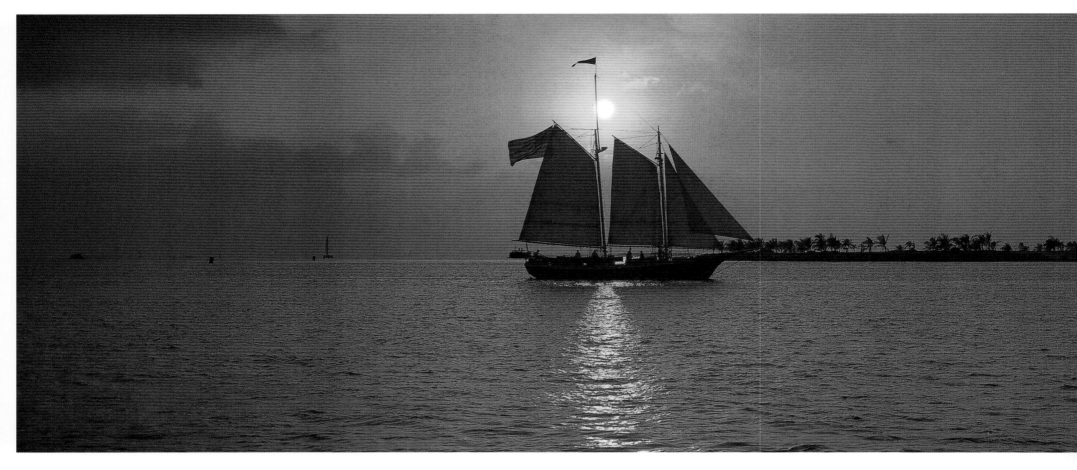

*TROPICAL FOREST OF CYPRESS,
FERNS, AND AIRPLANTS,
BIG CYPRESS NATIONAL PRESERVE*

SUNSET CRUISE, KEY WEST

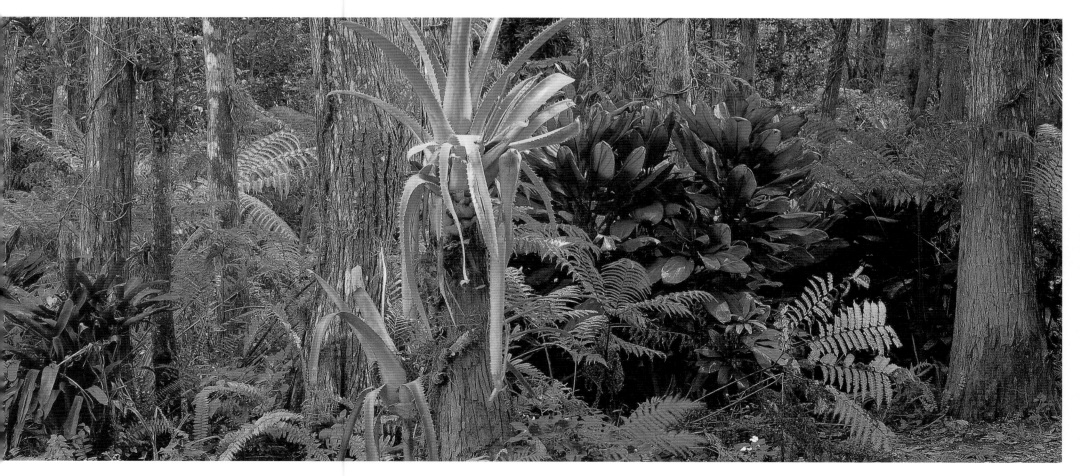

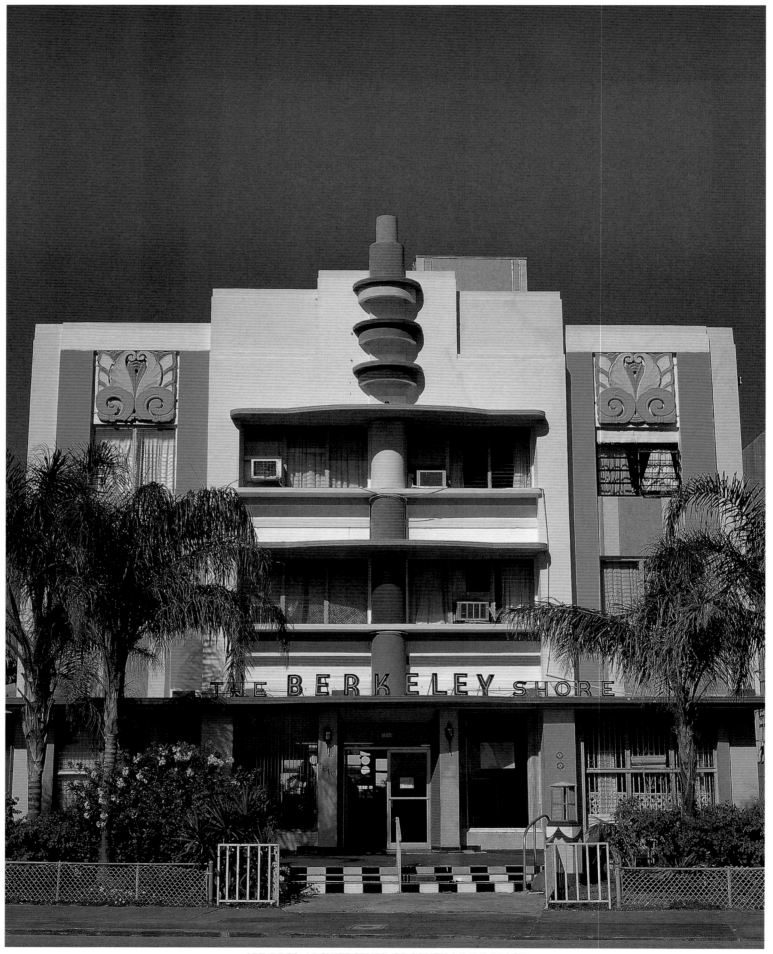

ART DECO ARCHITECTURE OF SOUTH MIAMI BEACH

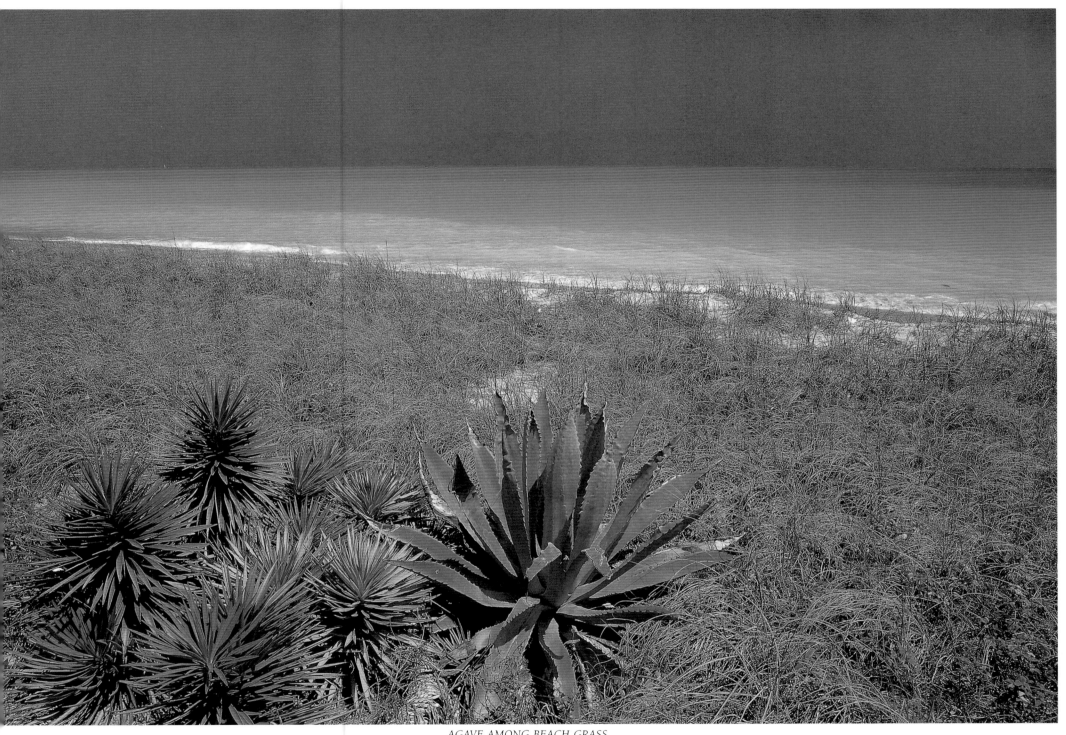

AGAVE AMONG BEACH GRASS,
SOUTH MIAMI BEACH

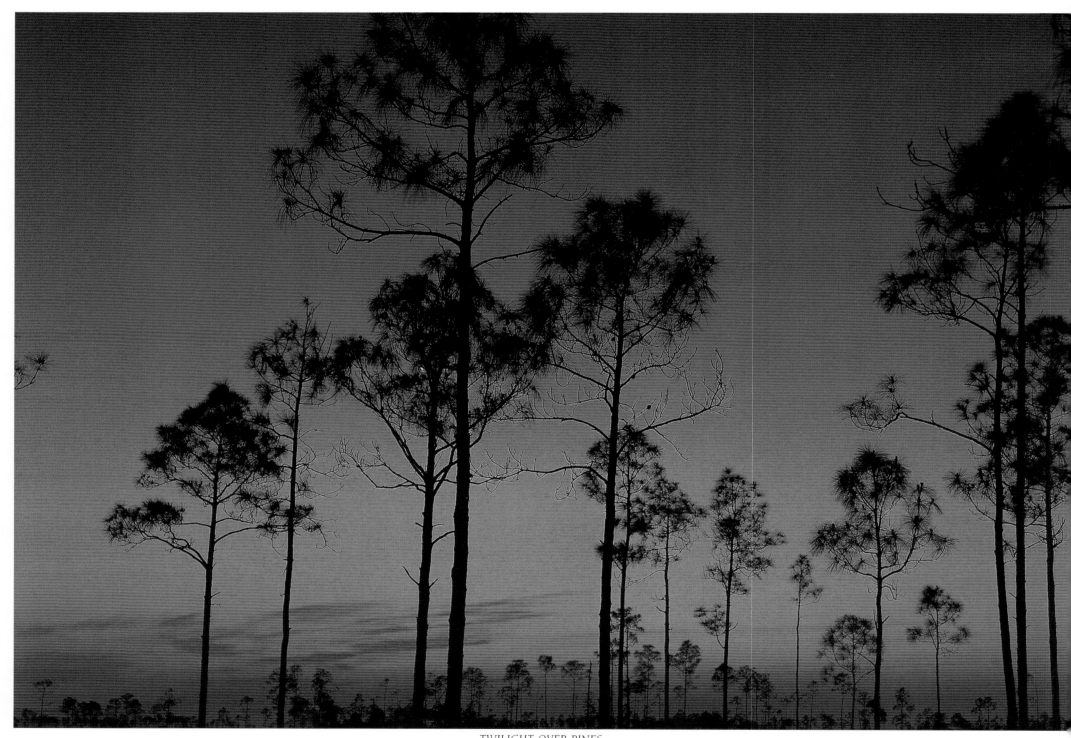

TWILIGHT OVER PINES,
MAHOGANY HAMMOCK AREA, EVERGLADES NATIONAL PARK

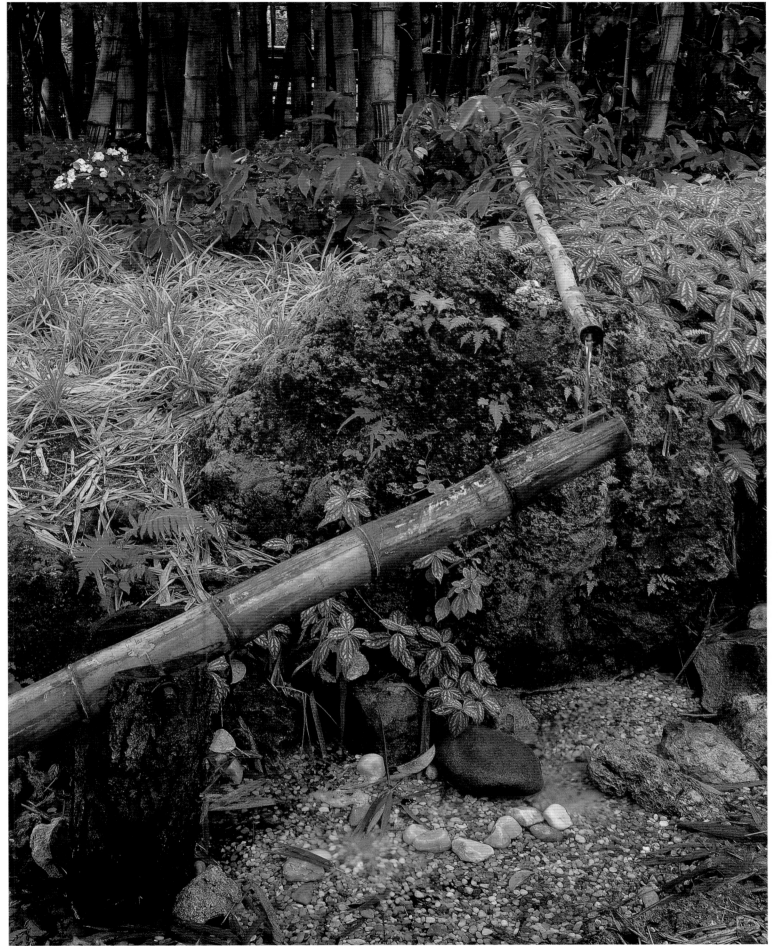

*JAPANESE GARDEN DISPLAY AT CYPRESS GARDENS,
WINTER HAVEN*

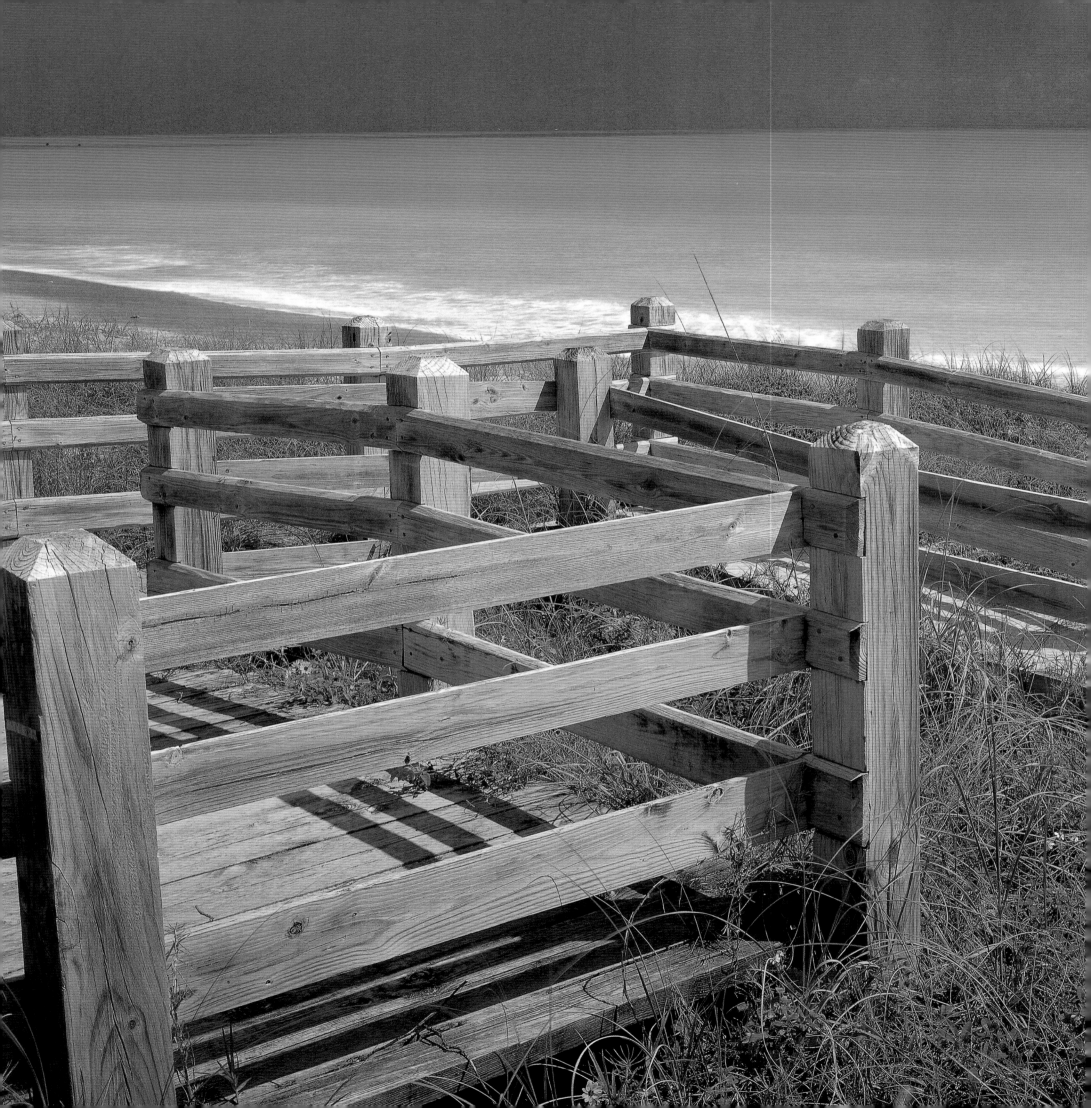

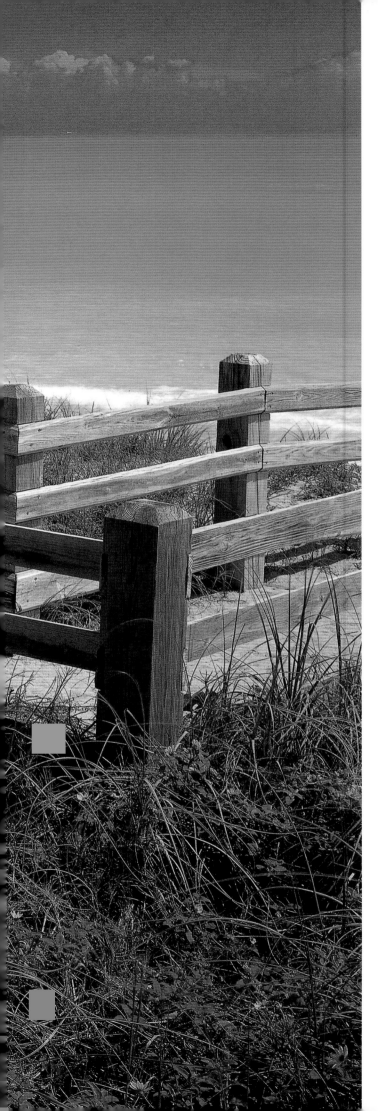

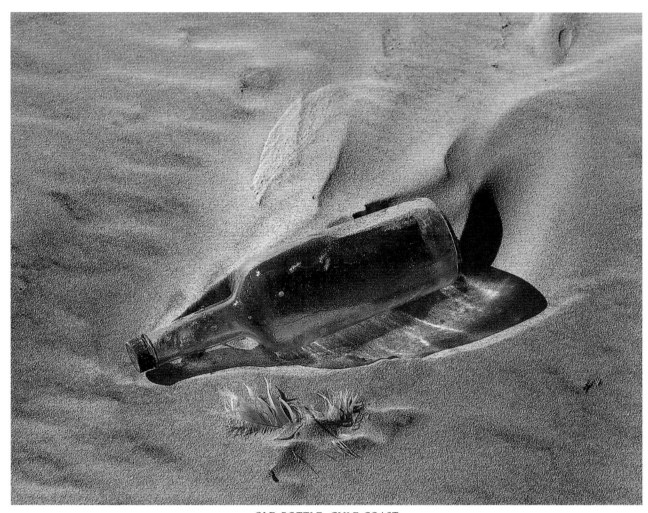

OLD BOTTLE, GULF COAST

BEACH WALKWAY,
MIAMI BEACH

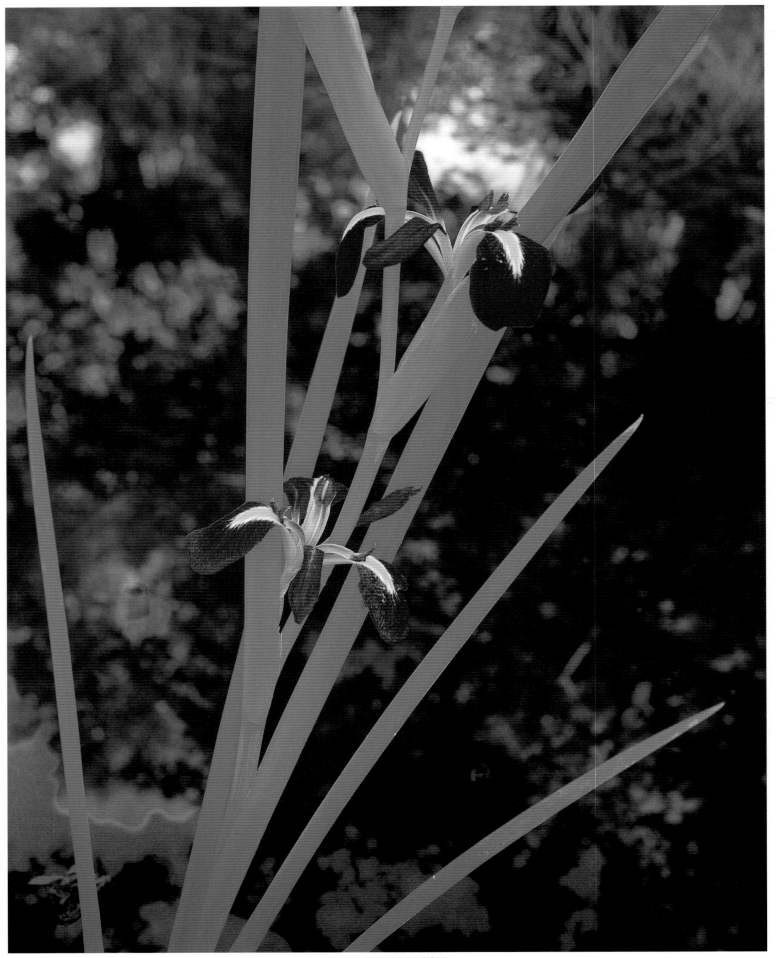

IRIS IN SPRING BLOOM,
ST. MARKS NATIONAL WILDLIFE REFUGE

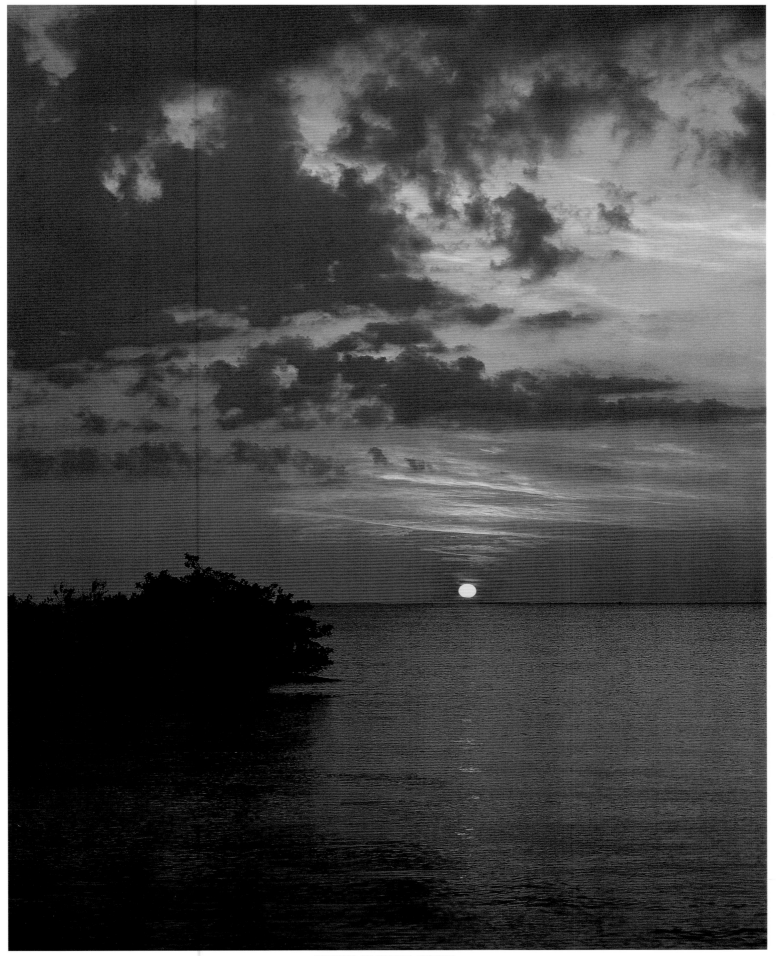

SUNSET AT PUNTA GORDA,
GULF OF MEXICO

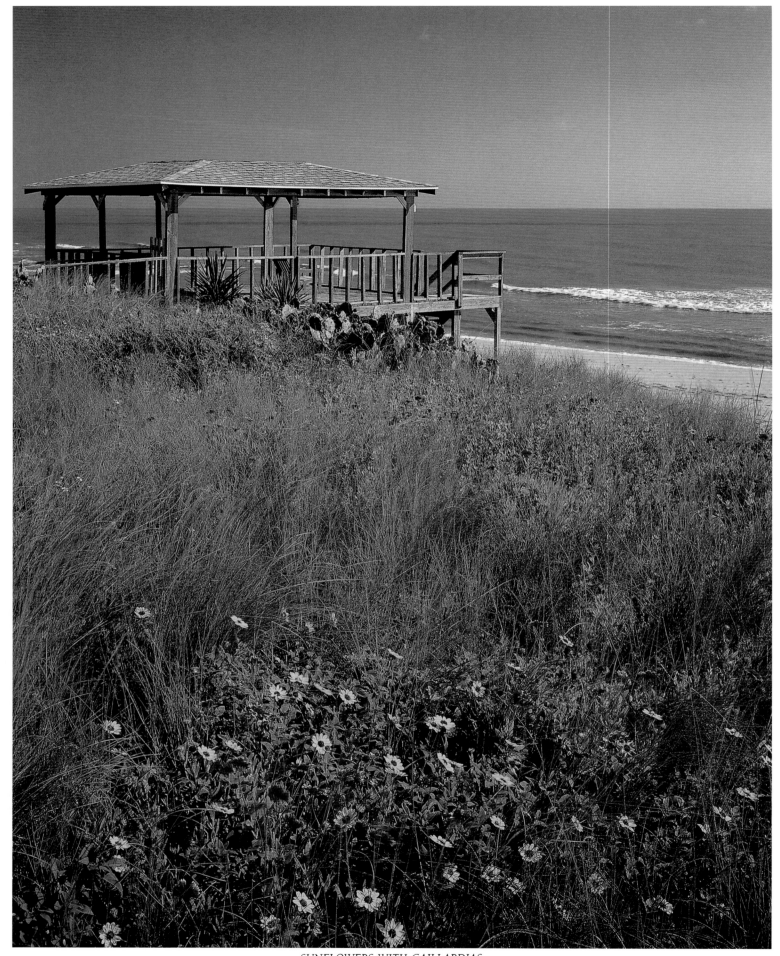

SUNFLOWERS WITH GAILLARDIAS,
FLAGLER BEACH, ATLANTIC OCEAN

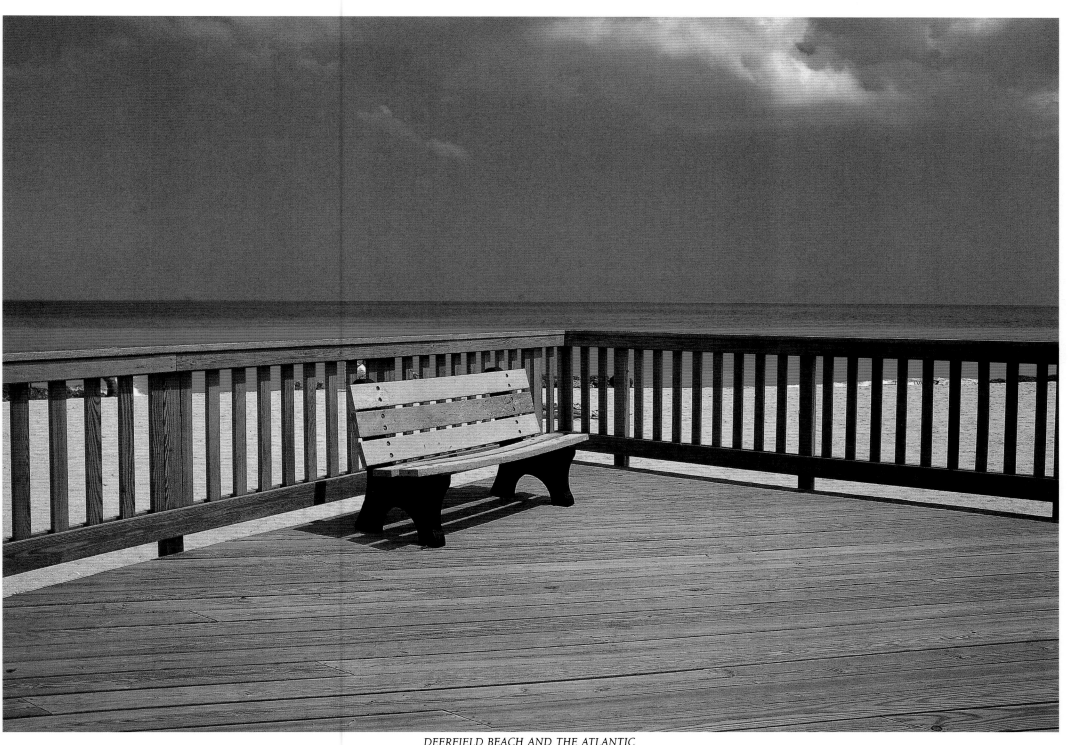

DEERFIELD BEACH AND THE ATLANTIC
NEAR POMPANO

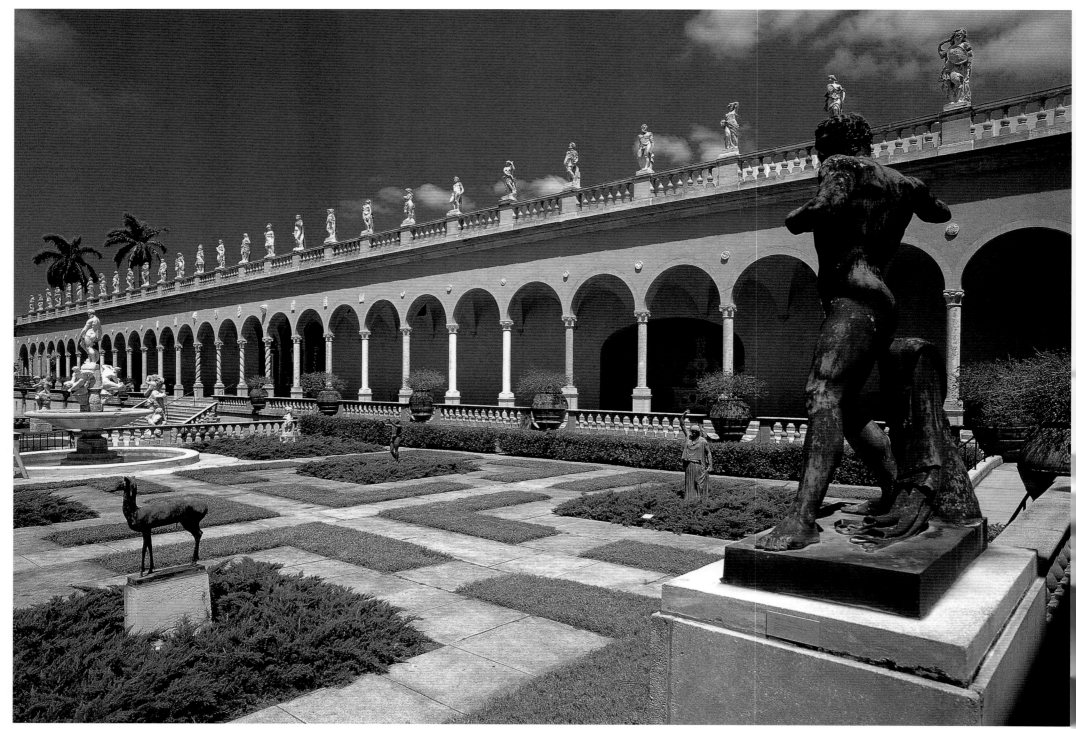

COURTYARD OF RINGLING MUSEUM OF ART, SARASOTA

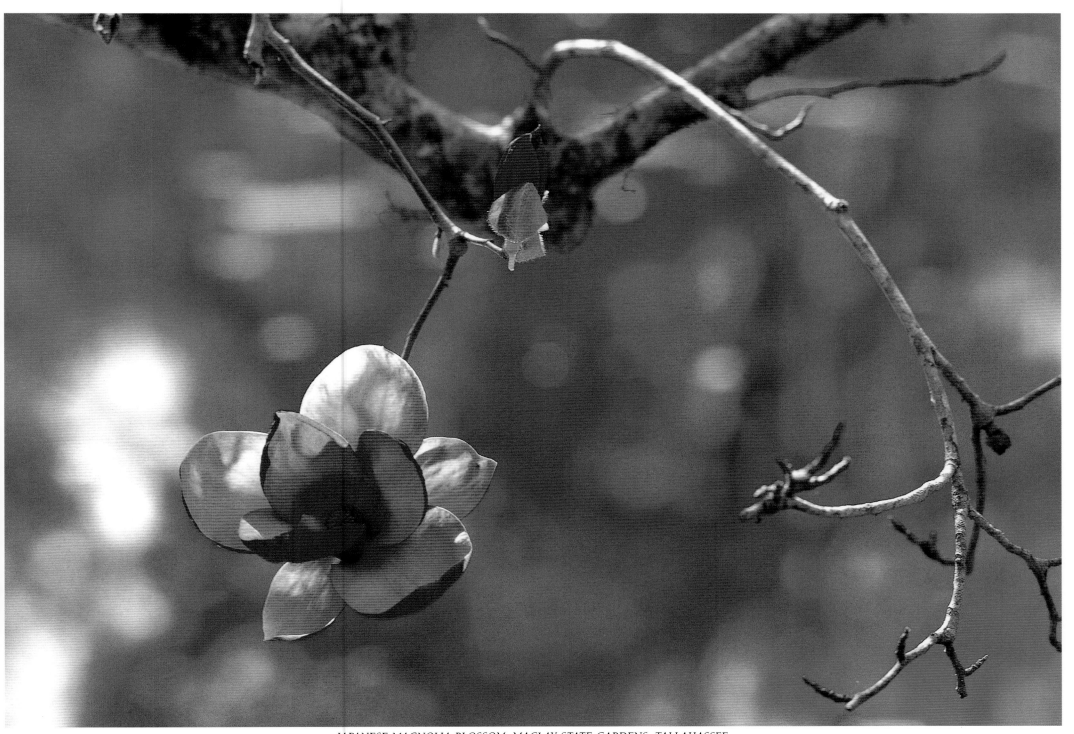

JAPANESE MAGNOLIA BLOSSOM, MACLAY STATE GARDENS, TALLAHASSEE

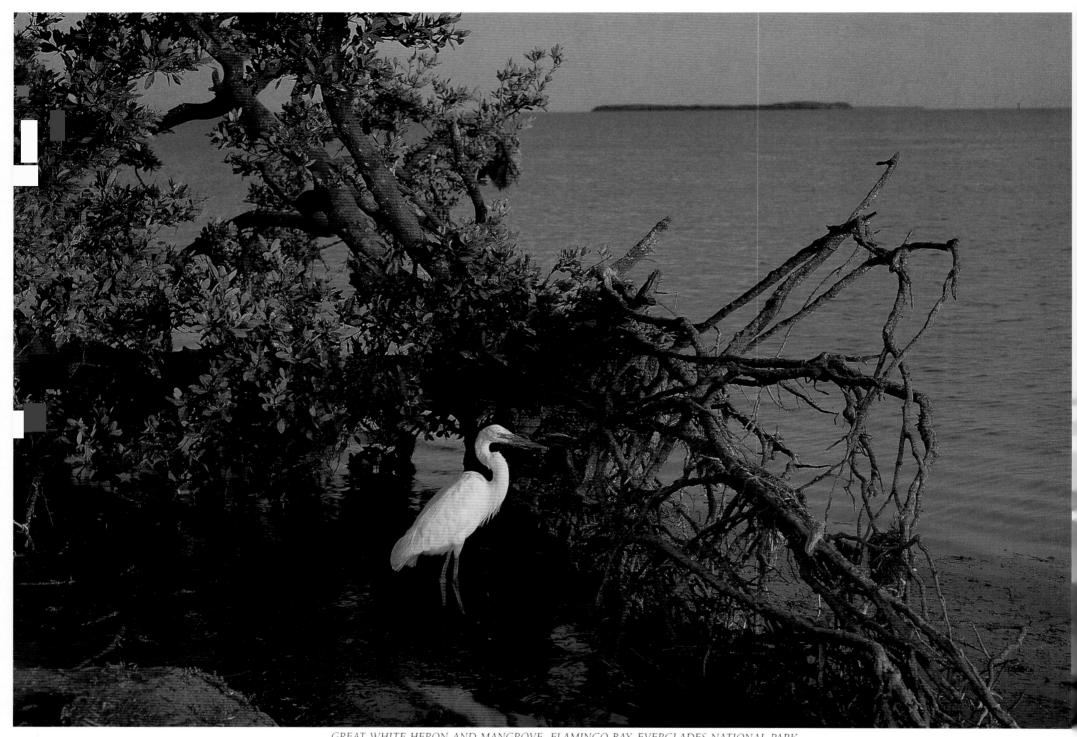

GREAT WHITE HERON AND MANGROVE, FLAMINGO BAY, EVERGLADES NATIONAL PARK

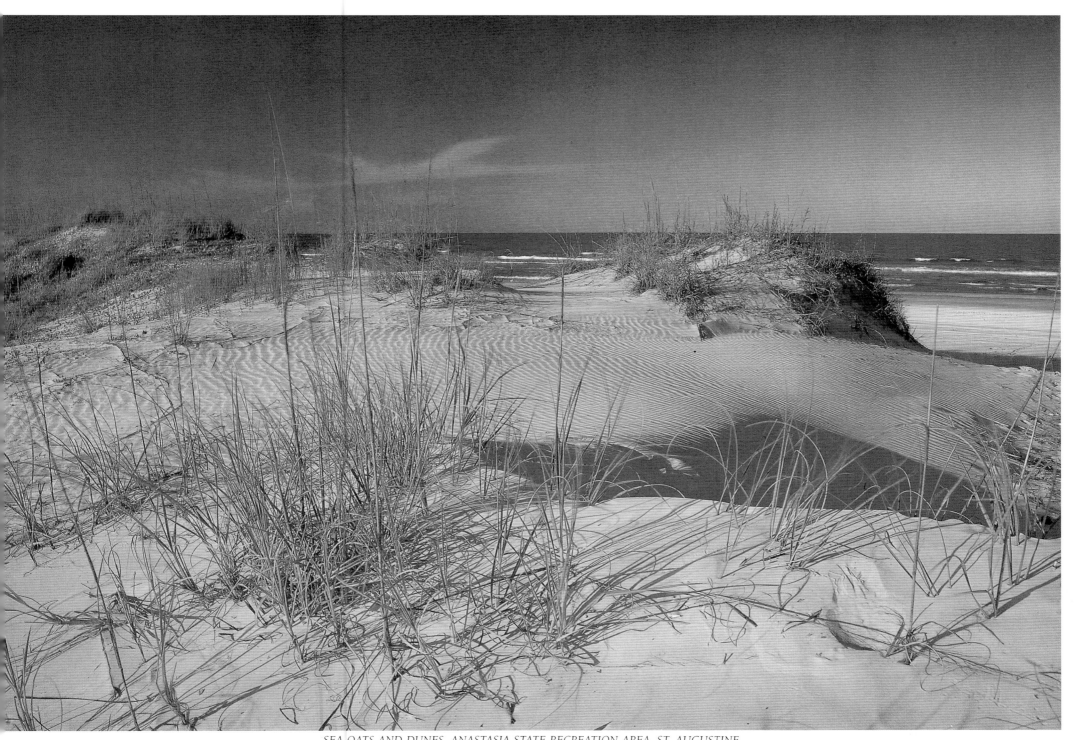

SEA OATS AND DUNES, ANASTASIA STATE RECREATION AREA, ST. AUGUSTINE

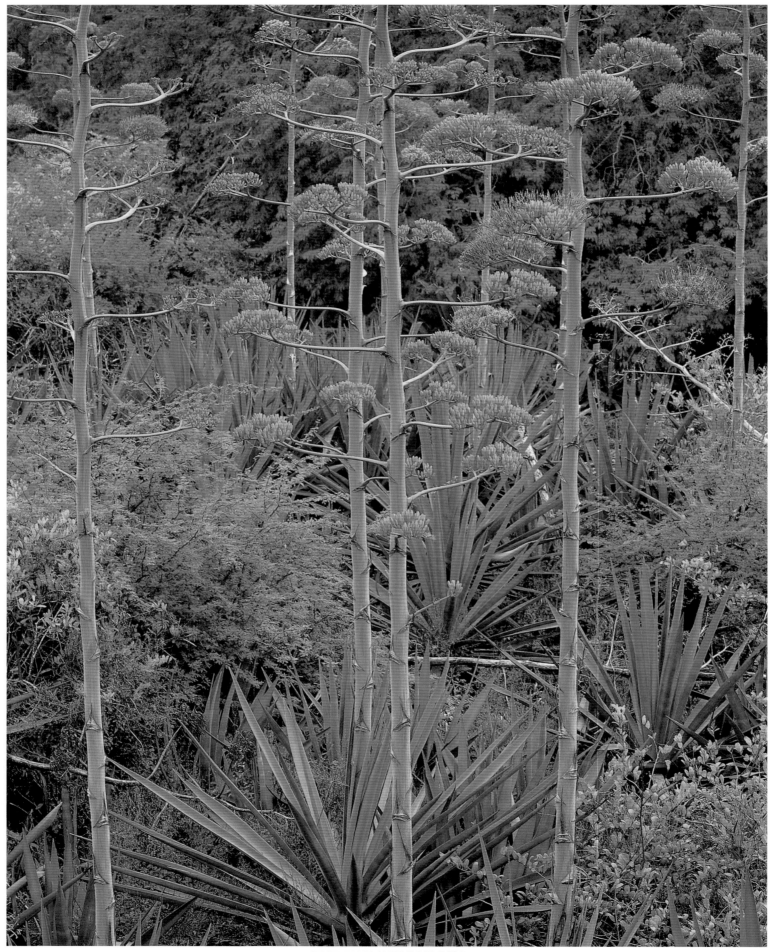

CENTURY PLANTS IN BLOOM,
INDIAN KEY STATE HISTORIC SITE

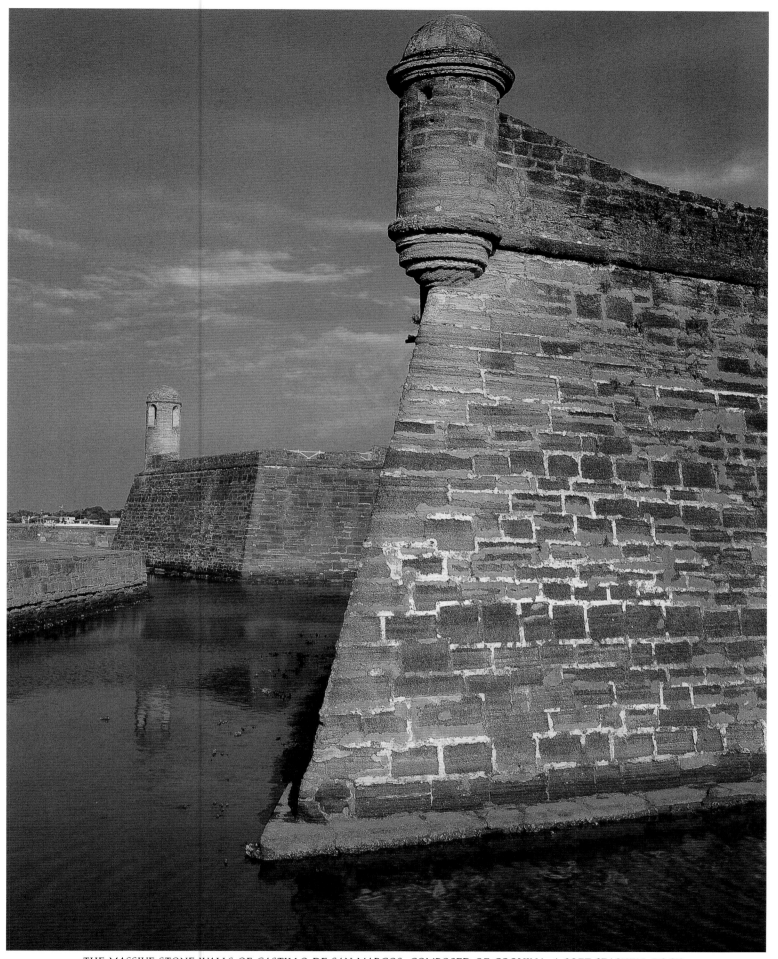

THE MASSIVE STONE WALLS OF CASTILLO DE SAN MARCOS, COMPOSED OF COQUINA, A SOFT SEASHELL ROCK,
CASTILLO DE SAN MARCOS NATIONAL MONUMENT, ST. AUGUSTINE (COMPLETED 1697)

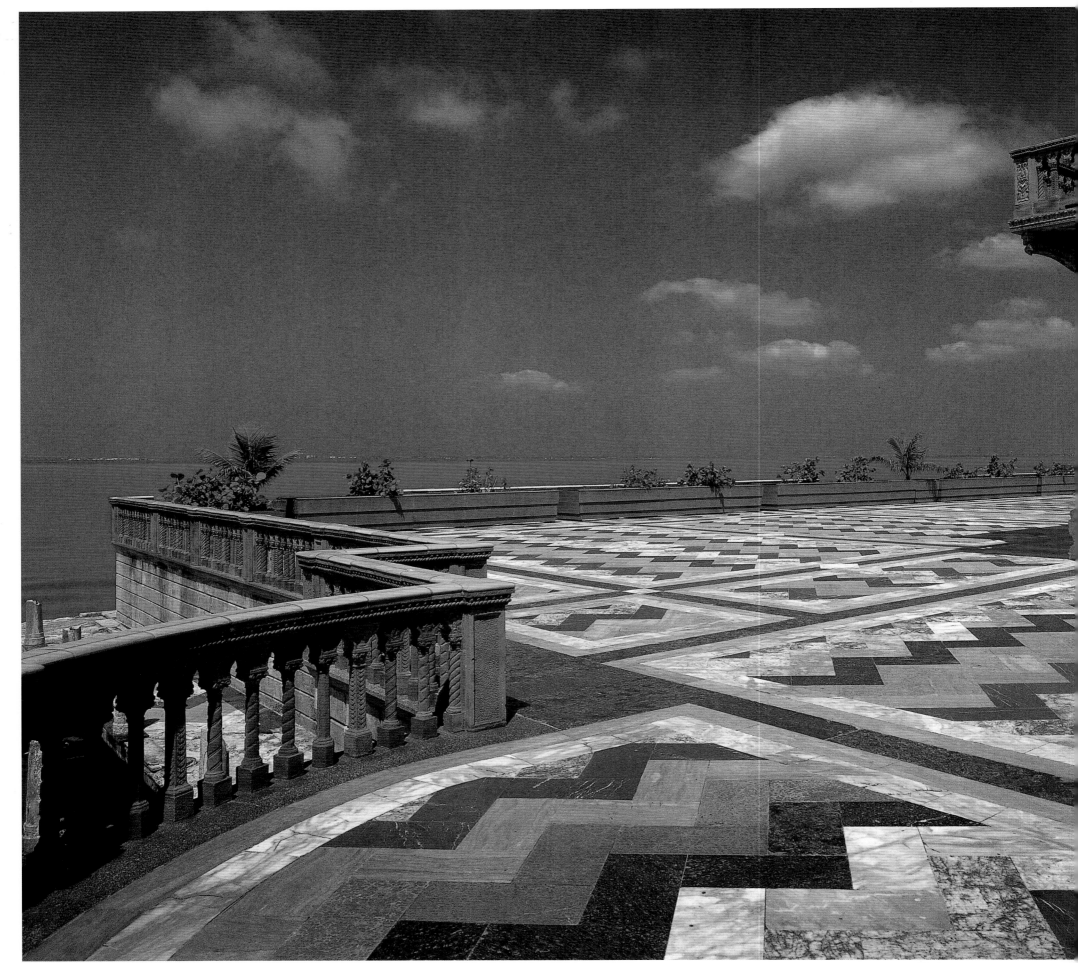

TERRACE, RINGLING MANSION, CA'D'ZAN, SARASOTA

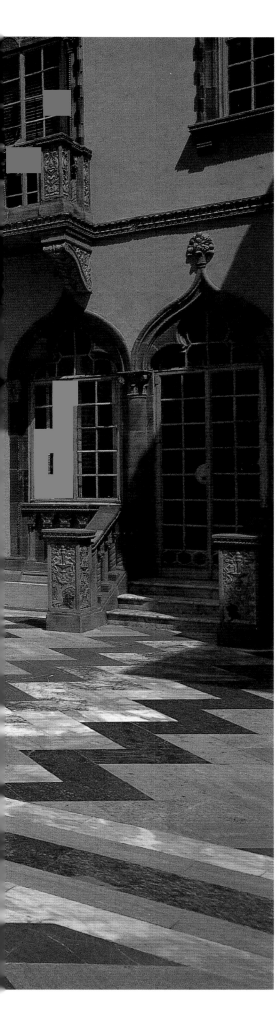

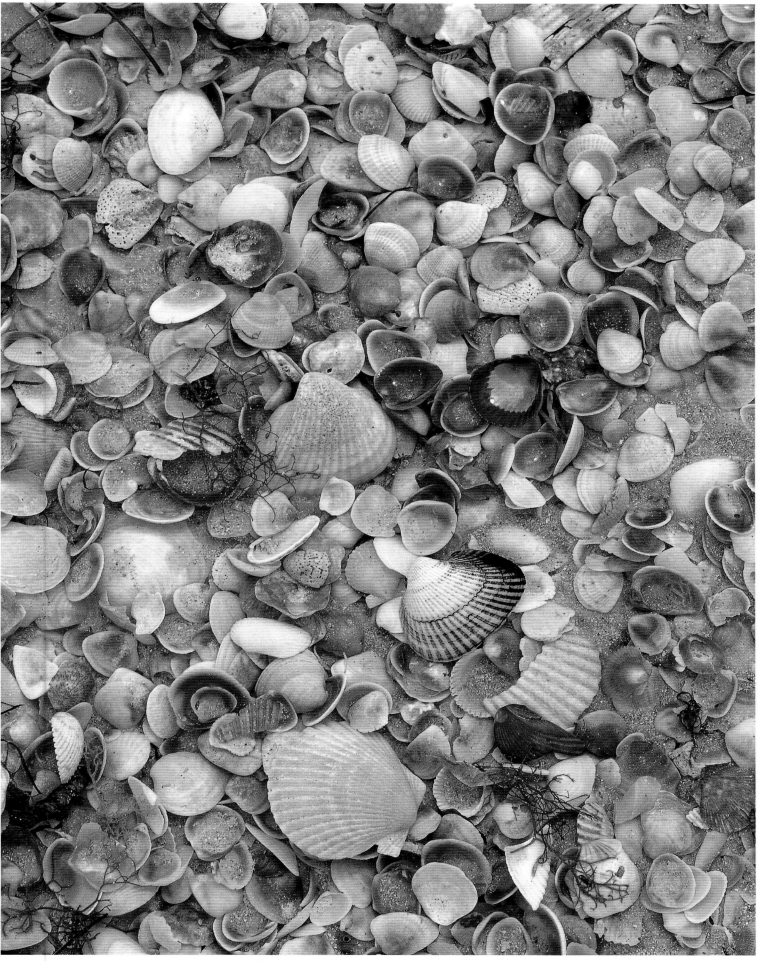

CLAM SHELLS, CALADESI ISLAND STATE PARK

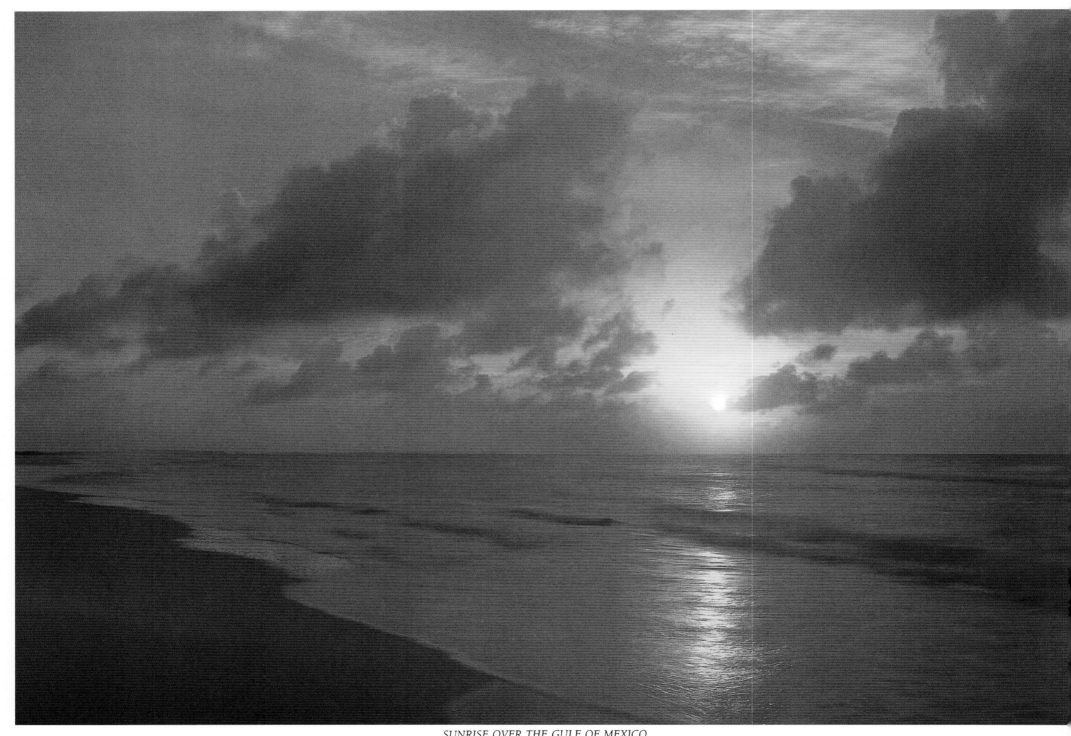

SUNRISE OVER THE GULF OF MEXICO,
ST. GEORGE ISLAND STATE PARK

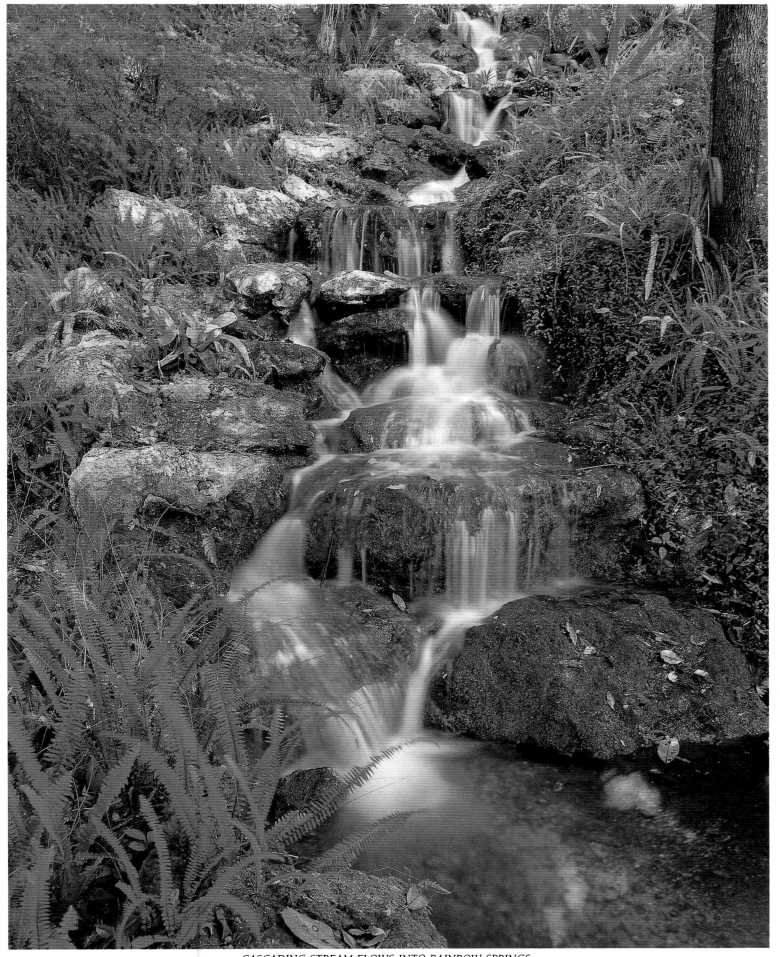

CASCADING STREAM FLOWS INTO RAINBOW SPRINGS,
RAINBOW SPRINGS STATE PARK NEAR DUNNELLON

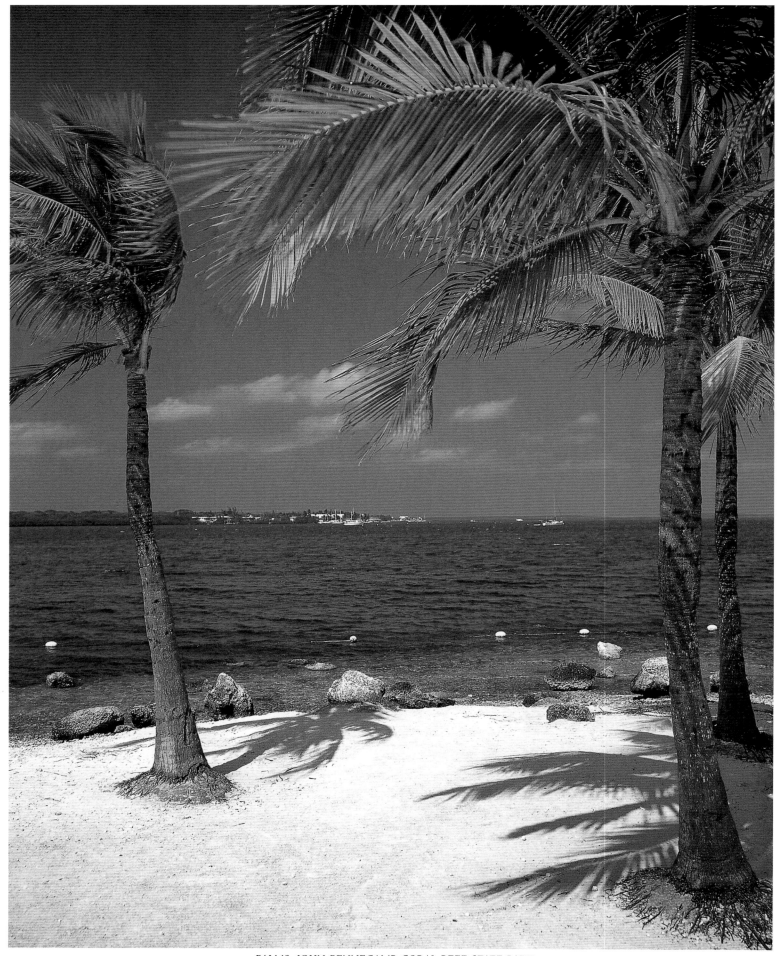

PALMS, JOHN PENNECAMP CORAL REEF STATE PARK

SEASHELL AMONG
SEA PURSLANE VINES,
CALADESI ISLAND STATE PARK

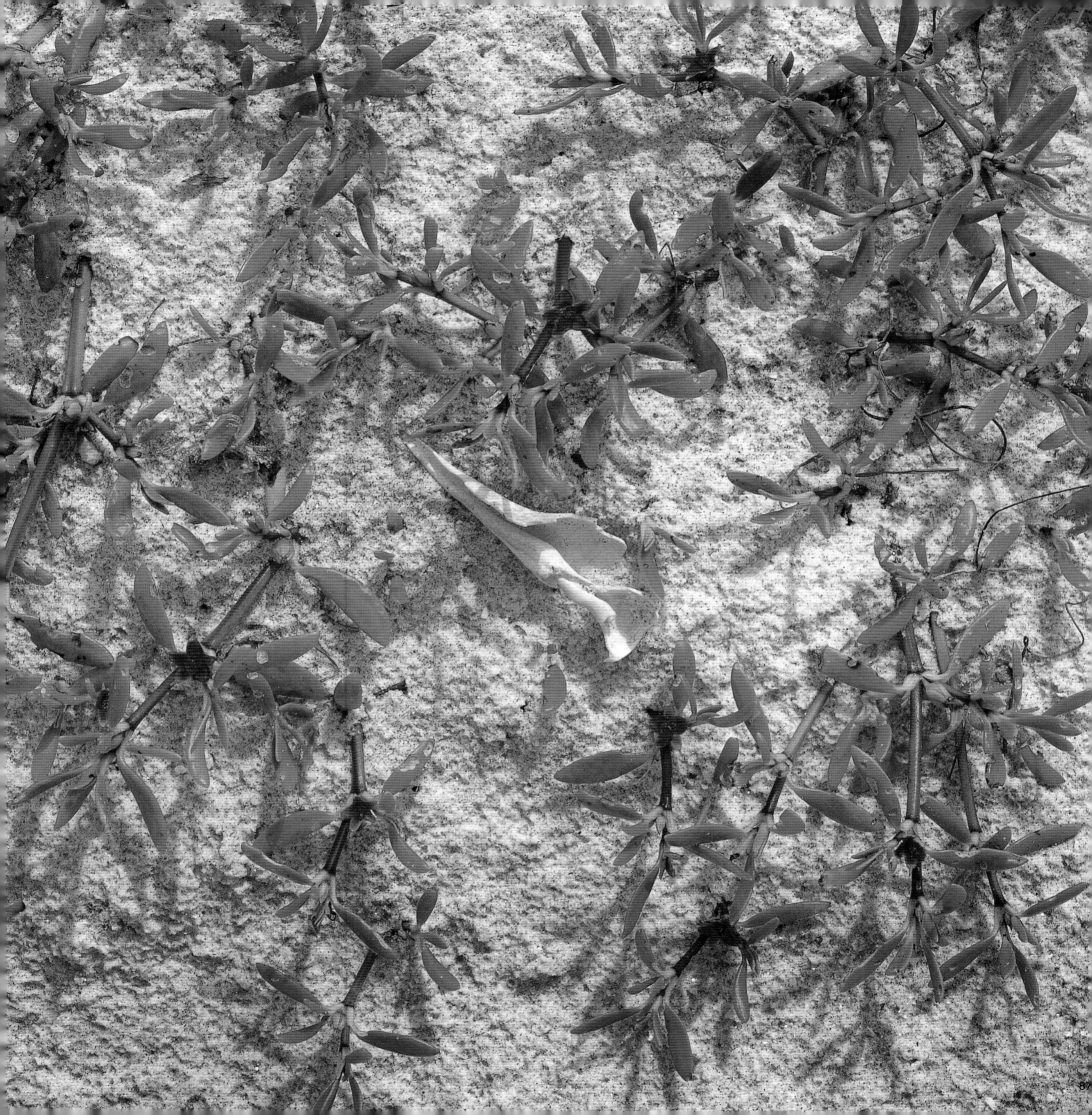

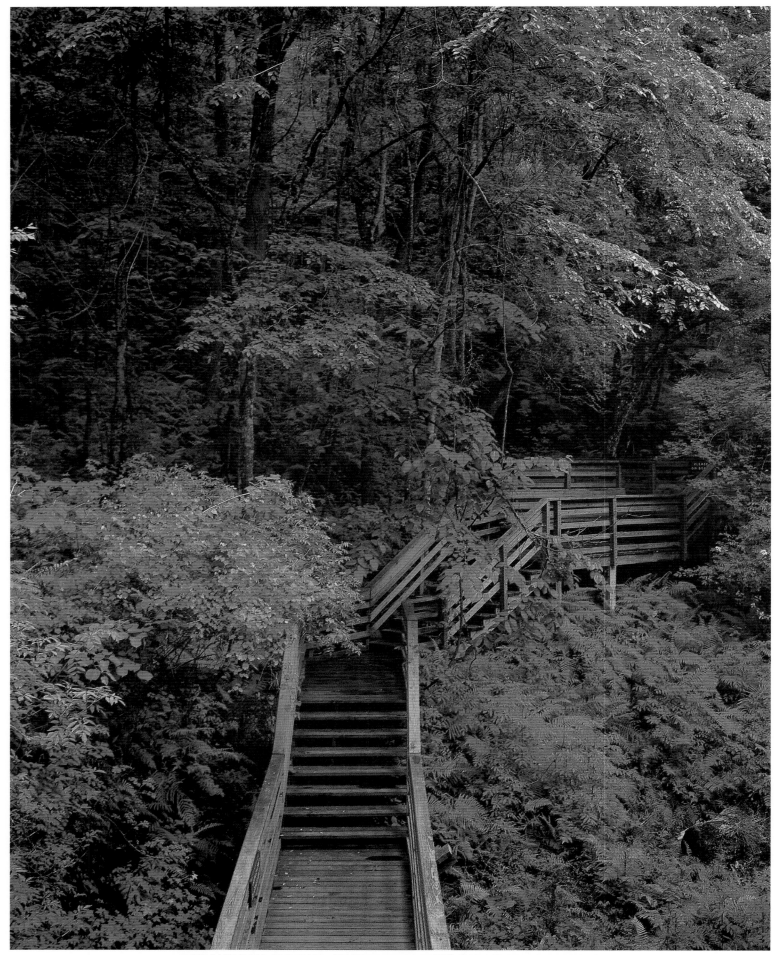

STAIRCASE INTO SINKHOLE COVERED WITH FERNS AND MIXED HARDWOODS,
DEVIL'S MILHOPPER STATE GEOLOGIC SITE

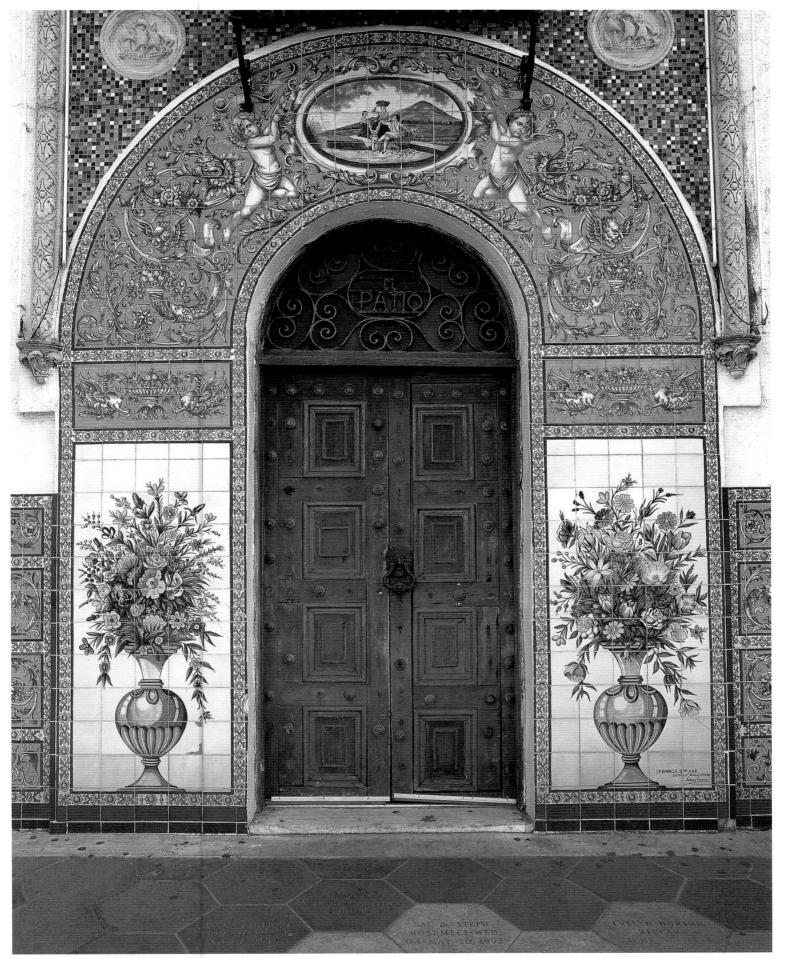

INTRICATE CERAMIC TILES DECORATE STOREFRONTS
OF OLD YBOR CITY, AN HISTORIC AREA OF TAMPA

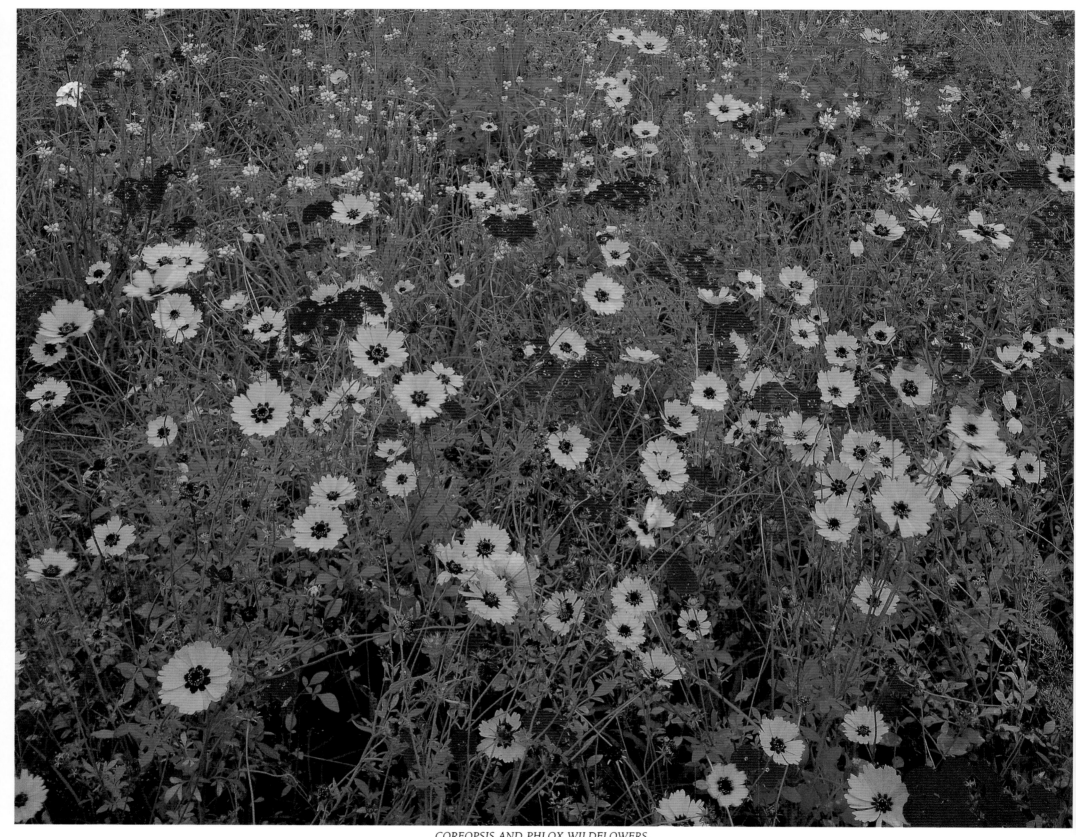

COREOPSIS AND PHLOX WILDFLOWERS,
HIGH SPRINGS

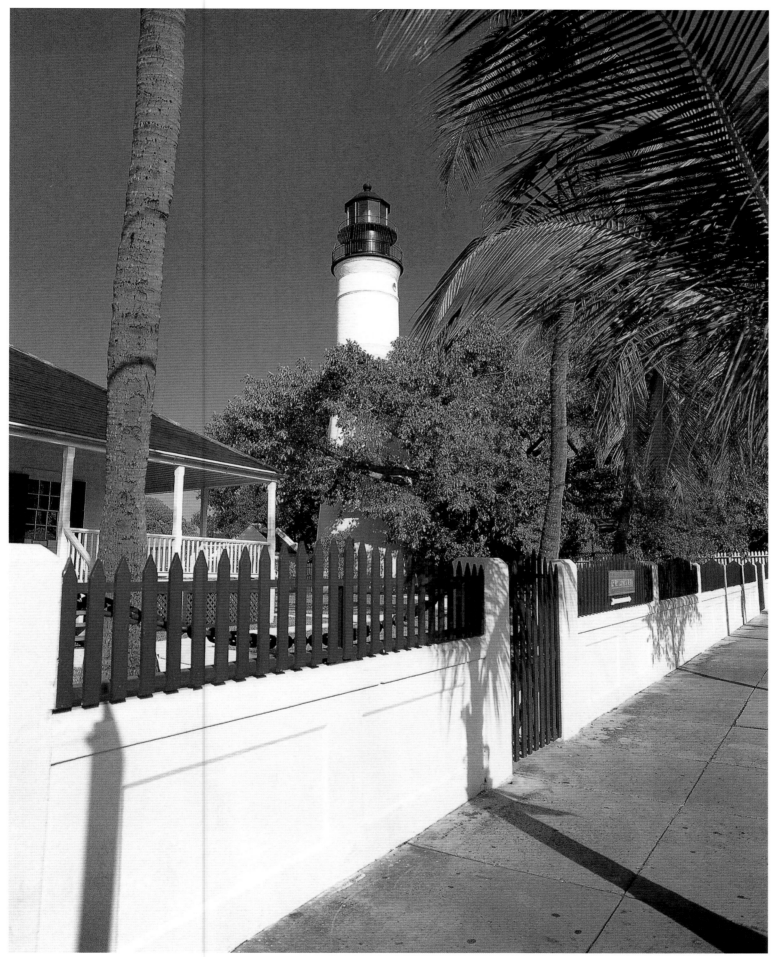

LIGHTHOUSE AND MUSEUM, KEY WEST

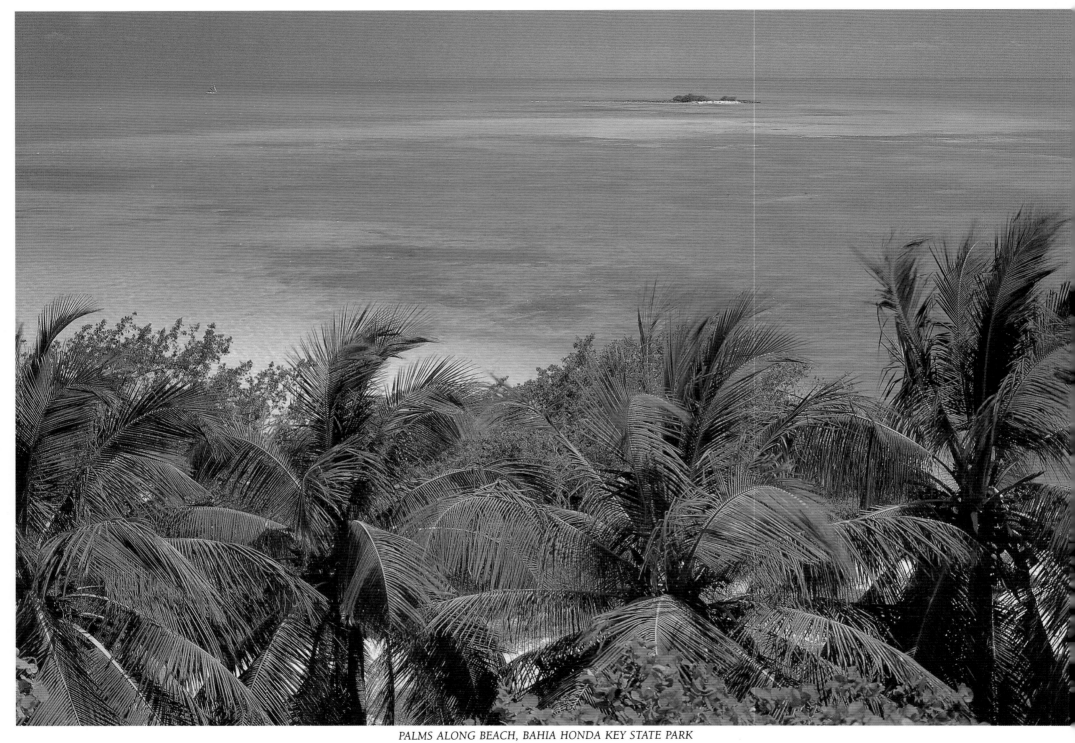

PALMS ALONG BEACH, BAHIA HONDA KEY STATE PARK

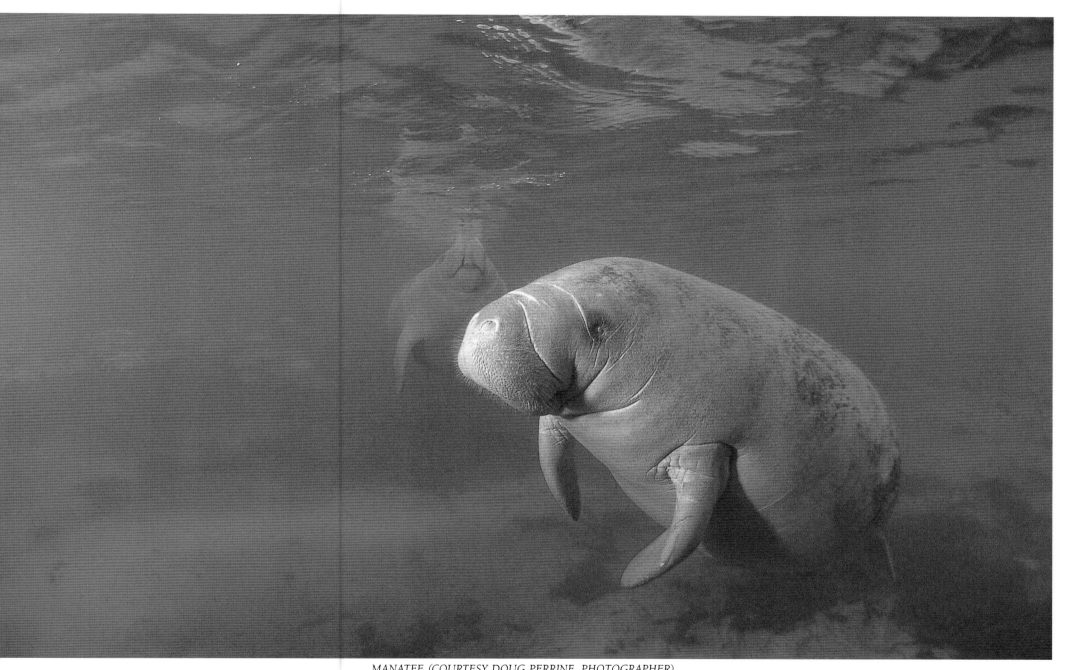

MANATEE (COURTESY DOUG PERRINE, PHOTOGRAPHER)

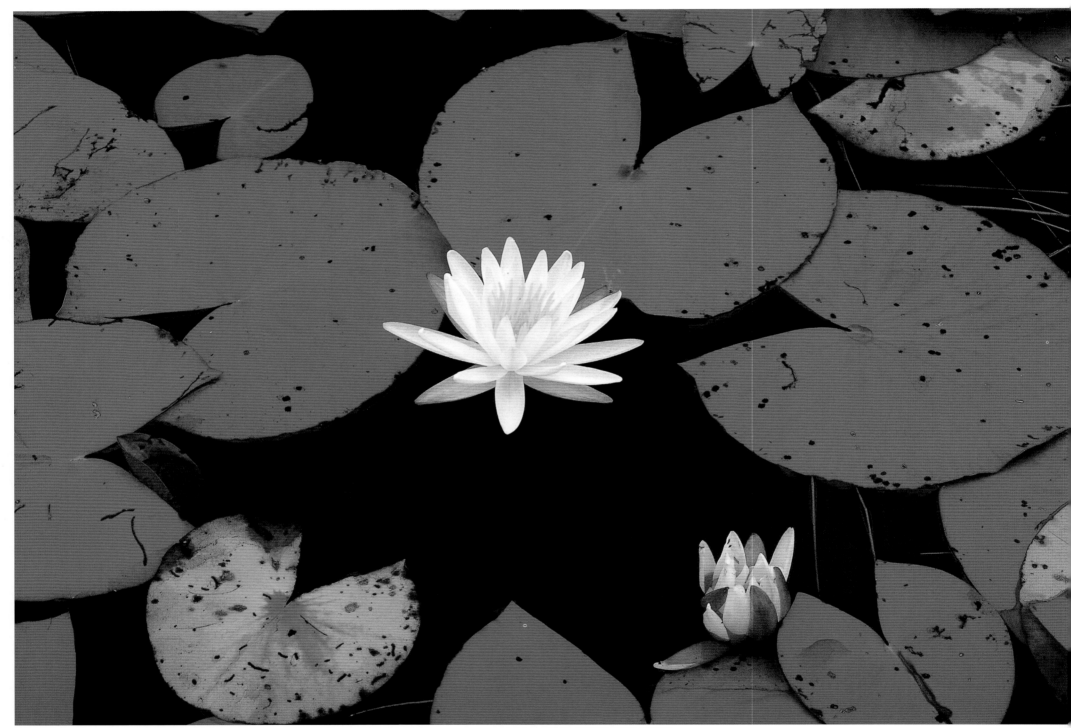

WATER LILY IN BLOOM NEAR SUWANNEE RIVER

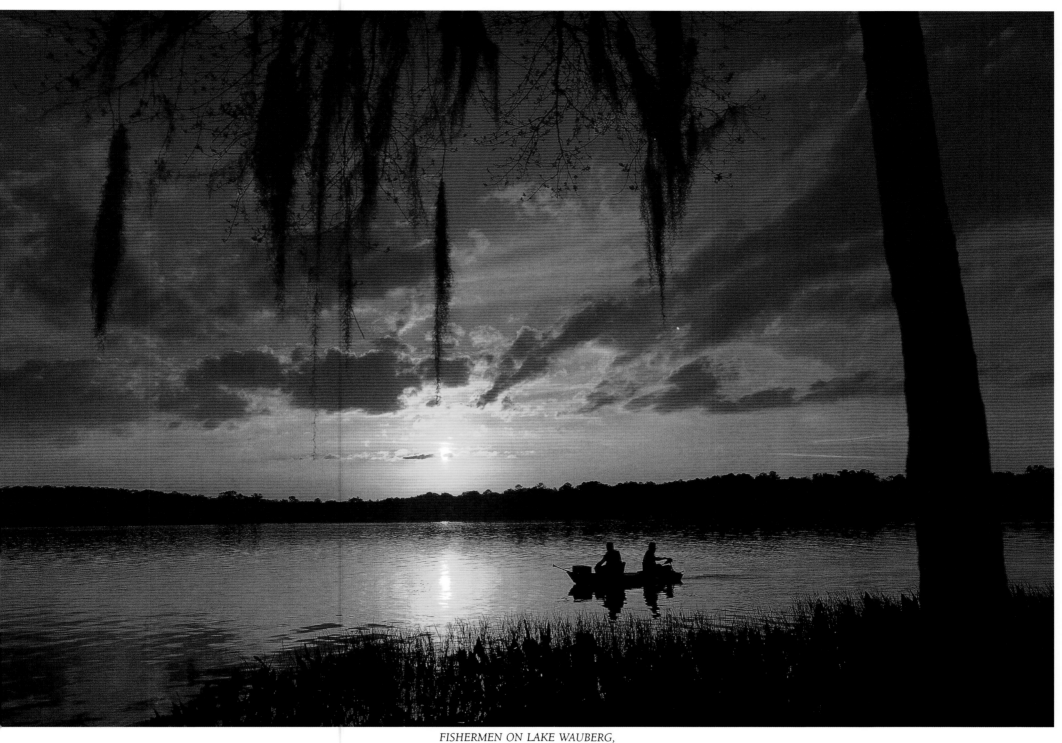

FISHERMEN ON LAKE WAUBERG,
PAYNES PRAIRIE STATE PRESERVE, GAINESVILLE

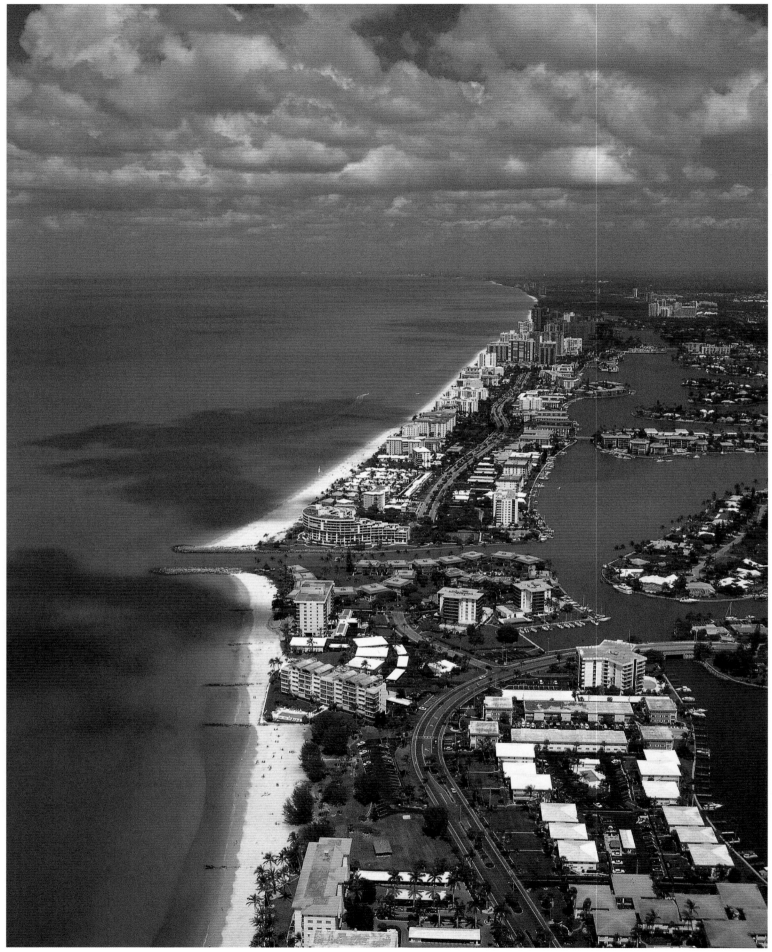

AERIAL VIEW OF FT. MYERS BEACHES AND THE GULF OF MEXICO COAST

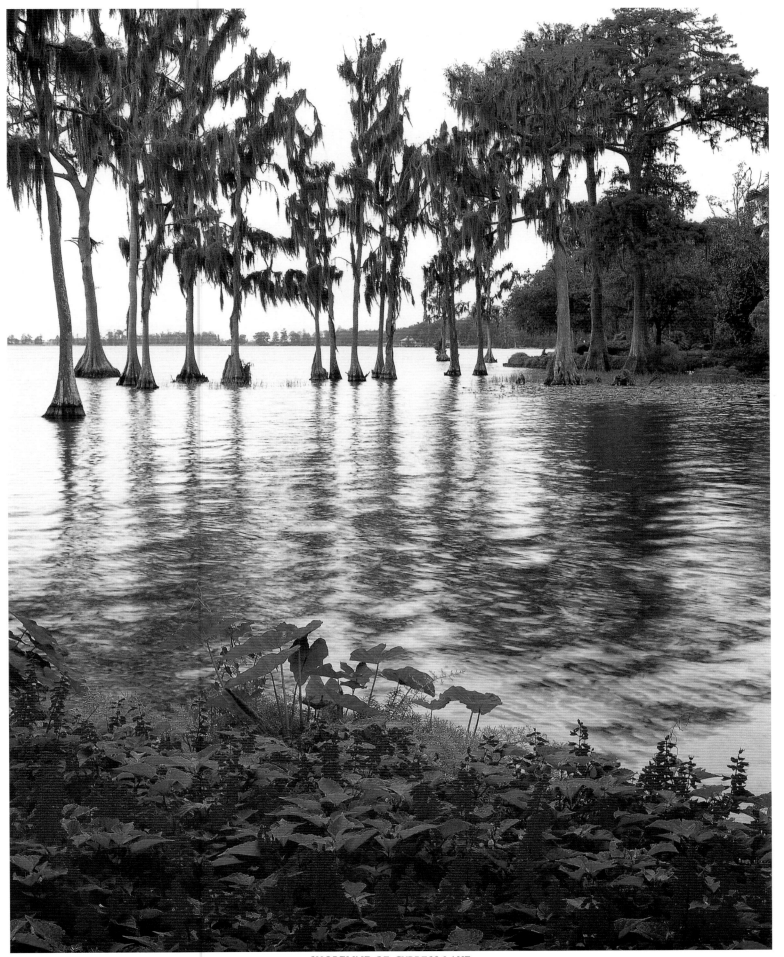

SHORELINE OF CYPRESS LAKE,
CYPRESS GARDENS, WINTER HAVEN

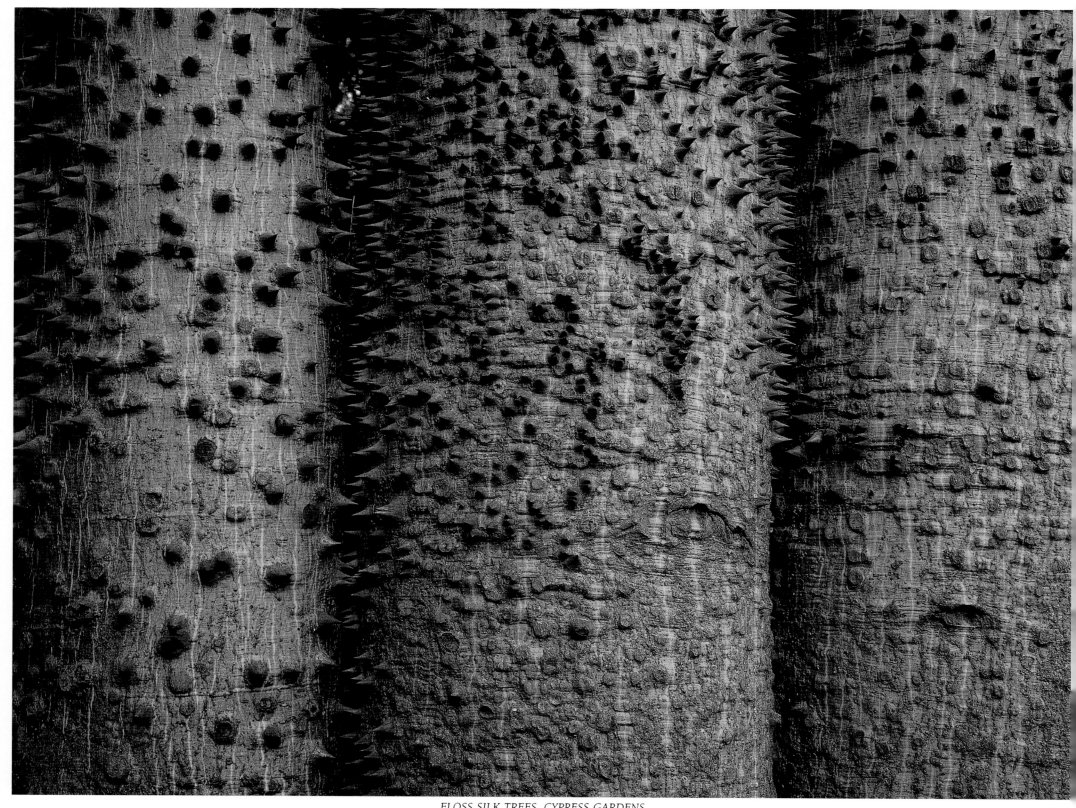

FLOSS SILK TREES, CYPRESS GARDENS

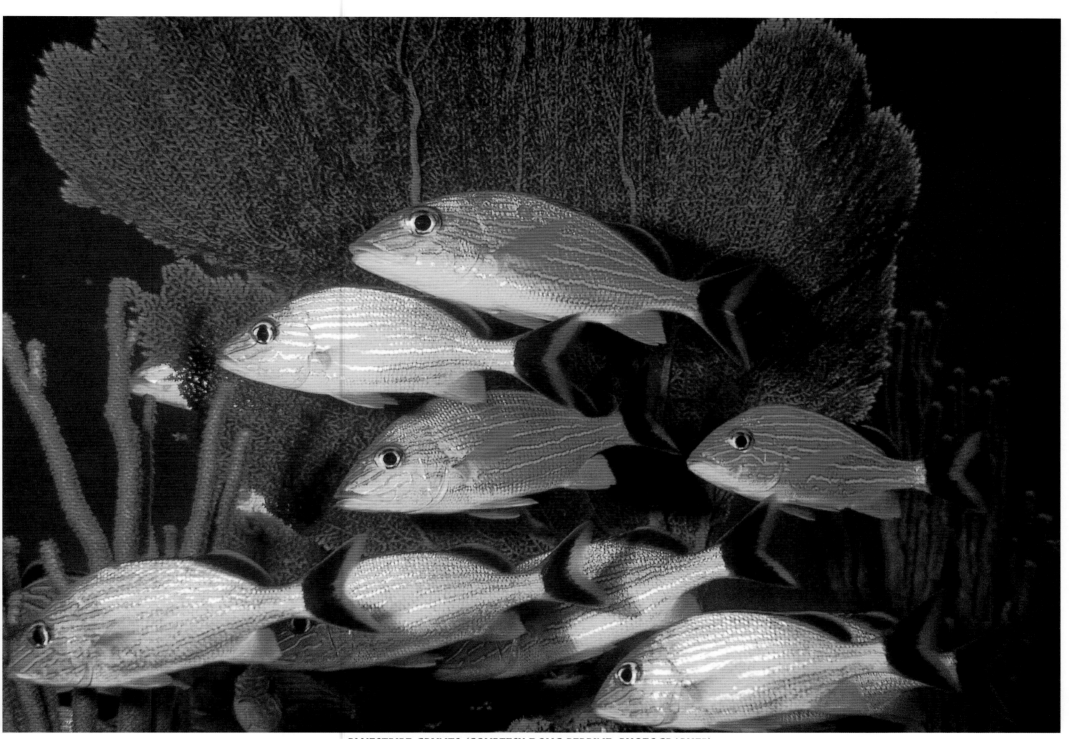

BLUESTRIPE GRUNTS (COURTESY DOUG PERRINE, PHOTOGRAPHER)

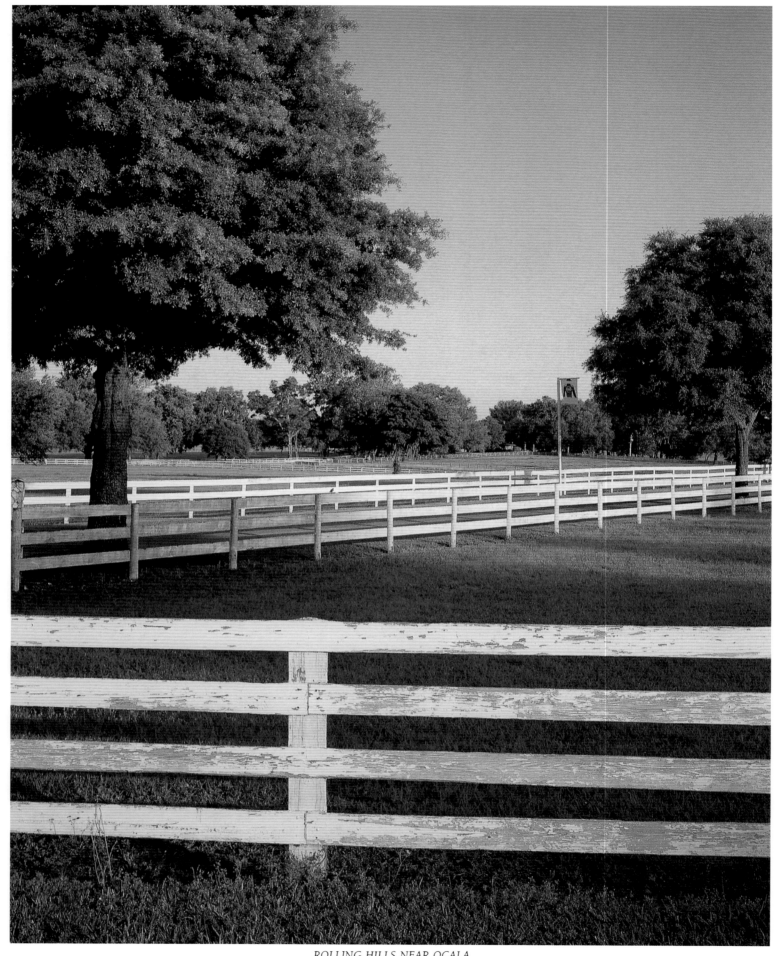

ROLLING HILLS NEAR OCALA

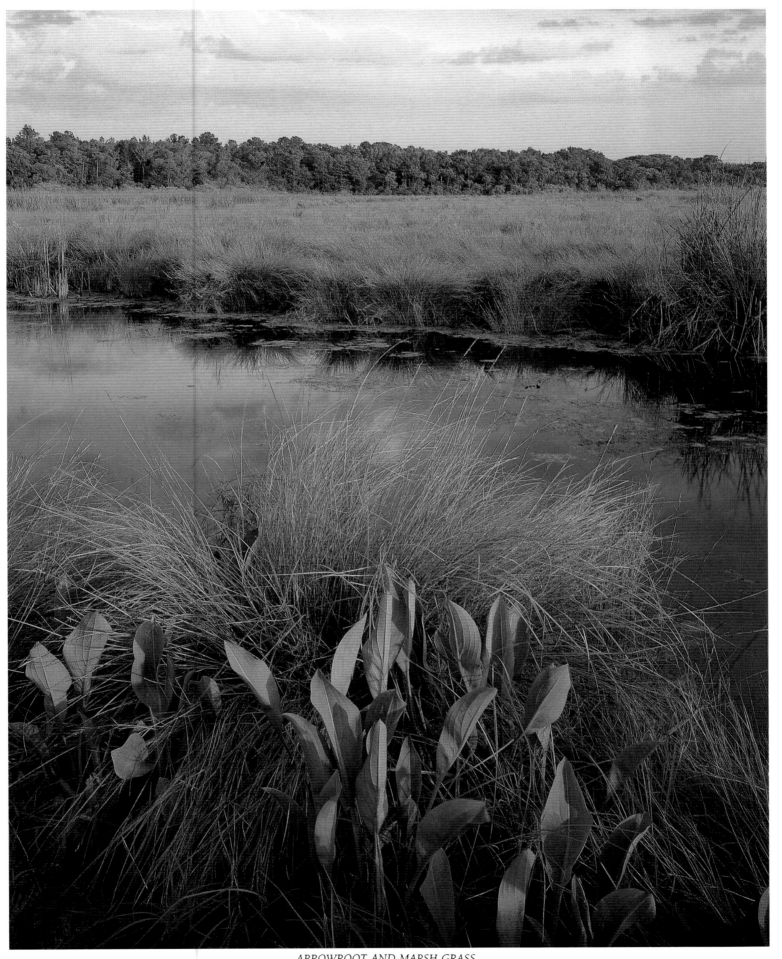

ARROWROOT AND MARSH GRASS,
LAKE WOODRUFF NATIONAL WILDLIFE REFUGE

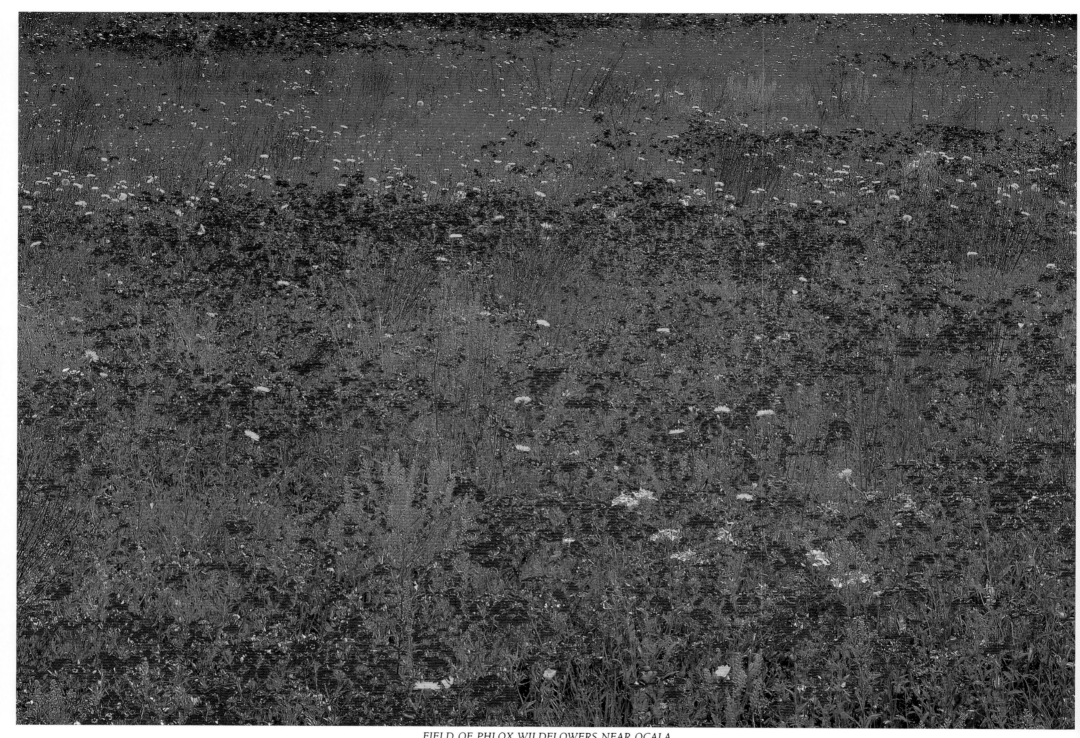

FIELD OF PHLOX WILDFLOWERS NEAR OCALA

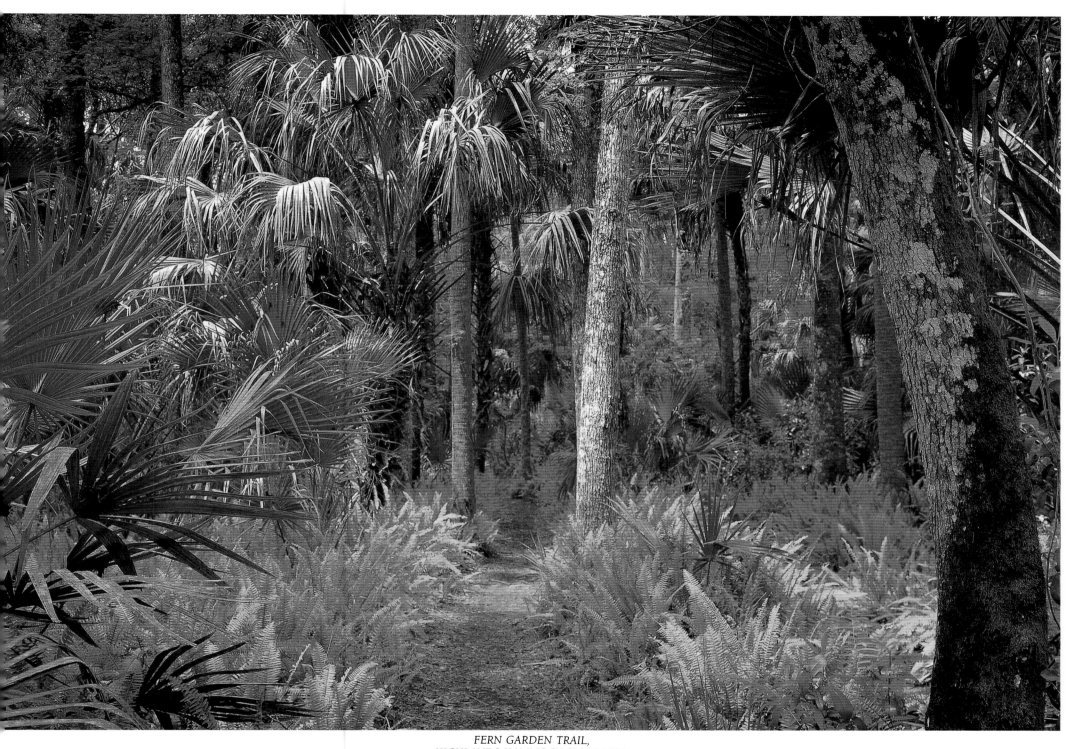

FERN GARDEN TRAIL,
HIGHLANDS HAMMOCK STATE PARK

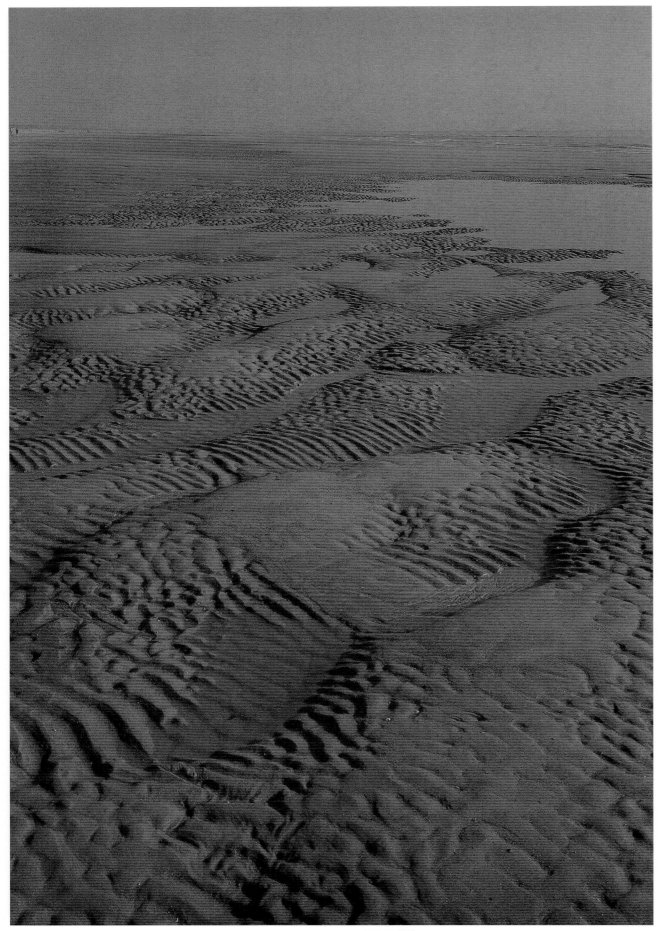

SAND PATTERNS IN TIDE FLATS,
ANASTASIA BEACH, ANASTASIA STATE RECREATION AREA

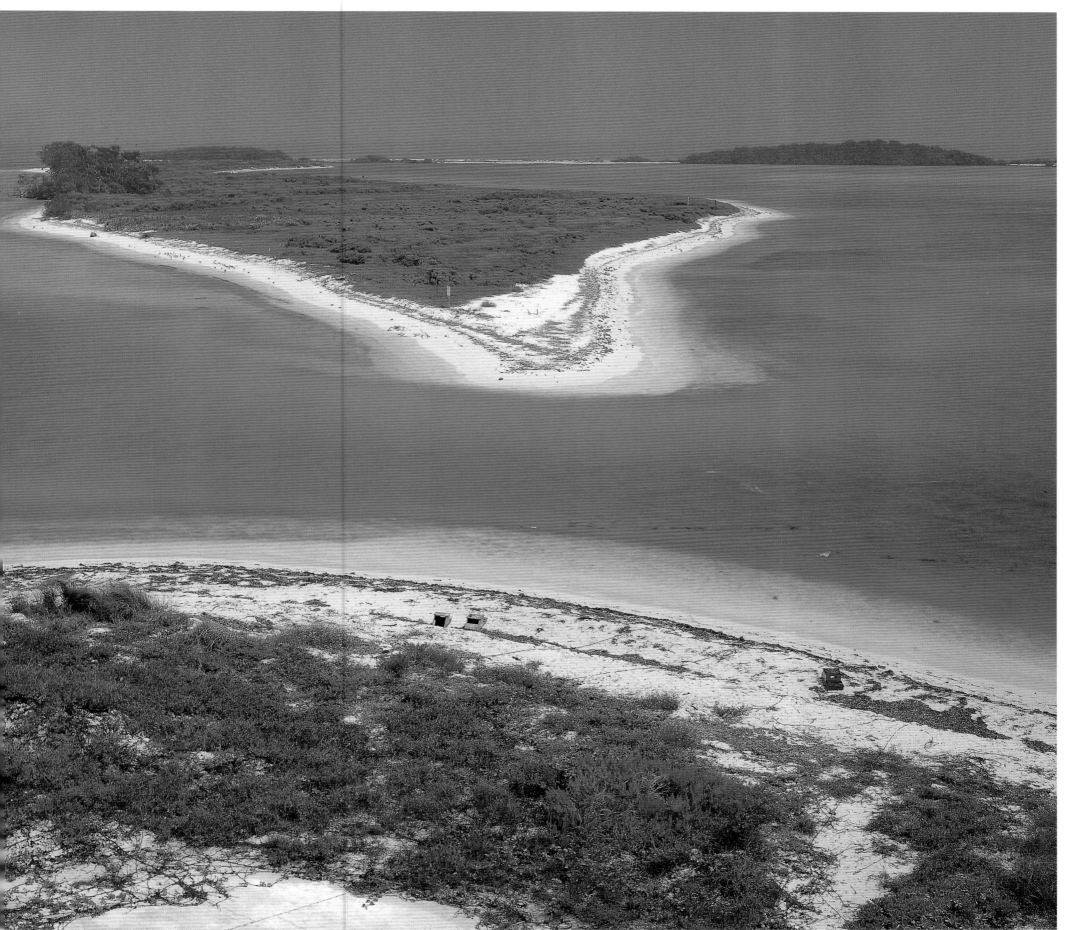

BUSH KEY, DRY TORTUGAS NATIONAL PARK

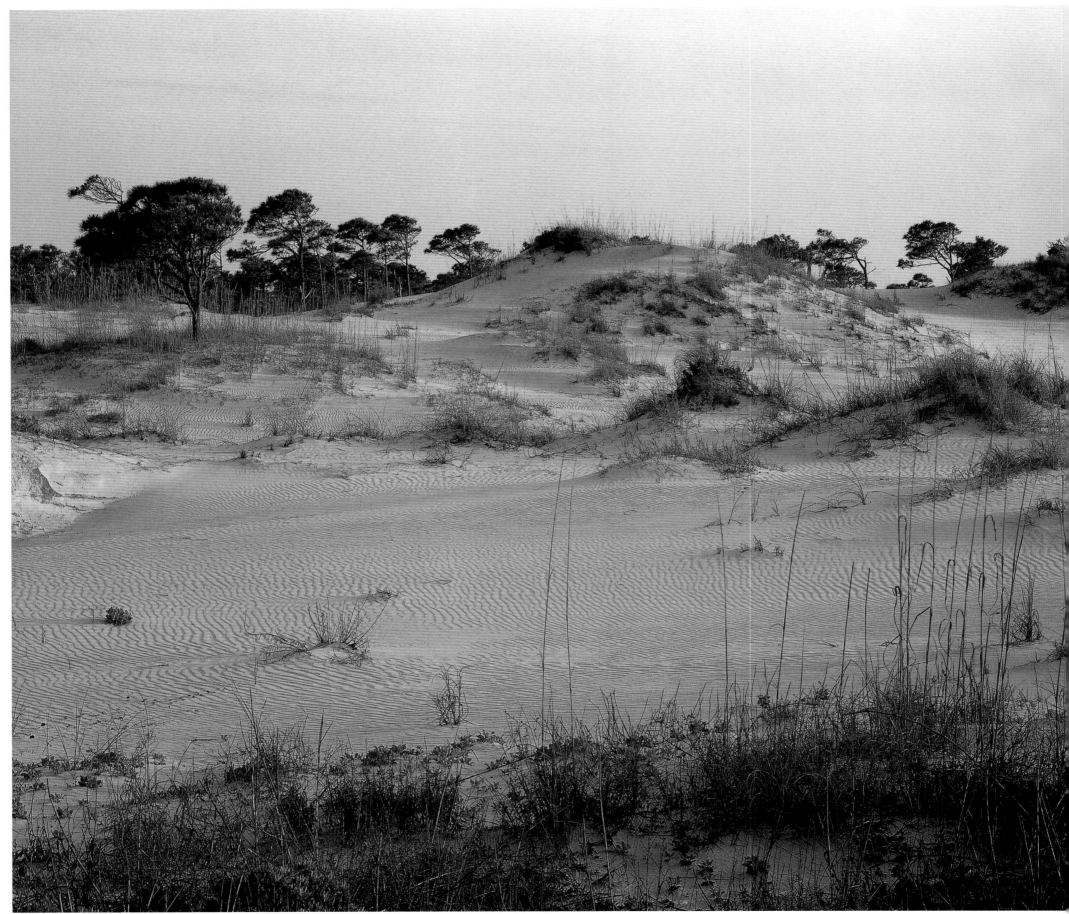

PELICANS, FARO BLANCO LIGHTHOUSE AREA, MARATHON KEY

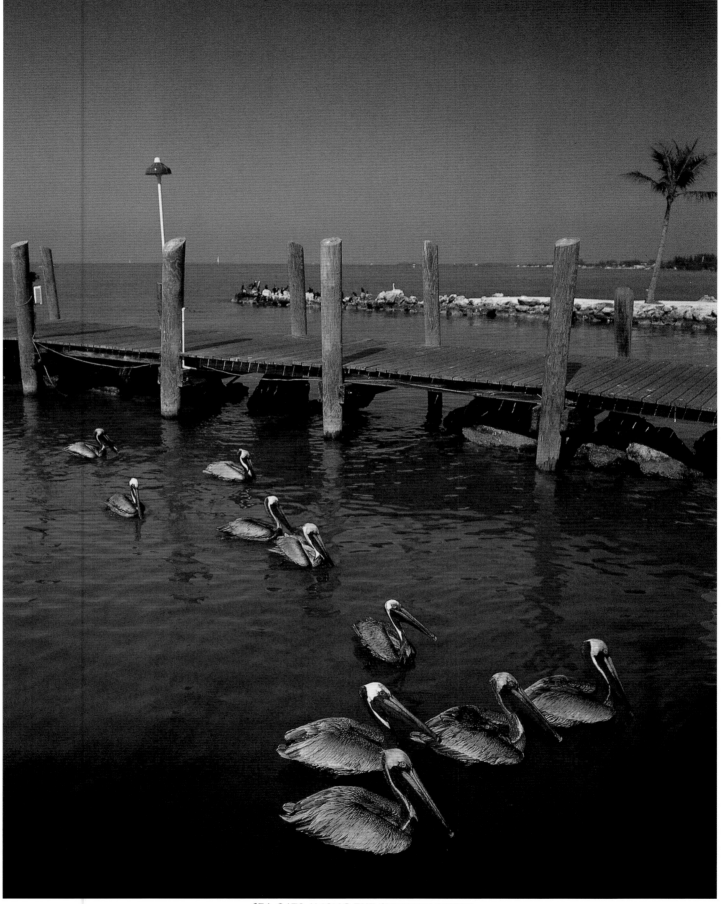

SEA OATS AMONG THE SHIFTING DUNES,
ST. GEORGE ISLAND STATE PARK

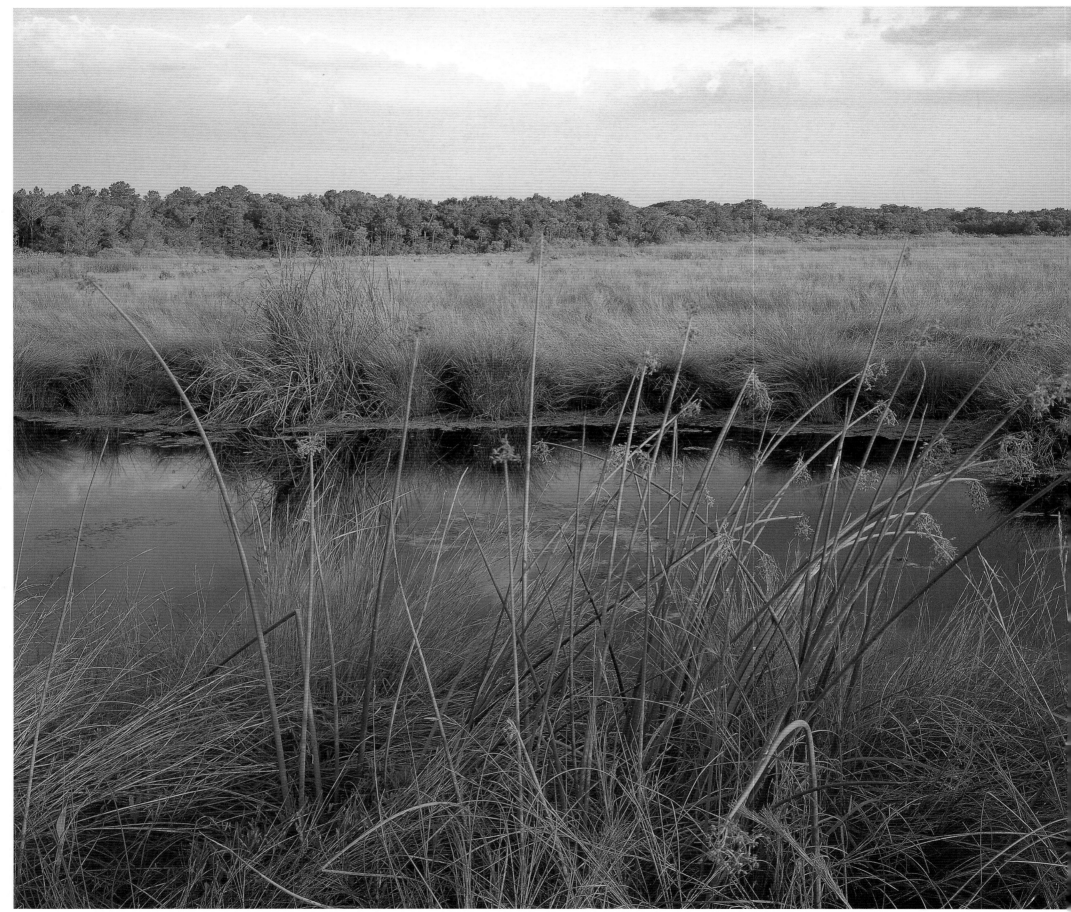

RUSH GRASS ALONG CHANNEL OF LAKE WOODRUFF NATIONAL WILDLIFE REFUGE

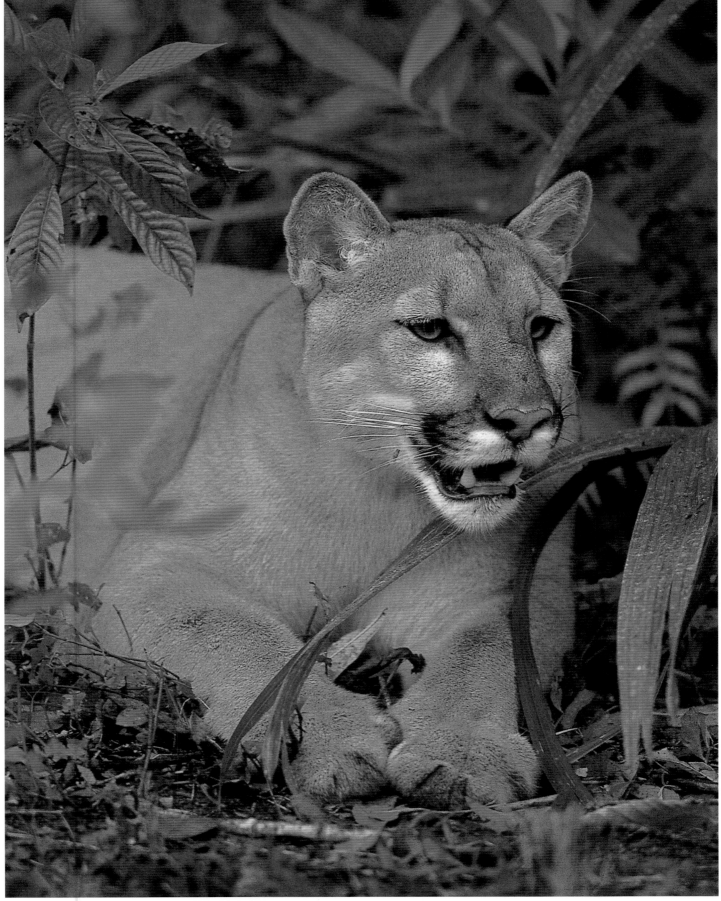

FLORIDA PANTHER (COURTESY ART WOLFE, PHOTOGRAPHER)

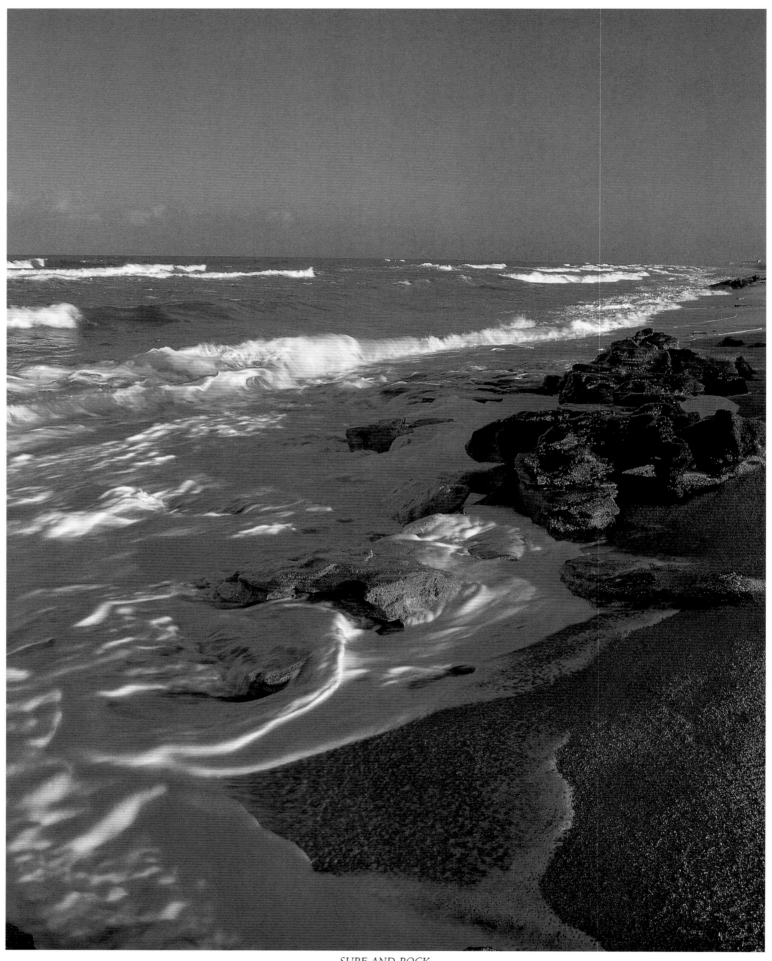

SURF AND ROCK,
WASHINGTON OAKS GARDENS STATE PARK

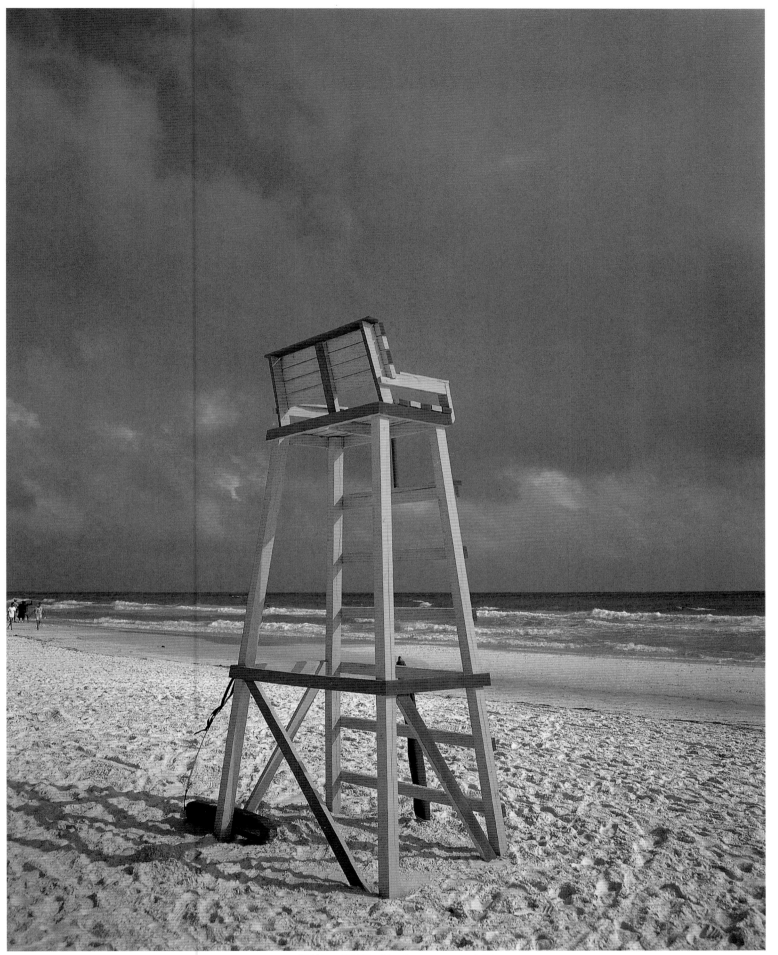

LIFEGUARD CHAIR, PANAMA CITY BEACH,
GULF OF MEXICO

SEA GRAPE CHANGING COLORS, LONG KEY

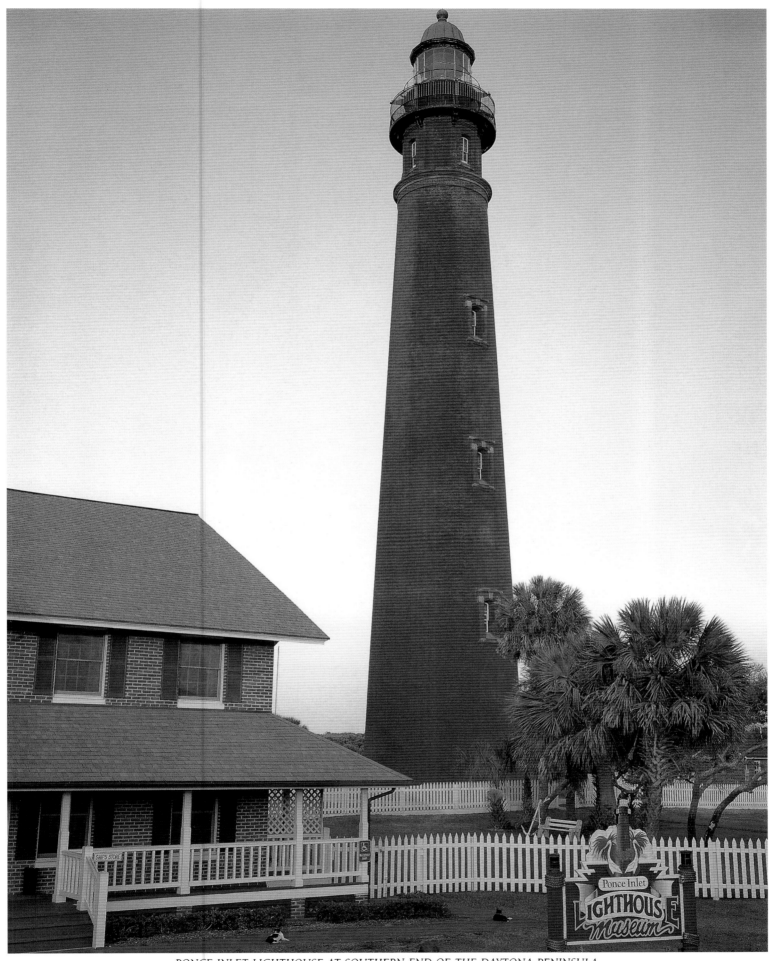

PONCE INLET LIGHTHOUSE AT SOUTHERN END OF THE DAYTONA PENINSULA

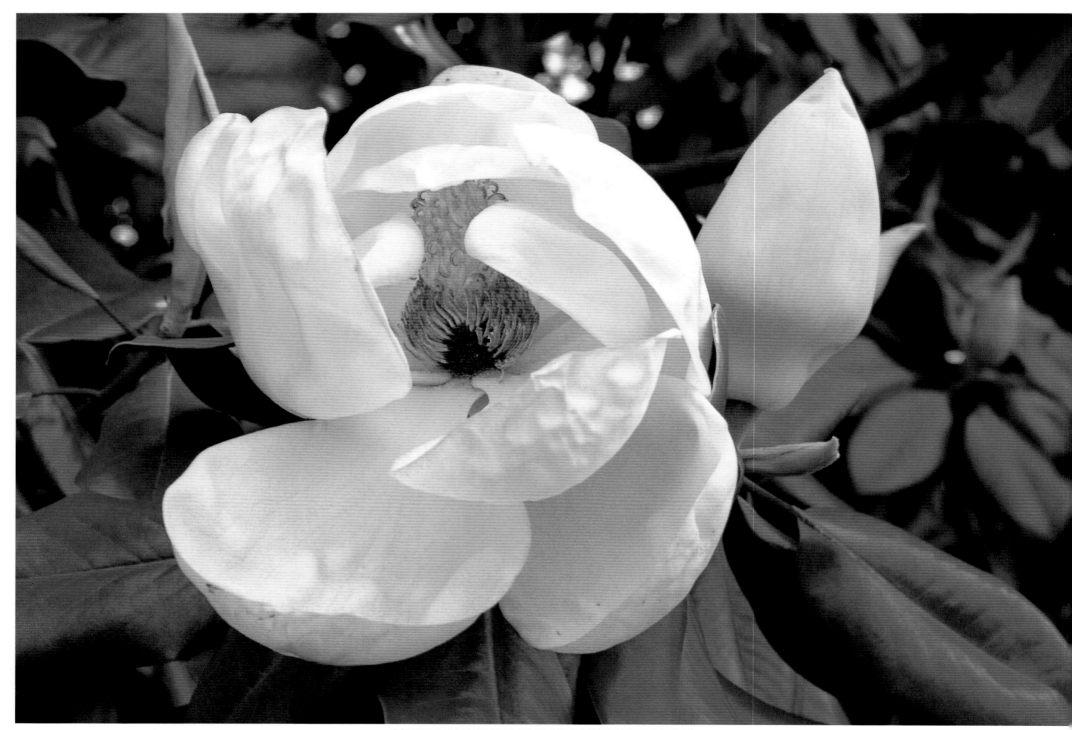

SOUTHERN MAGNOLIA IN BLOOM, NEAR JACKSONVILLE

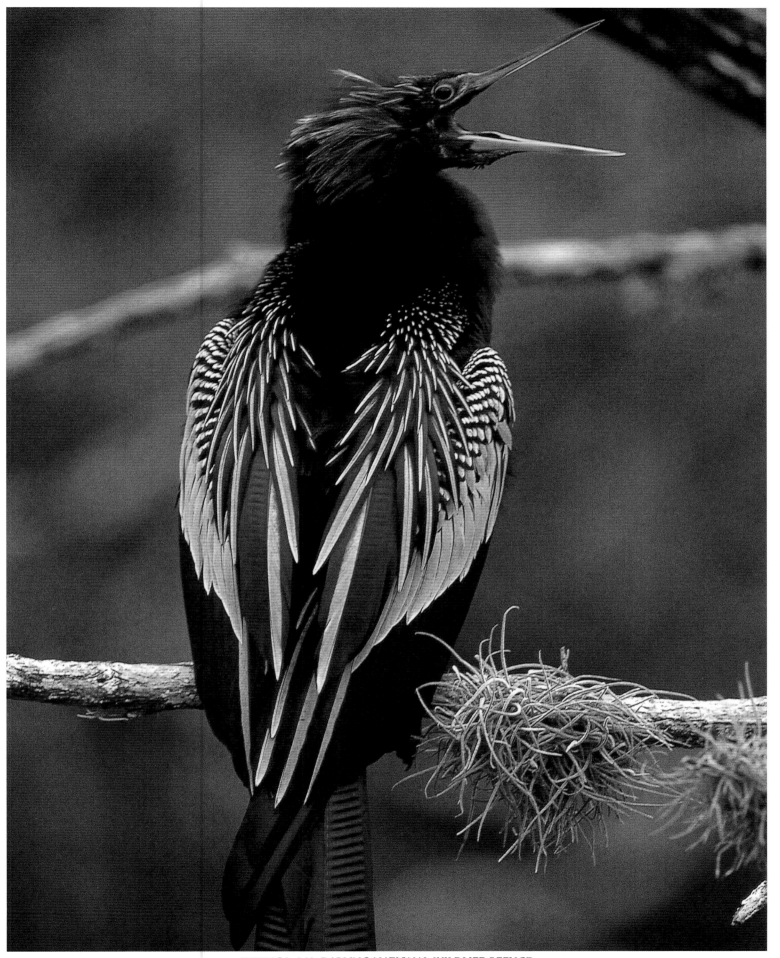

ANHINGA, J.N. DARLING NATIONAL WILDLIFE REFUGE,
SANIBEL ISLAND

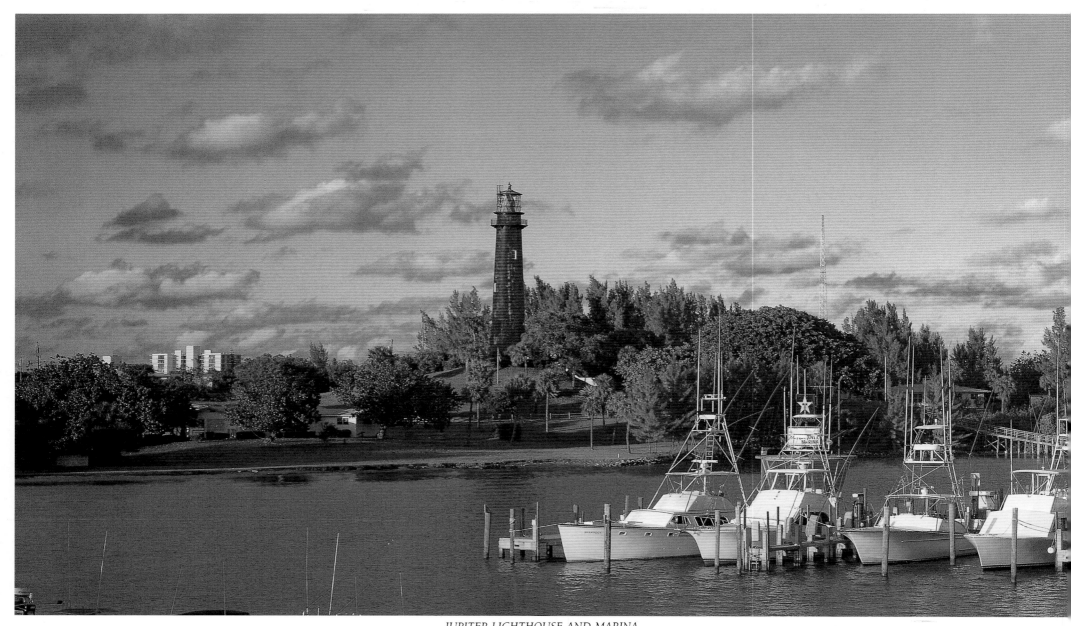

JUPITER LIGHTHOUSE AND MARINA,
THE LOXAHATCHEE RIVER, JUPITER

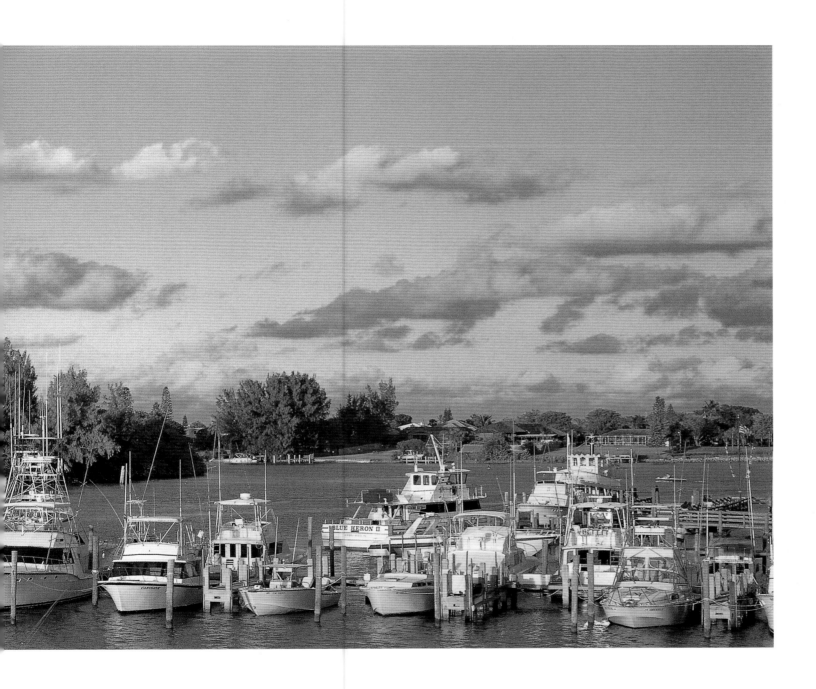

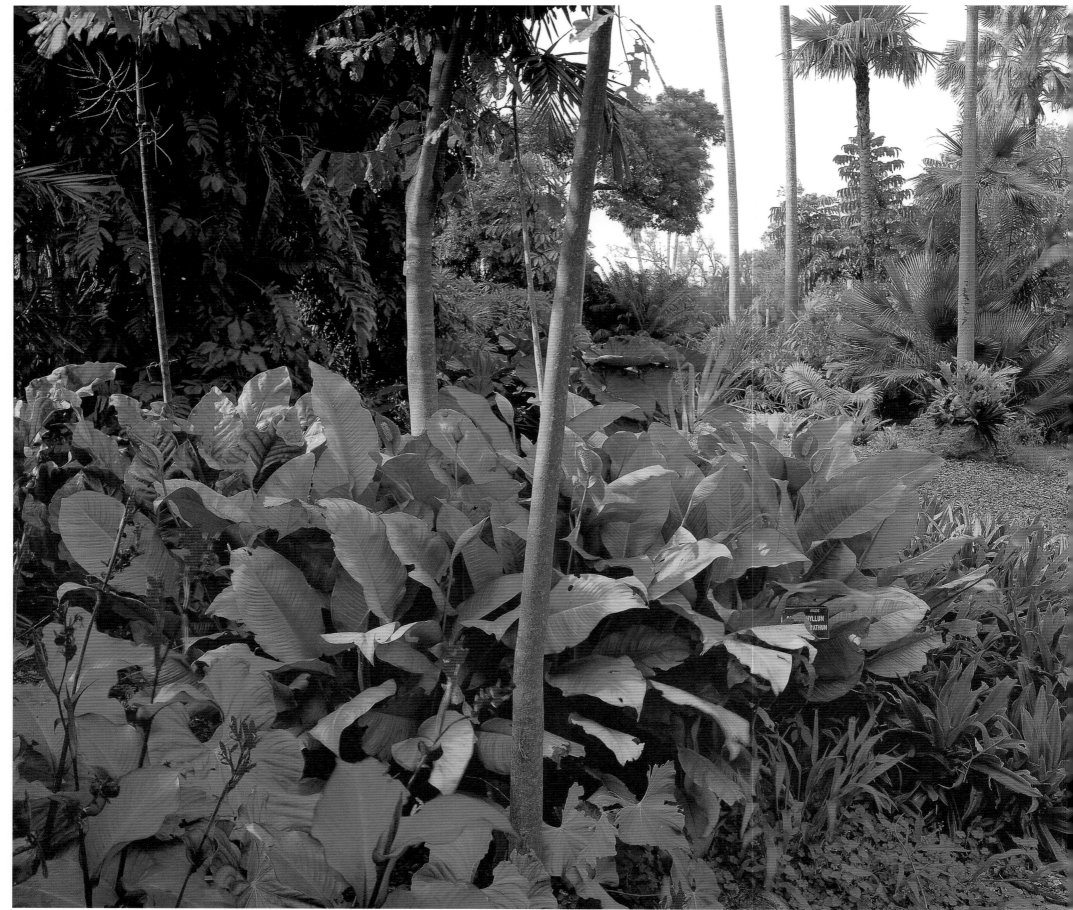

FAIRCHILD TROPICAL GARDENS, MIAMI

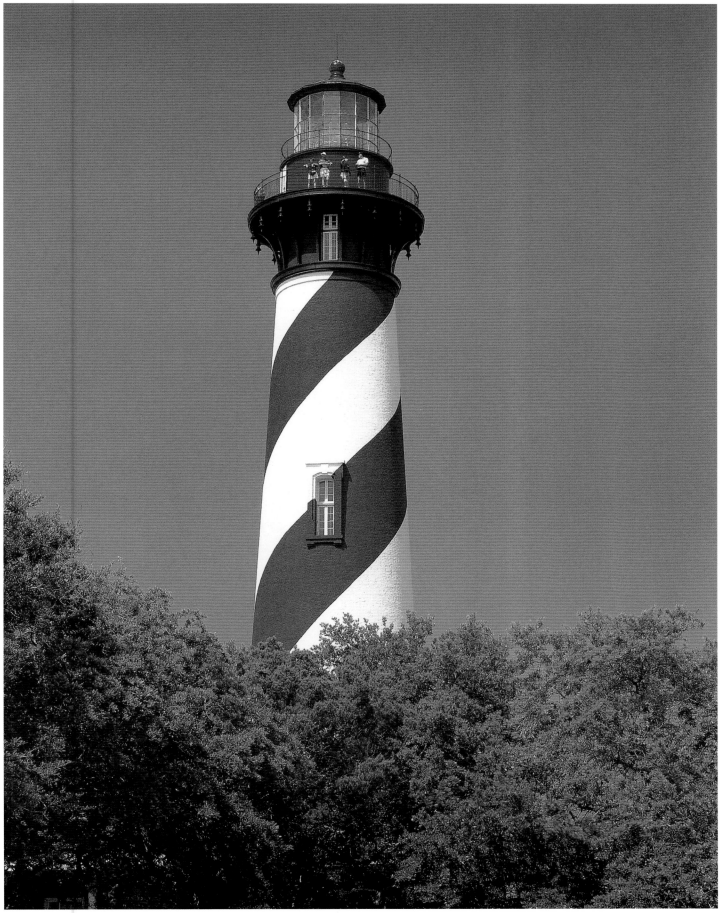

ST. AUGUSTINE LIGHTHOUSE, ST. AUGUSTINE

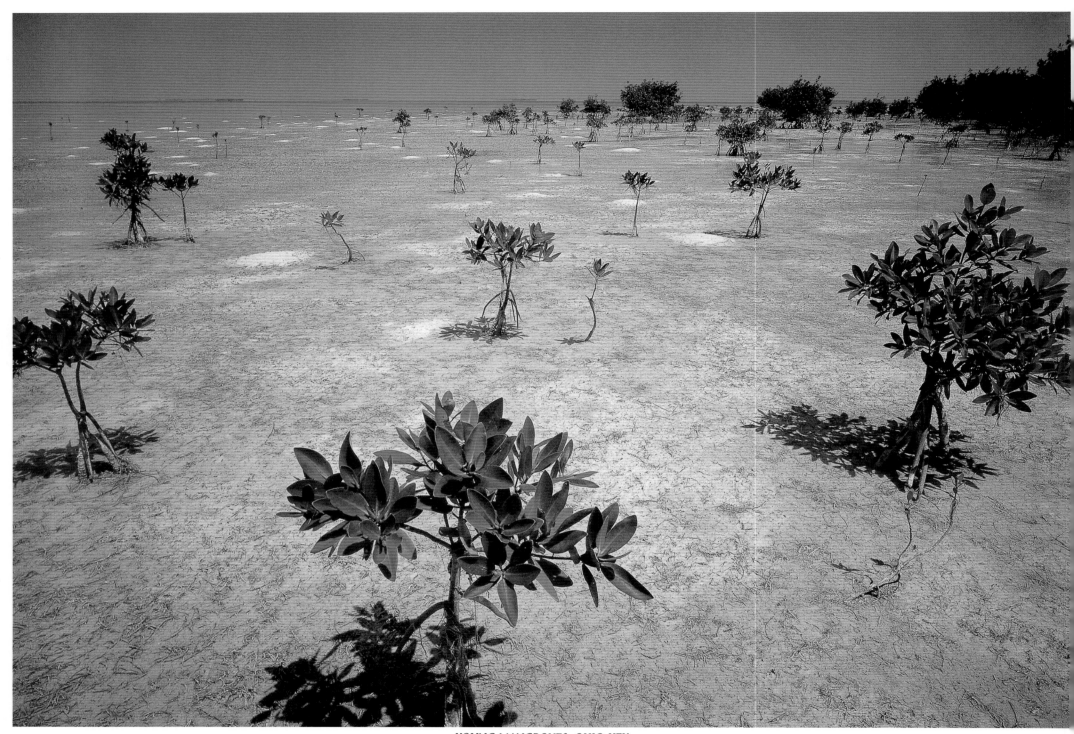

YOUNG MANGROVES, OHIO KEY

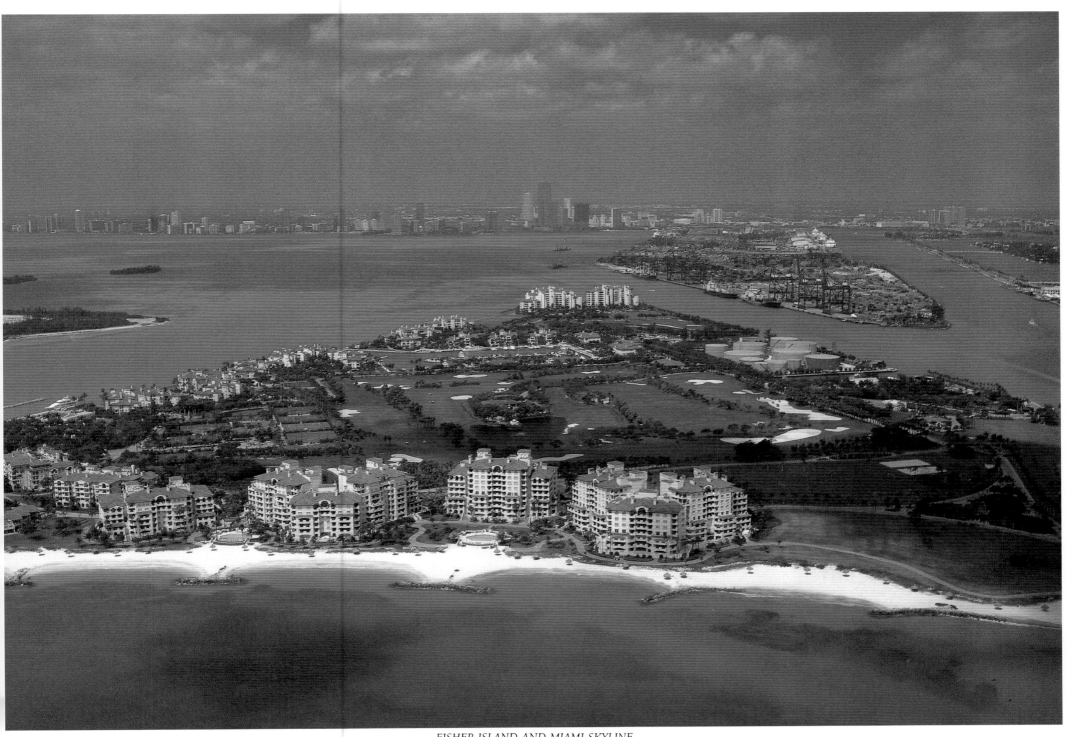

FISHER ISLAND AND MIAMI SKYLINE

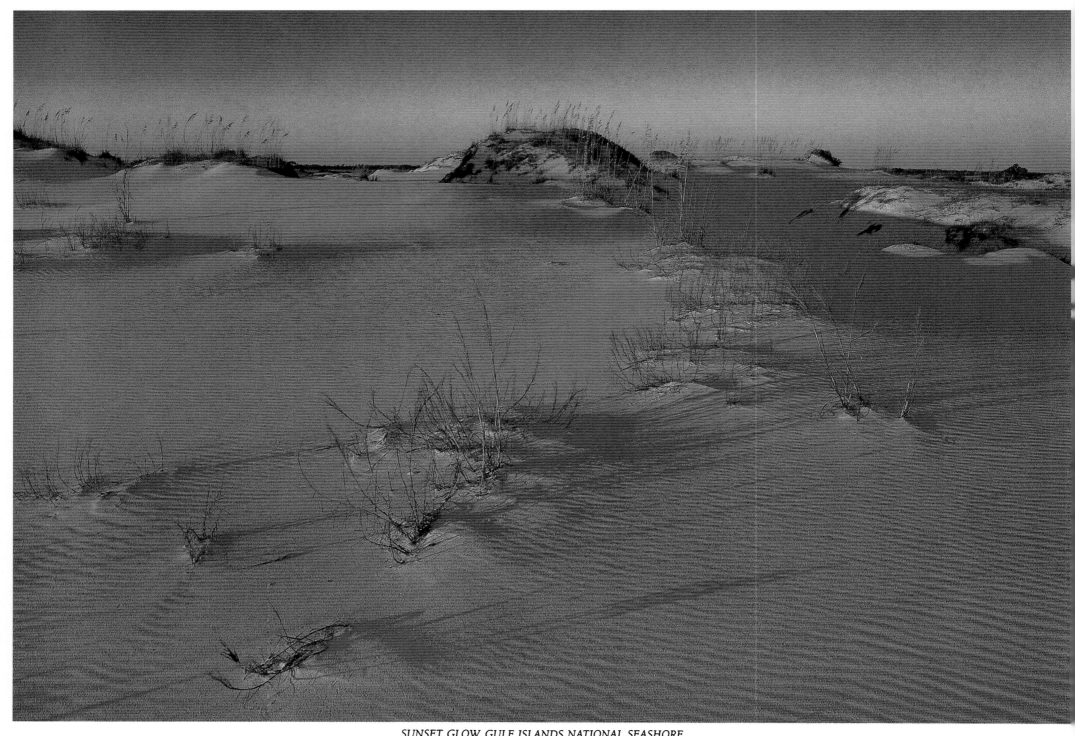

SUNSET GLOW, GULF ISLANDS NATIONAL SEASHORE

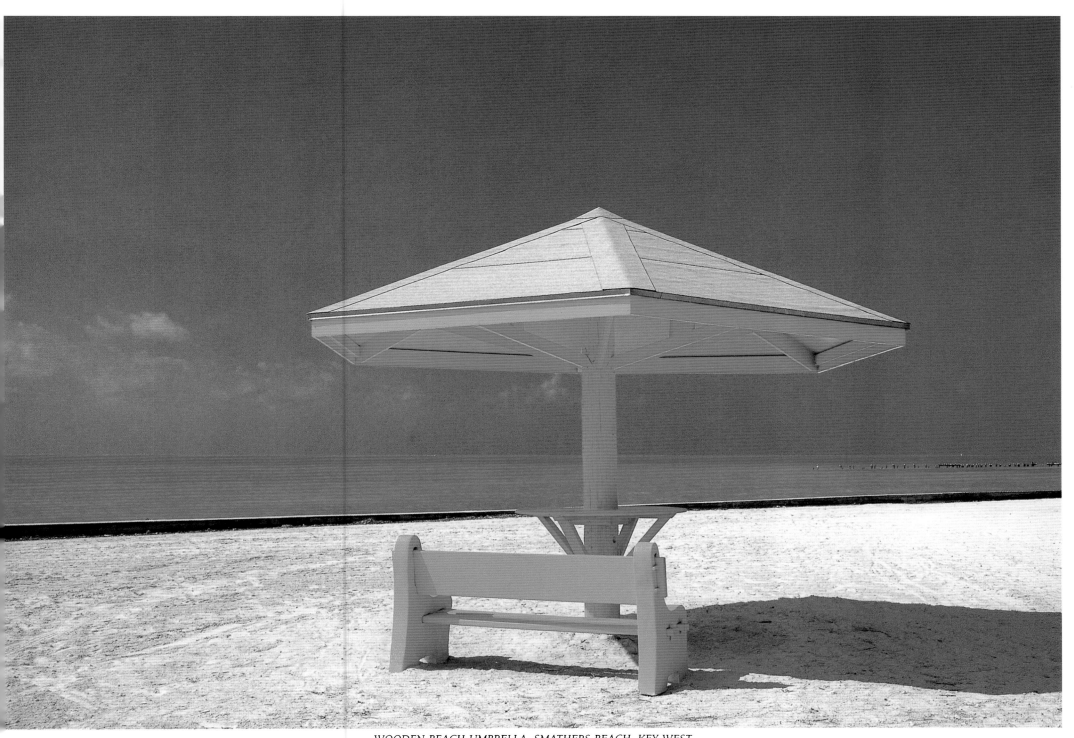

WOODEN BEACH UMBRELLA, SMATHERS BEACH, KEY WEST

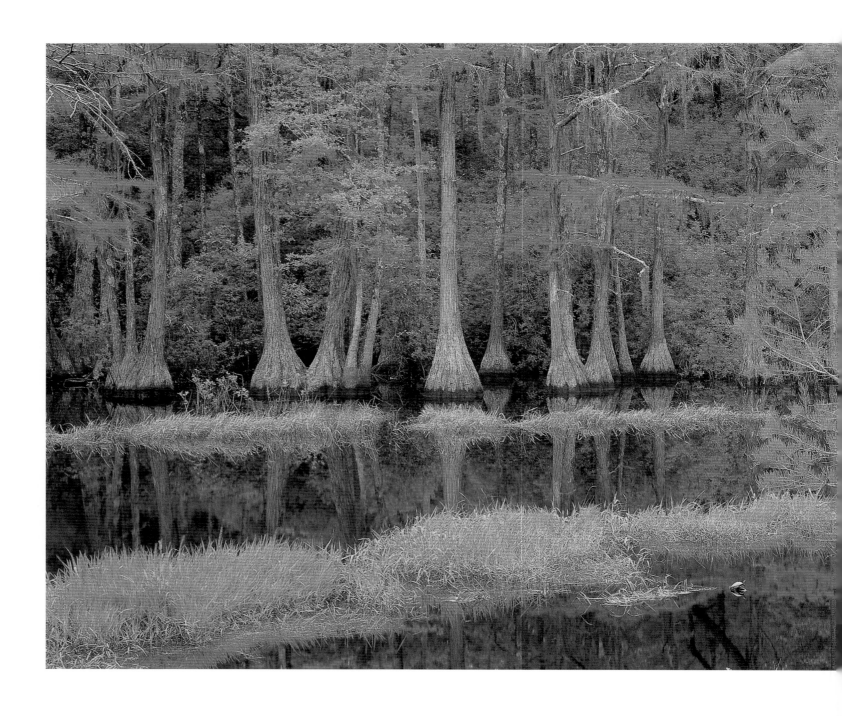

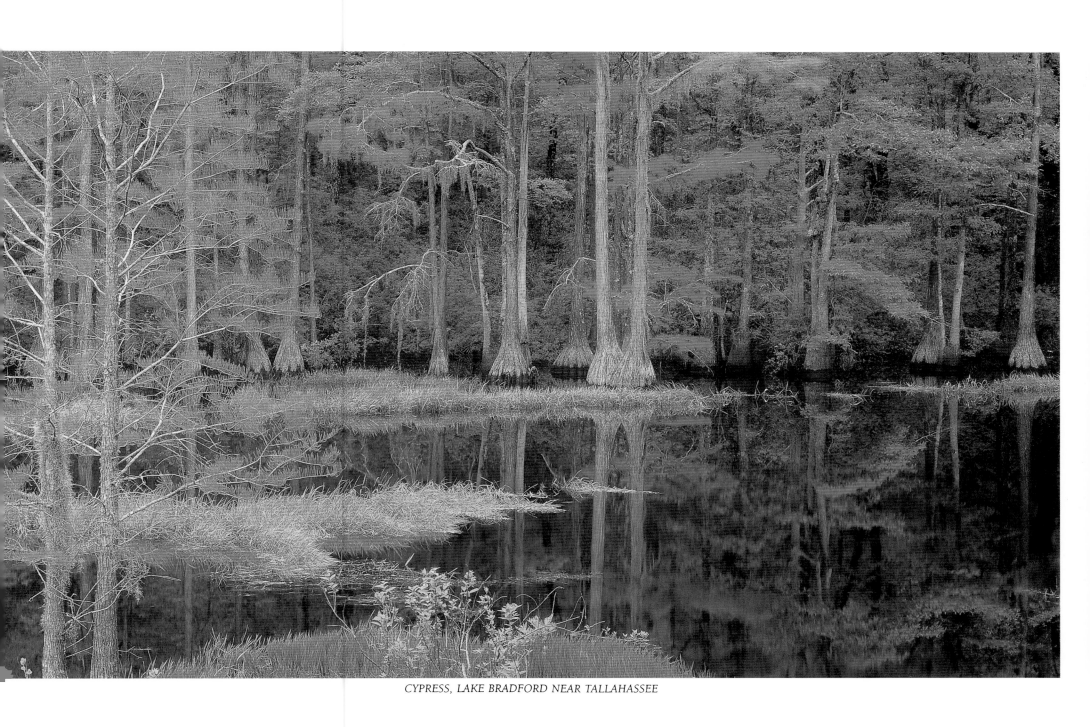

CYPRESS, LAKE BRADFORD NEAR TALLAHASSEE

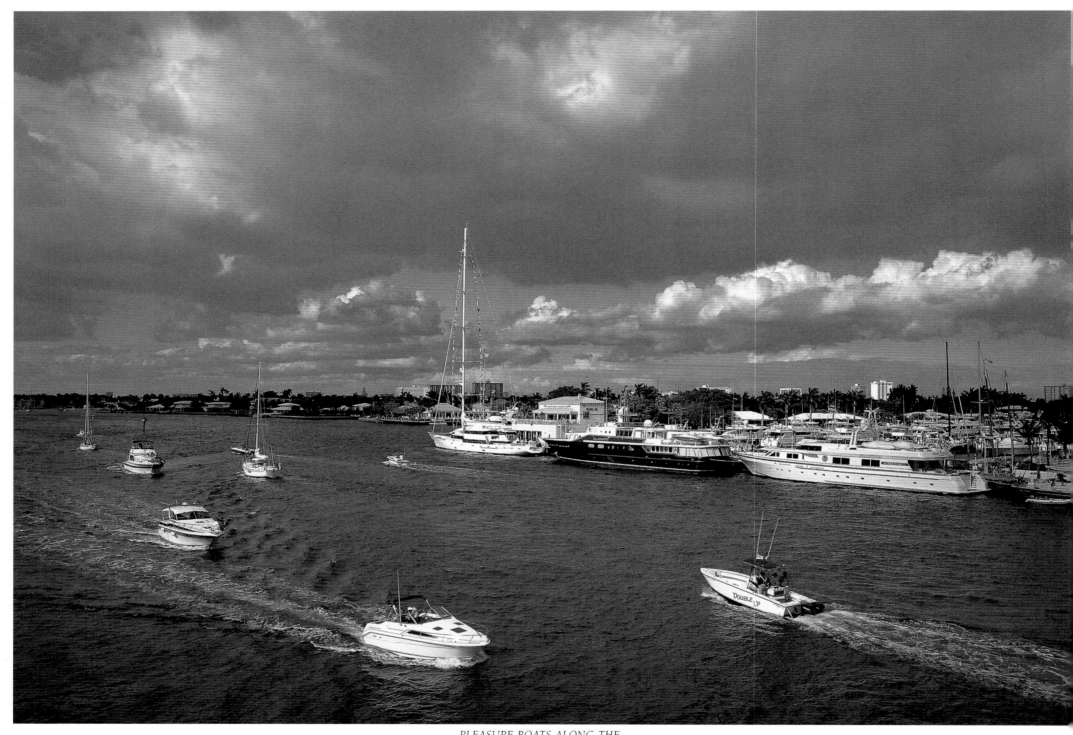

PLEASURE BOATS ALONG THE
INTRACOASTAL WATERWAY, FT. LAUDERDALE

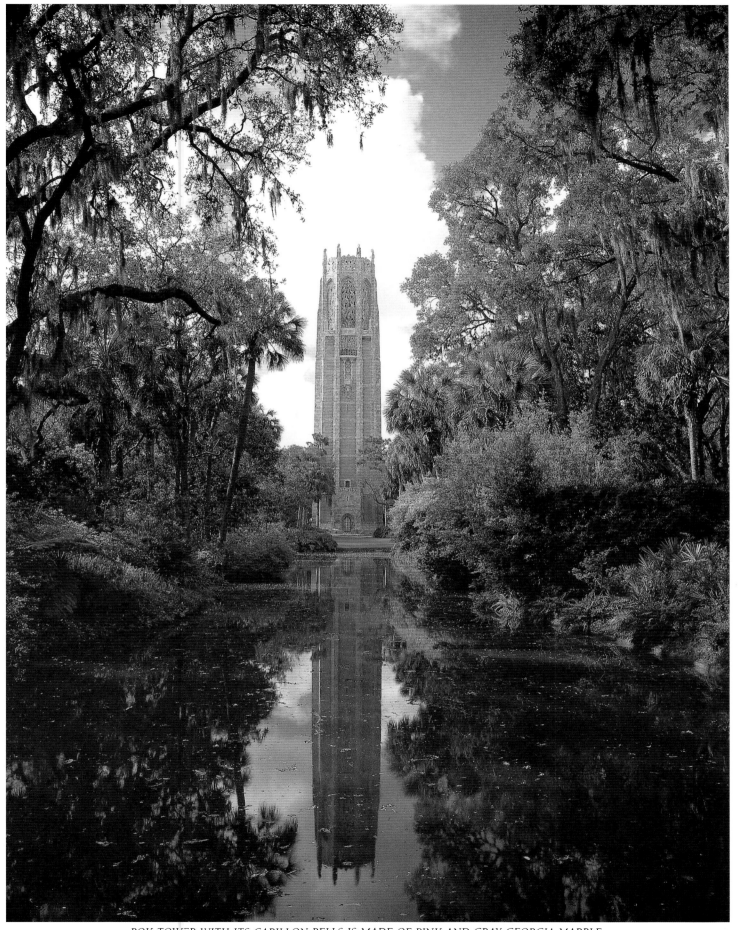

BOK TOWER WITH ITS CARILLON BELLS IS MADE OF PINK AND GRAY GEORGIA MARBLE,
BUILT IN 1929 BY EDWARD BOK AND DONATED TO THE STATE OF FLORIDA

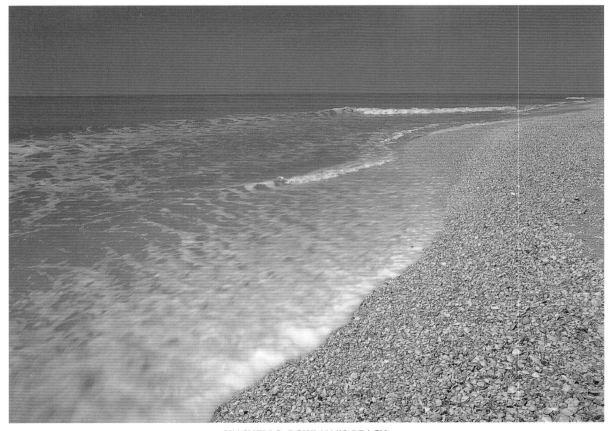

SEASHELLS, BOWMAN'S BEACH,
SANIBEL ISLAND, GULF OF MEXICO COAST